T0094636

YELLOW RIVER ODYSSEY

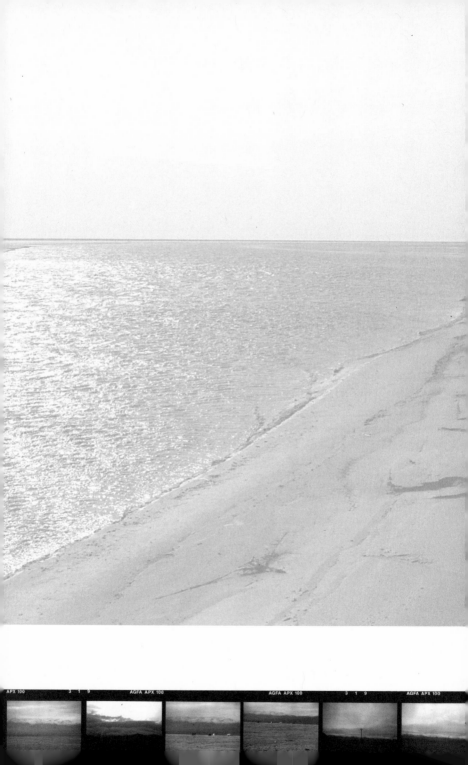

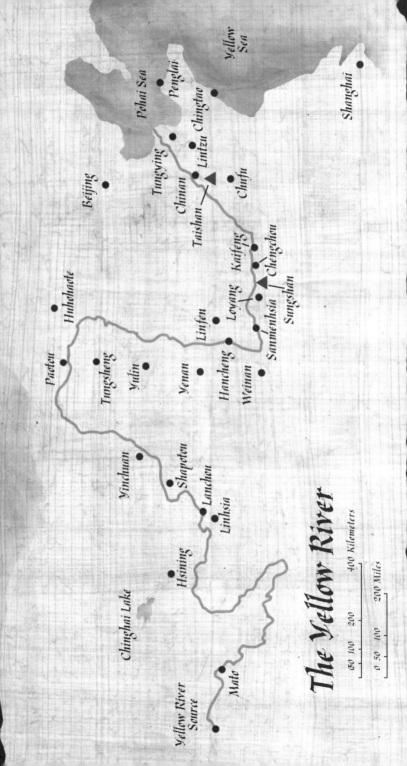

The Yellow River

Yellow Sea

Pohai Sea

Shanghai

Penglai

Lintzu Chingtao

Tungying

Beijing

Chinan

Chufu

Taishan

Kaifeng

Loyang Chengchou

Hohhote

Sanmenhsia Sungshan

Linfen

Paotou

Tungsheng

Yenan

Hancheng

Yulin

Weinan

Yinchuan

Shapotou

Lanchou

Linhsia

Hsining

Chinghai Lake

400 Kilometers

200 Miles

150 100 200

0 50 100

Yellow River Source

Mato

SHANGHAI

I asked the concierge to unlock the window so I could smell the city. I was on my way from Hong Kong to follow the Yellow River from its mouth to its source and couldn't resist the temptation to stop in Shanghai for the China Coast Ball. This annual bacchanal was organized by and for the Hong Kong expatriate community, and it was normally held in March at the Belle Vista in Macao. But in 1991 the Belle Vista was being renovated, and the organizers turned to the Peace Hotel in Shanghai as a suitable replacement. The Peace had been boarded up during the Cultural Revolution, and the splendor of its art-deco interior had survived intact.

From the airport, I took a taxi to the Peace, but the Peace was full, as were the other hotels opposite the river promenade known as the Bund. The ball's organizers were expecting over 500 members to show up and had reserved all available rooms six months in advance. Revelers were coming from as far away as Europe and Australia. Fortunately, a few blocks away, the former Russian consulate-general's residence had reopened the week before as the Seagull Hotel, and I had my choice of accommodations. The place still reeked of glue from the newly paneled hallways, so I sought relief in the lesser evil of the Huangpu River. And

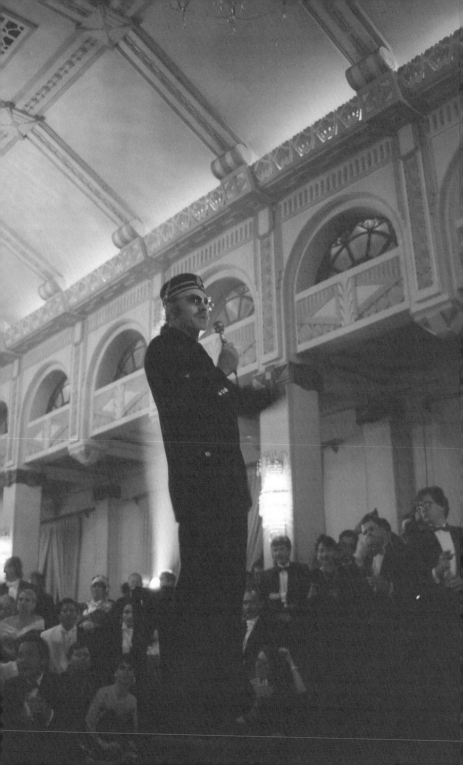

the concierge was kind enough to unlock my room's window. The river flowed past the Seagull and the other hotels on the Bund, and twenty kilometers to the north it joined the waters of the Yangtze and the East China Sea. It was the junction of these waterways that was the reason for the city's existence. Most of China's billion citizens lived in the Yangtze watershed, and Shanghai connected them with the rest of the world. That didn't mean much until a few centuries ago, but the city had made up for lost time. I thanked the concierge and looked out onto the Bund.

In Samuel Couling's 1917 account of Shanghai in the *Encyclopaedia Sinica*, he wrote, "The whole district is a mud-flat with no natural beauty, and art has done little to improve matters, except in a few of the buildings on the Bund." The city had changed, but I wasn't there to see the changes. I was there for the ball, and the ball was still a few hours away. So I went for a walk. From the Seagull, I walked north through what was once the American spoils of the Opium Wars. It began raining, but my parka kept me dry enough. A few blocks later, I entered Hungkou Park and stopped to pay my respects at Lu Hsun's grave.

Lu Hsun was China's greatest twentieth-century writer, and Shanghai was where he spent the last decade of his life, until his death in 1936 at the age of fifty-five. His bronze statue sat near his tomb in a bronze wicker chair. It was remarkable for its simplicity. I bought some flowers from a vendor and laid them next to a wreath left by a group of Japanese. To avoid arrest in China for his anti-imperial writings, Lu Hsun fled to Japan and stayed there until the Chinese Revolution succeeded in toppling the Ch'ing dynasty in 1911. Despite his socialist leanings, he was, and still is, viewed as a hero in

Japan. The park also included the Lu Hsun Museum, where it seemed everything he ever owned was on display: his pocket watch, his umbrella and, of course, his books and journals. There was a collection of woodblock prints he made early in his career that revealed better than words his sympathy for the sufferings endured by his fellow Chinese. They reminded me of the work of Kathe Kollwitz. I looked at his death mask and thought about the changes in China since he last closed his eyes.

From the park, I continued walking north and stopped several times to ask directions. I finally found the lane I was looking for and then the plaque for Lu Hsun's home. The two-story brick house was normally open to the public, but it was closed that day. A man across the lane saw me and said the caretaker kept the place closed whenever it rained in order to keep people from tracking mud inside. The man's name was Li Hou. He said he was an artist, and he invited me to join him for a cup of tea. While I sat in an armchair in his living room, he showed me his paintings, unrolling them one by one on the room's cement floor. The long paper scrolls of black ink and colored washes made me think Lu Hsun had simply packed up and moved across the lane and exchanged the realism of youth for the abstraction of old age.

I would have stayed longer, but I didn't have time to linger. I thanked my host and headed back to the hotel. By the time I got back, it was dark. I looked outside my window again at the Bund. All the buildings were lit up. "*Bund*" was a Hindi word for a river embankment or promenade. The English picked up the word when they colonized India. And they brought the word with them to Shanghai along with opium. And that night their descendents had paid the city US$5,000 to turn on the lights normally reserved for special holidays, such as Lunar New Year and National Day.

In the distance, I could see taxis pulling up to the Peace

Hotel and partygoers getting out. I walked down and crossed the bridge that spanned Suchou Creek and joined them. I entered the hotel's revolving door along with several couples. And as we did so, we were greeted by a gauntlet of young Chinese girls wearing white ballet tutus and waving bouquets. We walked past them and waved back and crowded into an elevator. Eight floors later, we were swept into the ballroom. At the door, the maitre d' was collecting invitations, and I didn't have one. And my purple parka did not exactly match the formal attire of the other guests. He motioned me aside. But I was prepared. I had a camera hanging from my neck, and I showed him my Hong Kong journalist ID. It was for Metro News, the English-language radio station where I worked. It didn't occur to the man that radio journalists didn't use cameras. But he waved me in anyway, and I joined a throng of more than 500 gowned and tuxedoed expatriates who were there to party. Just in case someone was looking, I took a few photos. But mostly I danced.

The music was supplied by the Peace Hotel's Old Time Jazz Band, whose members were in their seventies and eighties. They had managed to survive the Cultural Revolution, and they could still play the "Chatanooga Choo-choo." Fortunately, their age soon caught up with them, and they were replaced by a Chinese rock-and-roll band that blew out two sets of speakers playing Jimi Hendrix. The party lasted all night, and at noon the next day I boarded a coastal steamer heading north.

The Bund, Shanghai

CHINGTAO

The ship was listing badly, and I was surprised it left at all. It even left on time and without fanfare. No one waved goodbye. I was on a ship full of migrant workers heading home. They watched silently from the ship's railing as we moved slowly down the Huangpu River past factories and shipyards and the Paoshan Steel Mill and into the muddy Yangtze and finally into the equally muddy East China Sea.

I shared a second-class cabin with seven other passengers. Third-class had twenty bunks to a cabin. And fourth-class had no bunks at all, just an empty floor. You had to bring your own bedding, or at least some cardboard. There was no first-class, not on a ship like this. But outside on the main deck, we were all equal. Outside, there were easily a hundred other passengers, and we all watched the sun go down and the sky fill with stars. Then we all went to bed. One of the crew members came by and dimmed the cabin lights. He said the lights were never turned completely off to prevent thefts. Somewhere in the night the sea turned green, and I spent the next day stretched out on a hatch cover basking in the sun and from time to time reading a few lines of the *Diamond Sutra*, thinking maybe this trip I would understand it.

We finally reached Chingtao in the late afternoon.

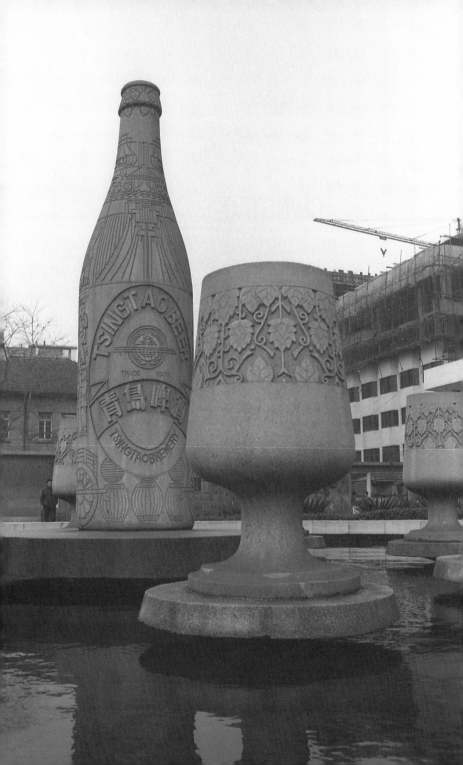

Although that part of the coast had been used for centuries to offload grain for transshipment to North China, a major port wasn't established there until Germany occupied the area after two German priests were killed in 1897. Since then, Chingtao had become a city of a million residents. And they were joined by ten million tourists every summer on the city's beaches – or beach. As many as 250,000 people a day crowded 600-meter-long First Beach. Second and Third Beach were not open to the public. They were reserved for senior party members and government officials. It was a town where Chinese VIPs came to relax.

It was too cold to go swimming in March, but Chingtao didn't mean beaches to me, it meant beer. I drank my first Chingtao in 1977 on the Apache Indian Reservation in Arizona. China's Cultural Revolution had just ended, and the Apaches, as always, were trying to annoy the US government (bless their hearts). So they started importing Chingtao. It was a great hit with all of us who were working in the Forest Service, and we often went miles out of our way to stop at the reservation store on the way home after a day of working in the woods to enjoy a cool one from China.

And there I was at the Chingtao Brewery at nine o'clock the next morning, listening to the official in charge of visitors point out how the foam clung to the sides of the glass – a sign, he said, of a superior beer. I drank four superior beers and followed him into the bottling plant. The brewery, he said, was founded in 1903 by German and English brewers, and the beer was made with hops from Central Asia, grain from Australia and Canada, and water from nearby Laoshan. After fermenting for sixty days, it went to the bottling plant, where I watched a labyrinth of bottles being steamed, cooled,

Chingtao Brewery

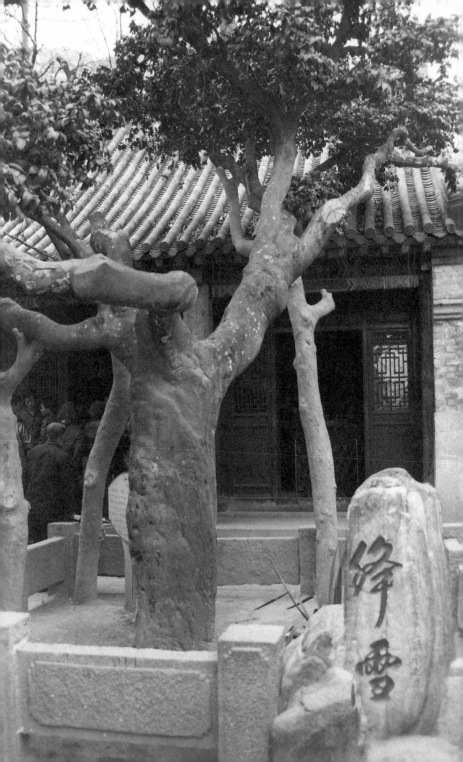

filled, capped, labeled and sent off to my friends in the White Mountains of Arizona. Sufficiently primed for the day, I went back to my hotel and hired a taxi to take me to the mountain that supplied the water for the beer, not to mention the water for the tea drunk by some of China's most famous Taoist masters. Over 2,200 years ago, one of them convinced China's first emperor that the Island of the Immortals was in the ocean just east of Laoshan. The emperor gave him a ship, rich presents, 500 servants (to attend the immortals) and orders to bring back the elixir.

From Chingtao, the road to Laoshan hugged the coast and led past beds of kelp and mussels and several small harbors of fishing boats. Along one stretch of beach, I asked the driver to stop so I could see the place where the ship bound for the Island of the Immortals sailed from but to which it never returned. Despite such failure, Laoshan had remained a center of Taoist practice, and not far from that strangely vacant beach, I arrived at Taichingkung Temple and the residence of one of China's most famous living Taoist masters, K'uang Ch'ang-hsiu.

Master K'uang lived at the foot of Laoshan in one of the temple's courtyards. Tourists were not allowed inside that part of the temple, but someone had left a side gate open, and I slipped through it. I saw Master K'uang in a reception hall talking to a young man. But when the Master's attendants saw me, they waved for me to leave. As I turned to go, the young man said something to Master K'uang, and the attendants called me back. Master K'uang motioned for me to come inside the hall and sit beside him. The young man turned out to be a Taoist priest I had met a year earlier in the Chungnan mountains a thousand kilometers to the west. Adding one

Camellia tree at Taichingkung

surprise on top of another, he reached into his shirt pocket and pulled out the name card I had given him the year before. Even Master K'uang laughed at the serendipity.

He was eighty-eight, with a foot-long white beard, a top-knot of silver hair sticking through his black hat, and he was holding onto a cane of twisted wood. When I asked him about Taoist practice, he said it wasn't easy, but anyone could do it, but that was all he would say. His attendants hurried him off to lunch, and I went outside with the young Taoist I had met the year before. I asked him why he wasn't wearing his robes. He said Taoist temples were no longer good places to practice. He was going to build a hut somewhere in the countryside, in Kiangsu Province, he said. All that he owned was in his rucksack, including a flute sticking out from the top.

We said goodbye, and I continued my tour of the temple. A few minutes later, I found myself in the courtyard where P'u Sung-ling lived three hundred years ago. P'u Sung-ling was one of China's most famous storytellers, and his *Liao-chai Chih-yi* (*Strange Stories from a Chinese Studio*) was as well known in China as Tom Sawyer was in America. Among the stories he told set at the temple was one about two female immortals who decided to remain in the world as camelia trees, one red and one white. Both were as lovely as ever, illuminating his old courtyard with hundreds of blossoms. There was a bench beside one of the trees, and I sat there for what seemed like forever.

ISLANDS OF THE IMMORTALS

When forever ended, I returned to Ching-
tao and boarded one of the minivans outside
the Chingtao train station that left as soon
as they were full. Since I was the first pas-
senger, I chose the lone seat across from the
driver. Although it was a potentially dangerous spot to sit, I
liked to see the road ahead. Twenty minutes later, the van was
full, and we were off to Yentai. A new highway was being
built across the Shantung Peninsula to Yentai, but it was only
half-finished. Still, we made good time because the driver
didn't slow down for the unfinished parts. Halfway there, the
sun went down, and I waited for the driver to turn on his
headlights. The road only got darker. When I asked him why
he didn't use his lights, he said they didn't work. Then he
opened the glove compartment and took out a flashlight,
and held it outside the window, aiming it at the road in front.
I'm not kidding. A flashlight. I think he did this to placate my
sense of unease. It didn't help at all. And he still didn't slow
down. Instead, he tried to stay as close as possible to the rear
of whichever truck he could keep up with. And when one
truck got too far ahead, he simply pulled over and waited for
another one to come along.

Three hours and 150 kilometers after leaving Chingtao, I finally checked into the Yentai Guesthouse. The receptionist compared my signature to the one in my passport and noted the difference. That was new. I told him I just arrived from Chingtao. He nodded. Apparently, my minivan experience was not unique. The hotel was at the west end of the beach, and just behind the hotel was the hill after which the town was named. In Chinese, *yen-t'ai* meant "fire tower." The tower on top of the hill had been replaced by a modern lighthouse, but the former British and American consulates just below it were still there, although in ruins.

In 1858, at the conclusion of the Opium War, the Chinese signed a treaty that allowed foreign powers to set up concessions in a number of ports, such as Shanghai, Chingtao and Yentai. Foreigners mistakenly called Yentai Chihfu, which they spelled Chefoo, which was actually the name of the village on the other side of the harbor. It wasn't much of a treaty port, because it didn't have much of a harbor, and no breakwater at all. During the winter, winds from the north made loading and unloading goods dangerous, until a breakwater was finally constructed in 1916.

What foreigners unloaded was opium. And as to what they loaded back on board their ships, there was this note in the *Enycyclopaedia Sinica* of 1917: "In addition to shipping one hundred thousand coolies to Siberia every year, the chief trade is in beancake (tofu), vermicelli, groundnuts and silks; there is also a good business done in hairnets, lace and fruits; the last being due to the Reverend Dr. Nevius, who grafted foreign fruits and gave instruction to the Chinese in fruit-growing."Yentai had since become famous for its cold-weather fruits, including apples, pears and plums. It was also famous for its grapes, which were not grown to be eaten.

Not long after the Good Reverend introduced the fruit that the ancient Greeks and Romans considered the

gift of the gods, a Cantonese businessman used grapes to produce wine. That was in 1892. His wine was an instant success, and his Changyu Winery had since become the city's best-known enterprise. The next morning, I toured its cellars, which were filled with the same huge oak barrels the winery's founder had imported from France a hundred years ago. I also toured the bottling plant. And, of course, I visited the reception room, where half a dozen bottles were opened on my behalf. The Cabernet and Riesling weren't bad, but the Muscat and Vermouth were so sweet even a wino would have cringed. However, I couldn't resist buying a bottle of forty-year-old brandy for the road.

By ten o'clock my tour was over, and once again I stepped into the day oblivious to misfortune. After collecting my bag from my hotel, I boarded a bus bound for the city of Penglai, seventy kilometers to the west. It was a regular highway bus and not a minivan, but it was another strange ride. We were stopped by the police three times. And each time they stopped us, they checked everyone's ID and searched everyone's bags, including those on the roof. And they did this not once, but three times. Apparently, while I was sampling Yentai's famous wines, three men entered a bank in Yentai and shot two tellers dead. But the robbers must have escaped by other means, or on a different bus. Thankfully, we weren't stopped a fourth time, and we finally arrived in Penglai just past noon.

In China, the mention of the name Penglai often has people sighing and staring off into space. The reason is that Penglai was the name the ancient Chinese gave to a group of islands that appeared from time to time off that part of the Shantung coast. These were no ordinary islands. They were the home of the immortals. And many were the fishermen and sailors who caught the occasional glimpse, only to see the islands disappear before they could reach their shores.

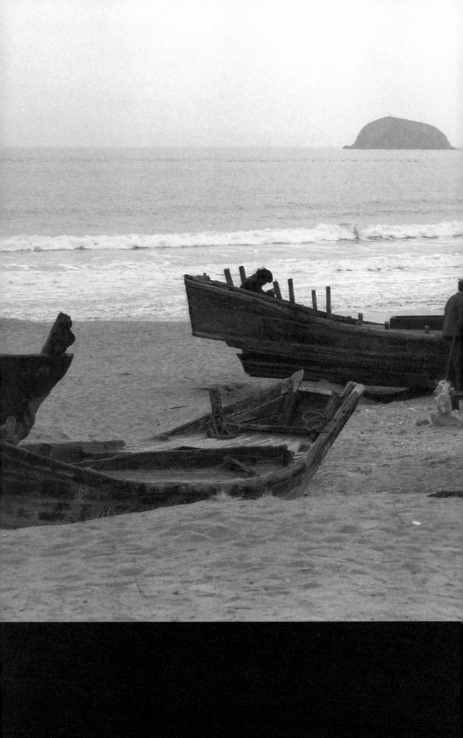

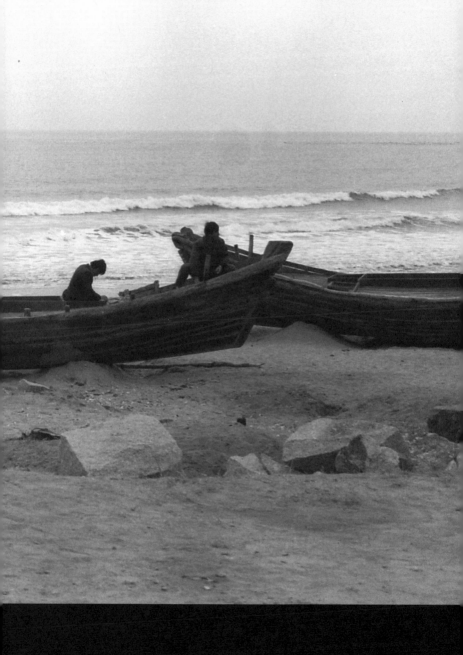

The beach from which the ship bound for The Islands of The Immortals sailed.

After checking into what looked like the only decent hotel in town, I walked about ten blocks to the town's small harbor, then hiked up the headland to Penglai Pavilion to check on recent island sightings. The Pavilion was situated on a cliff that overlooked the harbor and the Pohai Sea, where the islands were said to still appear from time to time. It was the most famous pavilion in China, and due to all the notoriety, it had long since ceased being a pavilion and had metamorphosed into a collection of shrines to various Taoist sages. In one of the pavilion's towers, the provincial television station had set up a camera, just in case, with orders to turn it on whenever the islands appeared.

The day I visited, there were no islands to be seen, so I walked back down to the harbor. This was the harbor from which a group of Taoists once crossed the sea to those islands of bliss. They were known as the Eight Immortals, and they were led by Han Chung-li, with his fan, and Lu Tung-pin, with his sword slung behind his back. They were joined by Li T'ieh-kuai, with his iron crutch, and the white-haired Chang Kuo, and the lovely Ho Hsien-ku, and the imperial cousin, Ts'ao Kuo-chiu, and the effeminate Lan Ts'ai-ho, with his basket of flowers, and Han Hsiang-tzu, the flute-playing nephew of the T'ang-dynasty poet Han Yu. Next to the beach, someone had painted them all on plywood, all except Han Hsiang-tzu, whose place I took long enough to share the camaraderie of his fellow immortals. Ah, Penglai.

MUSIC OF THE IMMORTALS

The next morning, I put an end to my Peng-lai reverie. Instead of a boat bound for the islands of bliss, I boarded another highway bus headed west, back toward the world of red dust. It was an old bus. And it was so accustomed to driving on bad roads, it bounced and shook, just out of habit, even though the highway was paved. The road followed the coast, then turned inland, and every ten kilometers or so there was another sign announcing the approach of the industrial city of Tzupo. Tzupo was 250 kilometers from Penglai, and it took all day to get there, or nearly there. Twenty kilometers short of Tzupo's industrial haze, I put an end to my ride among my fellow mortals and got off at another sign. The sign was in the middle of nowhere just outside the village of Lintzu, and it said that one kilometer to the north was the site of the ancient capital of the state of Ch'i.

During the first millennium BC, Ch'i was the most powerful state among all the states that contended for power in China. The success of Ch'i was in great part due to the efforts of one man, Kuan Chung. Master Kuan was the chief adviser of the state's ruler, Duke Huan, and was responsible for developing a series of financial policies that made Ch'i

the wealthiest of all the competing states. He was also report-edly the author of a treatise that bore his name, the *Kuantzu*. I asked directions from some farmers and found his grave in the middle of a barren field across the highway from where I got off. He was buried there in 645 BC. I was surprised his grave was still there, that it hadn't been plowed under or moved during road construction. I'm sure he wouldn't have minded. Graves are for the living. They give us a place to come to honor those who have gone and to think about the past. But there was so much traffic on the highway, I didn't linger.

I walked back across the highway and started to walk down the road to the ancient capital of the state that Kuan Chung made so wealthy. Among the states that sought the protection of Ch'i was the small state of Lu on its southwest border. In 517 BC, Duke Chao, the ruler of Lu, was forced to flee his capital by two lesser nobles who took exception to his complaints about their cockfighting. Strange, but true. And when the duke sought sanctuary in the neighboring state of Ch'i, he brought his young adviser with him. The ruler of Ch'i at that time was Duke Ching, who was far less wise than his ancestor, Duke Huan. And the adviser who accompanied Duke Chao was Confucius, who was only thirty-five but who was already considered wise. When Duke Ching asked Con-fucius about government, Confucius said, "Let the prince be a prince and the minister be a minister, let the father be a fa-ther and the son be a son," the idea being for people to live up to their roles. The Duke responded, "Well said! Indeed, when a prince is not a prince, or a minister not a minister, or a father not a father, or a son not a son, even if the state overflowed with grain, I, for one, would not be able to eat it." Duke Ching may not have been wise, but neither was he a fool.

Some days later, the duke asked again about govern-ment, and Confucius said, "The principal of government is economy in the use of wealth." The Duke was pleased and

decided to make Confucius an adviser. But his prime minister protested, "These educators are just a bunch of unruly windbags, arrogant and self-willed. There is no controlling them. They set great store in long, expensive funerals. It would never do if this became the custom. A beggar who roams the land isn't a man to entrust with affairs of state. This Confucius lays such stress on etiquette and codes of behavior, it would take generations to learn all his rules. To adopt his ways would not be putting the common people first." Hence, the duke told Confucius, "I'm too old to make use of your doctrines." And so when Duke Chao later returned to Lu, Confucius went back with him. But before he left, he left something behind – at least I hoped he did.

As I walked down the road, the farmer who had pointed me toward Kuan Chung's grave came up behind me on his tractor and asked me where I was going. When I told him, he said he would take me there on his tractor for 5RMB. It was only a kilometer, but I didn't feel like walking that far with my backpack. Ten minutes later I was there, and the farmer was 5RMB richer. He dropped me off at the southern section of the old city wall and pointed me toward the marker that I was hoping would be there. It commemorated the spot where Confucius heard the music of Shao. The music was composed 2,000 years earlier by the royal music master of Emperor Shun. For Confucius everything was about harmony, and he had never heard such perfect harmonies. For three months afterwards, he couldn't think of anything else, not even food. Harmony was the principle thread in Confucius' notion of ethics, of how people should behave. But the music of Shao was gone. I'm not sure what I was hoping to find there or hear there. All I could see was a stone on which someone had written that this was where Confucius had heard the music of Shao. But all I could hear was the wind blowing past the city's ancient dirt walls.

Some years later, Duke Chao was invited back to Ch'i, and a state banquet was held in his honor. Naturally, Confucius came along to advise his ruler on ceremony. During the banquet, Duke Ching called for musicians to entertain his honored guest with military music. But Confucius objected: "When the rulers of two states are meeting in friendship, why should there be such barbarous noise? Let these men be dismissed." Duke Ching had no choice but to wave his musicians away. He then called for another group of performers that included jesters, minstrels and dwarfs. Again, Confucius objected, "Commoners who beguile their lords deserve to die. Let these men be punished for such an intrusion." Not one to quibble about such matters, Duke Ching had the performers killed on the spot. Confucius was not on many guest lists after that.

Although Ch'i was the most powerful state during that period of Chinese history, a series of ever-changing alliances kept it from conquering the other states. That honor would finally go to the state of Ch'in, which united all of China for the first time in 221 BC. But until then, Lintzu was the political and cultural center of China, and archaeologists had uncovered some incredible treasures among its ruins. Several years prior to my visit, the government built a museum there to house what they uncovered. It was only a hundred meters or so from where Confucius heard the music of Shao. But apparently the ruins of Lintzu and its new museum were not on any tourist itineraries. Other than a few museum guards, I found myself alone. As I looked through the cases of artifacts, one item that caught my attention was a bronze hippopotamus inlaid with silver and gold. Lintzu was at the southern edge of the Yellow River Delta, and in Neolithic times that area was still home to these animals the Chinese called "sea horses." The memory of their actual form had faded but not their presence..

Near the building that housed the museum, there was another, much smaller building that housed a funeral pit that contained the bones of 600 horses. They were all lined up, as if in formation, and they were buried there alive to accompany Duke Ching in the afterlife. In his *Analects*, Confucius is recorded as saying, "The ruler of Ch'i possessed thousands of horses, but when he died, no one praised him as possessing a single virtue." Indeed, when it comes to virtue, some people are just black holes.

THE RIVER'S MOUTH

Past the ancient site of Lintzu, the road continued north into the Yellow River Delta. One of the guards at the museum walked out to the road with me and helped me flag down a passing taxi. I told the driver I wanted to visit the river's mouth. He had never been there, and he wasn't eager to go. It was an overnight trip. But the only other vehicles I saw were trucks and tractors, and I had no choice but to persist. The negotiation dragged on for half an hour. The final bargaining chip was to agree to let his girlfriend come along and to pay for their hotel room as well.

In prehistoric times, the Yellow River emptied into the Pohai Sea much farther north, just south of Beijing. And on several occasions in historic times it even veered almost as far south as Shanghai. Where it emptied into the sea was constantly changing. But, with the exception of several years during World War II, when Chiang Kai-shek blew up the dikes to drown the invading Japanese – and Communist sympathizers – it had emptied into the sea at its present location since 1855. And that was where we headed.

From Lintzu, we drove north eighty kilometers to the town of Tungying. Forty years earlier, the entire Yellow River Delta was one of the most unpopulated areas in China –

The mouth of the Yellow River

nothing but mudflats and swamps. Then oil was discovered in the 1960s, and the town of Tungying became the base of operations for the Shengli Oil field. Shengli meant "victory." It was a name the Chinese gave to all sorts of things during the Cultural Revolution. In this case, Maoist propaganda promised a place in the sun to those pioneers who heeded the call to produce oil for the country's industries. Of course, this was also an excellent place to send bourgeois elements for re-education. In less than thirty years, the town's population had grown from a few thousand to 300,000 at the time of my visit in 1991.

Fortunately, the area wasn't closed to foreigners, but visitors were required to register with the Tungying Foreign Affairs Police and arrange the necessary permit. While I was inside the police station, the officer in charge told me that Tungying was also the hometown of Sun-tzu, author of the *Art of War*. There were, however, no sites to visit: no home, no grave, no place where he heard his first martial harmonies. I thanked him for the information and for the permit and proceeded to the Victory Hotel, which was the only hotel open to foreigners. It was a huge, drafty place, and we decamped as soon as we could the next morning. Except for those in the oil business, few foreigners visited the area. The only thing to see was miles upon miles of oil wells. And oil was all anyone cared about. But as we drove closer to the sea, I soon realized that reaching the river's mouth was going to be a lot harder than I thought. No one we met along the way had ever been to the actual mouth, though they all agreed the best access was from the north side. Fortunately, there was a bridge just north of Tungying.

Other than a few floating bridges, this was one of the first permanent bridges built across the river. The local officials were justifiably proud. They had hung a huge banner over the roadway at the beginning of the span announcing

this as the first bridge on the Yellow River. Halfway across, I asked my driver to stop in the middle so that I could get out and take a photograph. There was so little traffic – maybe one car every minute or two – he also got out, and we both looked at the river beneath us. It was about five-hundred meters wide and the color of chocolate milk.

Once we crossed the bridge, we turned off on the first paved road that led east and began asking directions. We must have stopped to ask directions a dozen times. But we persisted – or my driver did at my urging. Four hours and a hundred kilometers of ever-changing roads later, the ruts that passed for a road finally merged with the mud. We had finally managed to work our way to the last stretch of mudflats separating the river from the sea. I shouldn't have been surprised that no one knew the way. So much silt was carried down the Yellow River each year that the land near the mouth had been growing at a rate of fifty-seven square kilometers per year since 1855, which was when the river chose the present location to empty into the sea.

As I walked toward the river's mouth, the mudflats were barren, except for the tall, dry grass of the previous year. But oddly enough, I wasn't alone. There were several teams of workers using high-pressure hoses and pumps. When I walked over to see what they were doing, the foreman explained that they were turning the mud back into muddy water and then pumping the water back into the river. They had tents set up nearby and worked in shifts twenty-four hours a day, 365 days a year. It was a never-ending battle, he said, to keep the river from silting shut and flooding the countryside.

In the past, a flood near the river's mouth would not have been cause for alarm. The river would have simply wandered around until it found a new exit to the sea. That, in fact, was how North China was formed over the past 10,000

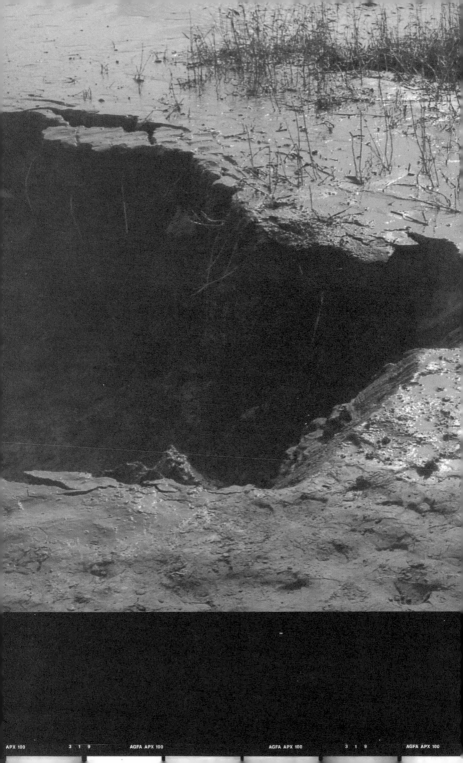

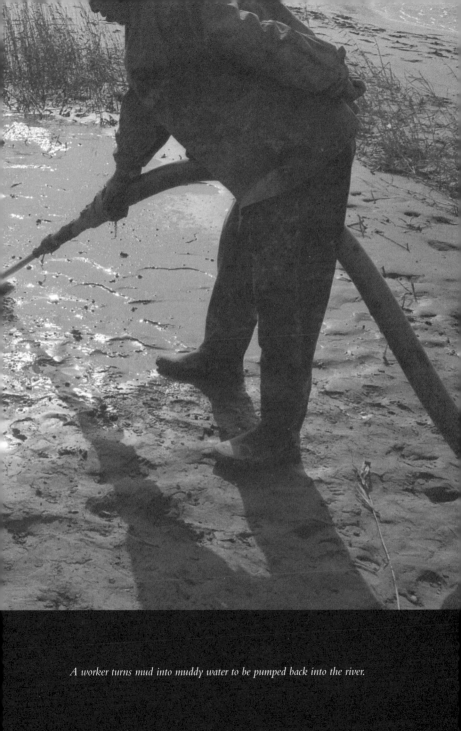

A worker turns mud into muddy water to be pumped back into the river.

years, with the Yellow River oscillating like a loose firehose, as it swung north and south and filled in what once was the ocean. But the Shengli Oilfield was one of the biggest oil fields in China, and salt water and mud would have devastated the wells, and thus a major part of China's petrochemical industry. Nor would it have been welcome in the grasslands that have since covered most of the delta and that supplied pasture for more than 10,000 horses.

The foreman said that during the winter, the air force had to bomb sections of the river to keep ice from blocking the river's flow. But it was March, and the temperature was above freezing. I thanked him for the information and trudged on another couple hundred meters to the river's last hurrah. I looked out on the sea that had been silting up with Yellow River mud for the past million years, ever since the river broke through the mountains west of Loyang. Extracting my feet from the mud, I took one last look and headed for the river's source, 5,000 kilometers away.

CITY OF SPRINGS

From the Yellow River Delta, I returned to the main highway near the ancient site of Lintzu and flagged down the next bus headed for Chinan, the capital of Shantung. If it had been fall, I might have stopped in Tzupo. Every fall the north wind blew away the polluted air from the city's petrochemical plants long enough for kite aficionados to test their creations and skill at China's biggest kite festival. But it was the end of March and too cold for kites. In fact, I arrived in Chinan in what the bus driver said was the biggest snowstorm of the winter, and my feet were frozen.

The English-language travel guides that I had looked at dismissed Chinan as not worth visiting. But snow covered its blemishes, and the city looked quite lovely in black and white. After checking into the old Chinan Hotel, I spent the afternoon sipping hot tea beside my open window, watching the snow fall and warming my frozen feet against the radiator. By the next morning, my feet were ready to walk again, and they took me to see the sights. Chinan was known as the City of Springs – until recently there were seventy-two of them, and I trudged through the snow and slush to see the most famous of them all. It was called Paotu Chuan, or Ever-Gushing Spring, and it was just inside the southwest corner

The moat and old city wall of Chinan

of the old city wall. The spring was in the middle of a pond, and the pond was in the middle of a park. But the spring was dry, and water was being pumped in from somewhere else to fill the pond. A man who was sweeping snow from the path near the spring said the excavation and construction of building foundations nearby had stopped the flow, and the same thing had happened to most of the city's other springs. Efforts to reestablish their flow had failed, and Chinan was the City of Springs in name only.

I sighed a sigh I'm sure was sighed by the city's own citizens and entered a memorial hall just beyond the spring. It was built in honor of China's most famous poetess, Li Ch'ing-chao. That part of town was where she lived in the eleventh century, both with and without her husband. She was married to a scholar-official. But when the nomadic Jurchens invaded North China and sacked the Sung dynasty capital of Kaifeng 300 kilometers southwest of Chinan, her husband, being an official, fled south with the government. And since it was not customary for officials to take their families with them on such distant assignments, Li Ch'ing-chao stayed in Chinan and wrote poems:

> Year after year I've gazed into my mirror
> rouge and skin creams only depress me
> one more year he hasn't returned
> my body shakes when a letter arrives
> I can't drink wine since he left
> autumn I consume my tears instead
> my thoughts vanish into distant mists
> the Gate of Heaven is far closer
> than my beloved south of the Yangtze.

Her husband served as magistrate of Nanching, not far upriver from where the Yangtze made its last bend and

headed for Shanghai and the East China Sea. But not long afterwards, her husband died, leaving her grief-stricken:

> Evenings find me with uncombed hair
> I have a comb and a mirror
> but now that my husband is gone
> why should I waste my time
> I try to sing but choke on my tears
> I try to dream but my boat of flowers
> can't bear the weight of such sorrow.

Thinking I might translate the weight of such sorrow into English, I bought a book that included a commentary along with her poems. Then I walked back outside the hall and through the park and past the old city wall. Although most of Chinan's springs had dried up, there was still plenty of water in the moat outside the wall, and I followed its snow-covered banks to Taminghu Lake. The lake was just inside the northern part of the wall. Near the entrance, I stopped to look at a huge stone on which someone had carved the golden calligraphy of Chairman Mao. My calligraphy teacher once described Mao's style as "all guts and no bones." I was never very good at calligraphy. I also had trouble with the bones.

Just past the calligraphy was the lake. I was surprised how big it was and how deserted. Then again, why would anyone want to visit a lake when the weather was so cold? There were still snowflakes in the air. The only other person there was a man who rented boats. Since I was also there, I decided I might as well go out on the water and row around. I rowed out to a small island and visited its lone pavilion. It was called Lihsia Pavilion, and it was immortalized after the poet Tu Fu and the calligrapher Li Yung spent a night there getting drunk in the year 745. The inscription that recorded

what they wrote that night was too faint to read, and I was losing feeling in my feet again. I rowed back to the shore and walked out to the road and flagged down a taxi. I asked the driver to take me to the north edge of town to the bridge of barges that carried cars and buses and trucks across the Yellow River.

The bridge of barges was a jury-rigged affair that rocked back and forth every time a vehicle crossed. Pedestrians had to hold onto a chain that separated them from the traffic and that also kept them from falling into the river. I walked out and tried to take a photo, but I couldn't let go of the chain long enough. In winter, the river shrank to the point where a person could throw a rock across. In fact, this was the narrowest section of the river on the entire floodplain. Even in summer, when the water level was at its highest, it was only 200 meters across in Chinan, which was the distance between the huge stone dikes on either side. According to a man who worked near the bridge, the bottom of the river was actually five meters higher than the city due to the constant deposit of silt – and that was just the bottom of the river, not the top of the river. He said every July an army of volunteers had to pile sandbags along the dikes and work around the clock to keep China's city of springs from becoming a city of mud.

STONE BUDDHAS

The snow was still there the next morning. It illumined the otherwise dark slopes of Chienfoshan, or Thousand Buddha Mountain, which formed the southern boundary of Chinan. Buddhists started carving buddhas into its cliffs as early as the sixth century, and there were as many as a thousand of them at one time. But most of the buddhas have moved on to other buddhalands, and their numbers have dwindled to sixty or so, the survivors of art collectors, wars and purges. I took a taxi to the trail that led up the hill and started walking. As I walked past one buddha after another, I wondered who paid for all this carving. And why in Chinan? The carving was not especially fine, but the snow gave the buddhas a serenity that art alone had failed to convey.

I walked as far as I could, until my shoes began to disappear in the snow and my feet began to feel numb again. Halfway to the top, I turned and headed back. I hadn't expected to see anyone else on the mountain. But on my way down, I met an old couple who said they walked up the mountain every day, rain or snow. When I told them I had hiked up the mountain to see the buddhas, they said there were much better buddhas in the mountains south of Chinan near the village of Liupu.

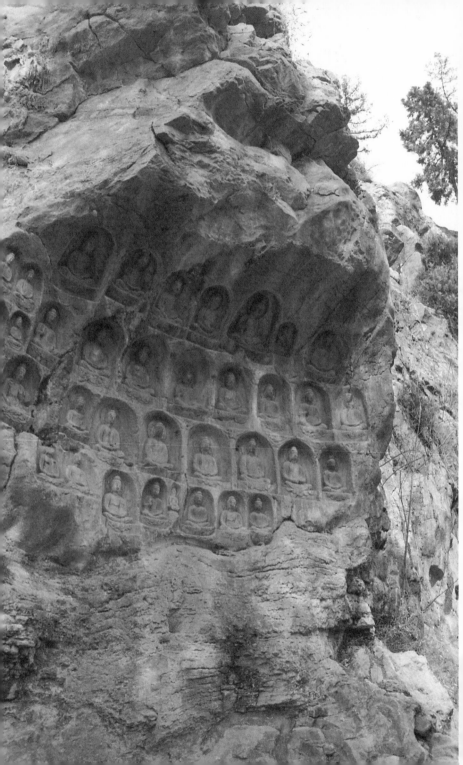

After I returned to my hotel and restored feeling to my feet, I checked out and hired a car to take me there. It wasn't far, maybe thirty or forty kilometers south of the city. On the way there, the sun came out, and the snow disappeared from the road, as if it had never fallen. An hour after leaving Chinan, just past the village of Liupu, we turned into a side valley. The road ended near a lone stupa standing at the edge of a grove of ancient cedars. Stupas were built to contain the remains of Buddhist monks. In fact, the form originated in India from burial mounds. But it had evolved into shapes that reminded me of small rocket ships. Some were so big, they even had staircases inside leading to windows and balconies.

The stupa at Liupu was different. It was not a rocket ship. Or if it was, it was a fat, square one. Most stupas were made of brick, but this one was made of stone. It was built in 611 and was fifteen meters high, and it was almost as wide. On each side was an arched entrance, and inside each entrance was a statue of one of the buddhas of the four directions: Amitabha, who welcomes the faithful to his Pure Land, faced west; Akshobhya faced north; Ratnasambhava faced east; and Shakyamuni, the buddha of the current dispensation, faced south.

This stupa once marked the entrance to a major Buddhist center that had since vanished. But the stupa wasn't the only relic from the past. A path led across the valley past another cliff face into which a dozen buddhas had been carved. There was an explanation below one of them that said it had been carved in 658 by the order of Li Fu, the thirteenth son of Emperor T'ai-tsung of the T'ang dynasty. The carving depicted Maitreya, the buddha who was prophesied to come after Shakyamuni. There was also an inscription carved inside

the niche: "May all people live to old age, may their families and countries be at peace, and may all beings everywhere attain buddhahood."

Past the cliff, the trail continued down a slope to a small grove of several more stupas. The biggest was eleven meters high and was also square. On the outside were carvings of dragons and tigers and the guardians of the four quarters. The setting, with mountains rising on three sides, would have been perfect for a monastery. But nothing except its cemetery remained.

My driver said there was an even bigger Buddhist cemetery west of Liupu across another range of mountains. However, there was no direct road. He said we would have to return to Chinan before we could head south again, which is what we did. Two hours later, we turned off the main highway that led south to T'ai-an onto a side road that led east into the mountains. A few minutes later, we arrived at Lingyen Temple. The temple was on a northern spur of Taishan, China's most sacred mountain. There was a saying that a pilgrimage to Taishan wasn't a pilgrimage if it didn't include a visit to Lingyen Temple. Although this had been true in the past, when Lingyen Temple was still a center of Buddhist practice, there wasn't a monk in sight, much less a pilgrim. In fact, my driver and I were the only visitors. Apparently, no one liked to go out when it was so cold.

The temple, though, was still intact, and the caretaker took us on a tour, which began with two gnarled cedars. They were planted, he said, 2,000 years earlier in the Han dynasty before someone built a Buddhist temple there. Just past the cedar on the right were three springs. I had read somewhere that Lingyen Temple was the origin of the tea ceremony that

A stupa at Liupu

eventually found its way to Japan and that these three springs were the source of the water. But the caretaker didn't know anything about the tea ceremony or the story. He led us instead into the Hall of a Thousand Buddhas.

The walls were lined with a thousand small statues of Shakyamuni, and in the center of the hall were three huge buddhas. The one in the middle was the only buddha made of rattan that I had ever seen. And it was 900 years old. The other two were made of bronze — 5,000 kilos of bronze, according to the caretaker. And along the base of the walls was a collection of one-meter-high statues made of clay. Other temples had statues of the sixteen or eighteen or even the 500 arhats, arhats being paragons of Indian Buddhism who had little, if any, connection with real people. But this group was restricted to historical figures and was equally divided between Indian and Chinese monks. There were forty of them, with Bodhidharma, the Indian monk who brought Zen to China, sitting in the place of honor.

Walking back outside, the caretaker led us to a huge stupa on the other side of the shrine hall. It was over fifty meters high, and there was even a staircase inside that went to the top. But the caretaker said it was too dangerous, and he led us instead to what he claimed was the second biggest Buddhist cemetery in China, second only to that of Shaolin. It included more than 150 rocket ships, all made of stone. It was such a surprising day. I saw so many stone buddhas and stone stupas but not a single living monk or nun. *Omitofo*.

TAISHAN

From Lingyen's forest of stupas, we returned to the main highway and continued south to T'ai-an. T'ai-an was the name of the town that had grown up around the temple where emperors came to pay their respects to Tai-shan. Mountains played an important role in Chinese culture. They were like acupuncture points on the body of the earth and home to powerful forces. And Taishan was their soul. It was where the recently departed spirits of the dead came for assignment to the afterlife. It was the earthly conduit to the netherworld, and the mountain was the single biggest center of pilgrimage in China. Emperors, too, came there to make peace, not only with the hereafter, but also with the forces of the present, whose assistance they needed in this life. I arrived too late in the day to follow them up the trail to the summit and contented myself with going to bed early. But the next morning I was ready to join the pilgrims. After checking out and storing my bag at the train station, I took a local bus to the temple at the foot of the mountain and stopped just outside the main gate at the pavilion where emperors dismounted to perform a simple ceremony announcing their arrival in the land of spirits. I followed them through the main gate and past five huge cedars planted by Emperor Wu in 110 BC and entered

the huge shrine hall where emperors performed the main ceremony.

In ancient times, imperial visitors conducted their ceremonies to the mountain at three temples: one at the foot of Taishan; one halfway up; and a third at the summit. Of the three, only the one at the foot of the mountain had survived. It was one of the biggest shrine halls in China: forty-eight meters wide, twenty meters deep, and twenty-two meters high. Only the Confucian Temple in nearby Chufu and the Imperial Palace in the Forbidden City were bigger.

The hall was built in 1009 at the beginning of the Sung dynasty, or nearly fifty years before William the Conqueror invaded Britain. And it was still there nearly a thousand years later. Its walls were national treasures. They were covered with thousand-year-old murals depicting an imperial visit complete with officials, attendants, ancestors and a pantheon of heavenly deities. The murals were among the great treasures of Chinese art, on a par with those of Michelangelo, only they were painted 500 years earlier than Michelangelo's. I tried to consider the enormity of the work: three and a half meters high, sixty-two meters long, a thousand years old. Taishan definitely received its share of respect.

According to Chinese mythology, the world was created by a creature named P'an-ku, who spent 18,000 years chiseling out the space between Heaven and Earth where humans have been living ever since. When he was done, P'an-ku lay down and died, and his feet became the Western Sacred Mountain of Huashan, his belly became the Central Sacred Mountain of Sungshan, his arms became the Northern and Southern mountains of Hengshan and Hengshan (same sound, different characters), and his head became the Eastern Sacred Moun-

The Diamond Sutra carved into a rock face

tain of Taishan. Thus, Taishan had been venerated as one of China's five sacred mountains since pre-historic times. But 2,000 years ago, just as humans revere their heads more than their hands and feet, Taishan was elevated above the other sacred mountains. This happened in the Han dynasty.

The Han was one of the most glorious dynasties of Chinese history, and the reign of Emperor Wu was the dynasty's most glorious period. In addition to his military and political accomplishments, Emperor Wu was known for his devotion to Taoist regimens that promised immortality. Acting on the instructions of his Taoist advisers, Emperor Wu conducted the most splendid and important religious ceremony of his entire reign at the foot of Taishan for the purpose of establishing harmony among the various spiritual forces whose assistance he required.

A thousand years later, during the Sung dynasty, the emperor who built the shrine hall that still stood at the foot of the mountain and whose visit was depicted on its walls raised the mountain's status to that of a divinity on a par with the emperor himself. It was about that time that the story began to circulate that Taishan's wife also lived on the mountain. Her name was Pihsia Yuanchun, the Primordial Princess of Rainbow Clouds. Over the past thousand years, Taishan and his rainbow-hued cloud bride had become two of the most venerated figures in the entire Taoist pantheon, and shrine halls in their honor could be found in cities throughout China. They were also said to appear from time to time on the trail to the summit, which began just behind the temple where Emperor Wu once drained his treasury to honor their mountain abode.

Leaving the shrine hall, I proceeded up the same path emperors also followed on their way up the mountain. After a few hundred meters, I passed through a great stone archway, and the road turned into a trail of stone steps paid for by emperors and worn smooth by countless pilgrims. People didn't

climb Taishan to get away from others. On an average day a thousand pilgrims hiked to the summit.

Not long after I began my own climb, I passed a stone slab proclaiming Taishan as China's No. 1 Mountain. Beside it was another, smaller archway. Carved across the top were the words: "K'ung-tzu-teng-lin-chih-ch'u: Confucius climbed here." Confucius lived seventy kilometers away, and he came there on a number of occasions to pay his respects to the mountain and to seek inspiration in its solitude – but obviously, not near the main trail. Mencius, the most famous among his later disciples, wrote: "Climbing the Eastern Sacred Mountain, Confucius found the surrounding state of Lu tiny. Reaching Taishan's peak, the Great Sage found the Middle Kingdom small." Mountains put the rest of the world into perspective. Walking through the archway, I didn't pause. The peak was still five hours away.

Just beyond the archway announcing Confucius' visit to Taishan 2,500 years earlier, there was an incinerator where pilgrims sent paper money drawn on the Bank of Hell to their loved ones. In addition to paper money, hawkers sold incense, and the trail was lined with wayside shrines from which clouds of smoke poured forth. I stepped into one such shrine to watch a new deity being fashioned out of straw and mud. The Taoist priest in charge said he hoped to have it ready in time for the pilgrimage season, which began in early April.

A few minutes later, I stopped at another shrine. This one was larger and it had a name: Toumu Temple. Tou-mu was the Goddess of the Big Dipper, and she was in charge of making sure people lived out their allotted span of years. Being the home of spirits waiting for re-assignment, Taishan was where the bereaved came to pray for a good afterlife for their departed loved ones. And while they were making the effort, many of them stopped to ask Tou-mu for a few extra years for themselves. A stele outside the gate explained:

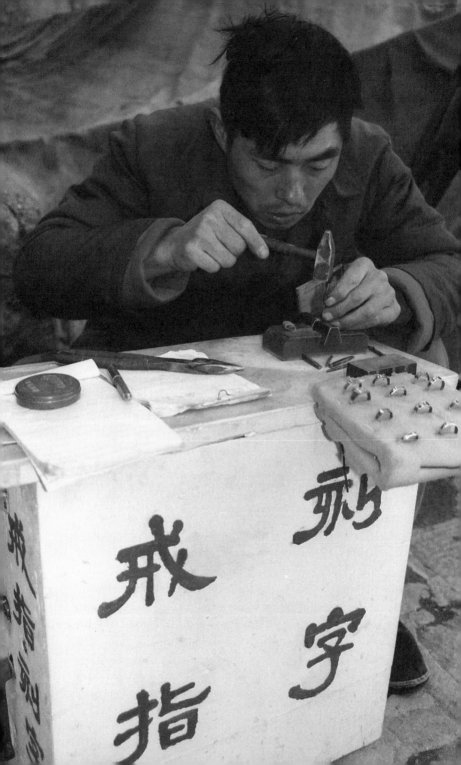

"Whom Heaven wishes to lift up, no person can cast down. The ups and downs of life are matters that can be ascertained, but not by human power. It is I who can see their source." Everyone wanted to be on good terms with Tou-mu. But when I went inside her shrine hall, she was gone. She had been replaced by Kuan-yin, the Buddhist Goddess of Compassion. Apparently, even the gods were not able to forestall their own transience.

Musing on this thought, I continued up the trail and came to a sign that pointed away from the main trail to Sutra Rock. I followed a side path through a pine forest and across a stream to a huge rock face on which someone had carved the entire text of the *Diamond Sutra*. The characters were bigger than my hand, and they were carved there over 1,500 years before I had a hand. The stream I crossed on my way there had once flowed across the rock face and had worn away two-thirds of the sutra's 3,000 or so characters. There was a small dam above the rock face now, blocking the water from cascading down. But I could still make out the hymn that ended the sutra: "As an illusion, a dewdrop, a bubble/a dream, a cloud, a flash of lightning/view all created things like this." It was advice even Tou-mu could understand.

Back on the main trail, I came to another rock face. On this one were carved the words "High Mountains and Flowing Water." These were the names of the two most famous songs for the zither composed by Yu Po-ya three thousand years earlier. Because only Chung Tzu-ch'i could understand what was in Yu Po-ya's heart when he played them, the two men became the Damon and Pythias of China, representing the truest friendship. But as I continued on, all I could hear was the wind in the pines and the panting of my own breath.

A man makes a name chop for the author's son.

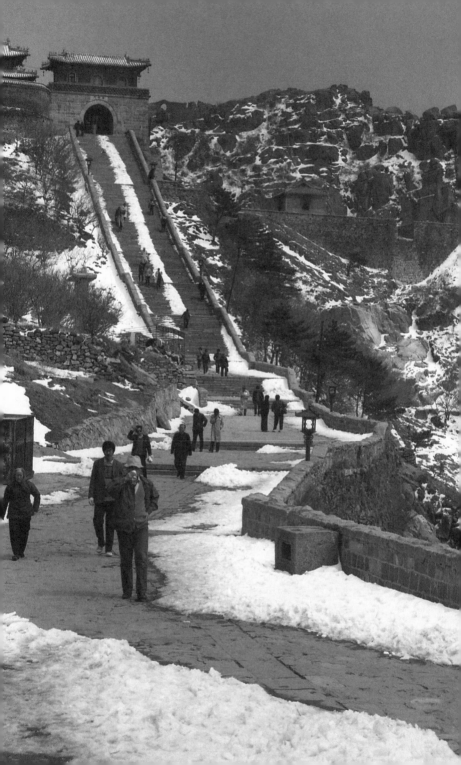

It took me two and half hours to reach Middle Heaven, which was the halfway point on the trail. Climbing Taishan along with hundreds of pilgrims was not the same as climbing a mountain by myself. I was part of a long line of pilgrims stretching back thousands of years. And since pilgrims needed to eat and drink along the path, at Middle Heaven, there were dozens of stalls set up to accommodate them. I sat down at one next to several pilgrims who were eating something that looked good. I didn't know what it was, but I ordered some too. It turned out to be hot, spicy tofu pudding. The weather was so cold and my throat so parched, it was ambrosia. I ordered a second bowl, and it was just as good as the first bowl. For those who weren't able or who didn't want to walk up the trail, this was where the road from town ended and where a cable car took over. But the cable car was expensive, and most people finished the second half on foot.

After catching my breath and restoring my well-being with the hot tofu pudding, I rejoined the other pilgrims on the trail. From Middle Heaven, the path continued along a long, fairly level stretch of trail that eventually led across Cloud Walk Bridge and then up a flight of steps to Five Pine Pavilion. In 219 BC, China's first emperor sought shelter there beneath a pair of pine trees during a rainstorm. In gratitude, he made the pine trees ministers in his administration. Originally, there were only two pines. But both were washed away in another rainstorm. And they were replaced by five pines, only three of which remained. Obviously, Taishan was not a good place to be during a rainstorm. But the pavilion built to mark the spot was still called Five Pine Pavilion.

Further on, I paused to catch my breath again and sat down next to a stall where a man was hammering out name

chops on brass rings. He charged 5RMB, or seventy-five cents, and said it would only take five minutes, so I asked him to make one for my son. While I was waiting, an eighty-year-old man I had met earlier waved as he passed by. Gasping between words, he said it was just-a-matter-of-perseverance, one-step-at-a-time. As soon as my son's name chop was done, I followed him, one step at a time.

Five hours after passing through the archway announcing Confucius' ascent, I, too, reached the final archway, which was also where the cable car debouched its passengers. On the other side was a gauntlet of trinket sellers and food stalls. It had snowed the day before, and someone had made a snow buddha. I sat down nearby and ordered a bowl of hot corn-meal gruel and some fry bread. I was so famished, once more I had seconds. I was really enjoying being a pilgrim, instead of a lone hiker.

The summit was 1,500 meters high, and in addition to the stalls that supplied pilgrims with sustenance and trinkets, there were a number of shrine halls scattered across the ridge. Chief among them was one dedicated to the mountain spirit's wife: the Primordial Princess of Rainbow Clouds. As I entered the courtyard, a Taoist priest hurried by on his way to conduct a ceremony inside. I stood outside the hall and watched as a half dozen priests chanted the daily liturgy to the accompaniment of drums and bells and chimes.

From above her shrine, the Yellow River was said to be visible on a clear day, and people often spent the night at one of the hostels near the summit to see the sunrise the next morning. But the lodgings were so flimsy, they reminded me of the big cardboard box that I kept in the garage when I was a boy and that I dragged into the backyard on nights when there was a meteor shower. I took a picture of the snow-covered roofs of the princess' temple and followed Confucius back down to the civilization he helped establish.

CONFUCIUS

By the time I returned to the foot of Taishan, the sun was also on its way down. I picked up my bag from where I had left it at the train station's luggage depository and caught the next bus headed for Chufu. It left as soon as it was full, and ninety minutes later, just as the last rays of the sun were disappearing, I checked into the Confucius Family Mansion. That was where Confucius' lineal descendants lived, until they were evicted during the Cultural Revolution. Despite losing their home, the Sage's relatives still controlled the town. Of Chufu's 500,000 residents, 130,000 traced their ancestry to Confucius.

The current, direct male descendant, however, was not there. His name was K'ung Te-ch'eng, and he was in Taiwan. The Nationalists brought him to Taiwan in 1949 to support their claim to represent traditional Chinese culture. I first heard about him from my fellow graduate students in the philosophy department at the College of Chinese Culture outside Taipei. Every Sunday afternoon, they attended his private class on the Confucian classics. I once asked if I could join, but Master K'ung said he doubted if a foreigner could grasp the subtleties of his ancestor's pronouncements, such as, "Man who sling mud at neighbor lose ground."

But there I was living in K'ung Te-ch'eng's house,

which was now a hotel. It was a rambling one-story affair with numerous courtyards and corridors. At one time, it vied with the imperial residence in Beijing. But that was before the Cultural Revolution. Still, my room was so big, my bed looked lonesome. The Mansion was also the home of the Confucius Family Banquet, and I was just in time for dinner. The full banquet had to be ordered in advance and included nearly a hundred dishes representing every province of China. But it was for tour groups and party officials on an expense account, and I was alone. Still, I hardly felt slighted by the smoked tofu, for which Chufu was rightly famous, bamboo shoots with black mushrooms, stir-fried pea tendrils and rice pudding. As the Sage himself once said, "When it comes to food, it can never be too fine."

Confucius was born just outside Chufu in 551 BC, a hundred years before the Buddha or Plato. The name Confu-cius was an early Latinized version of K'ung Fu-tzu. K'ung was his family name, and Fu-tzu was an honorific similar to the German "Herr Doktor" and meant "master." Chufu was also where Master K'ung died. And he spent most of the intervening seventy-two years there as well.

During his lifetime, Confucius was not well known outside of Chufu, though he did visit a few of the surrounding kingdoms to promote his notion of good government. In 478 BC, two years after Confucius' death, the ruler of the state of Lu, of which Chufu was the capital, built a small shrine to the Sage on the site of his old house, and over the centuries it was enlarged at imperial expense into the second biggest shrine hall in China, second only to the imperial shrine hall in Beijing's Forbidden City. The tourist pamphlet said it was visited by three million people every year. Early the next morning, I made it a point to arrive just as the front gate swung open and, gratefully, before the tour buses.

The complex was so vast, visitors needed a guidebook

or a guide, both of which were available at the entrance. From the front gate to the rear wall, the courtyards and shrine halls stretched for an entire kilometer, or about the same distance as they did in the Forbidden City in Beijing, with different views emerging through the archways that divided one shrine hall from the next. That was a concept the Chinese also used in their gardens, but in Chufu it was applied on a much grander scale.

From the front gate, the central processional led through park-like grounds shaded by towering pines and cedars, some of them 2,000 years old, and dozens of ancient steles recording the temple's renovation by various emperors. The first major structure was the three-story Kuei-wen-ke, or Palace of Scholars, inside whose walls were more than a hundred pictures of the Sage's life carved onto stone 1,500 years ago. Behind the Kueiwenke was a vast courtyard with even grander steles, most of them with their own enclosures. And beyond the courtyard of steles and off to one side was the Hsingtan, or Apricot Pavilion. That was where Confucius taught when the weather permitted. Next to it, a descendant of the original apricot tree was enjoying another spring. When the weather didn't permit outside instruction, Confucius taught inside his house, which had since become the second biggest shrine hall in all of China and whose eaves required the support of ten dragon-encircled pillars carved from single blocks of stone.

I tried to imagine the scene of instruction: "To put into practice what one has learned, is that not happiness? To greet friends from afar, is that not joy? To be unconcerned about being unknown, is that not the mark of a true man?" That was the passage that began the *Analects*, the collection of sayings that Confucius' disciples put together after he died. While Mao's sayings in his Little Red Book had come and gone, those of Confucius were still quoted. They first circulated

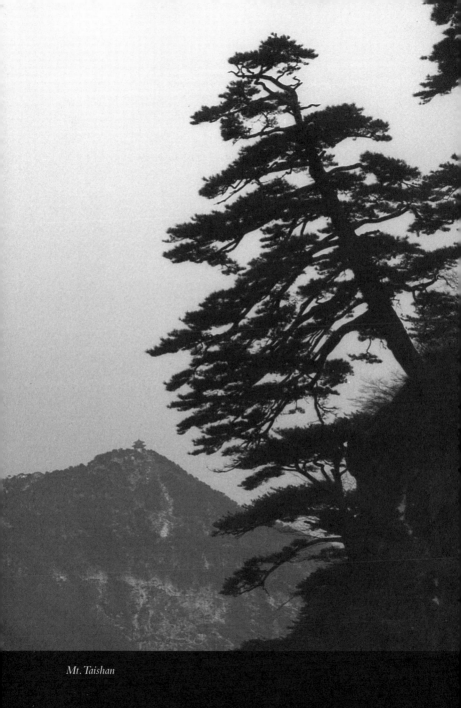

Mt. Taishan

among his disciples and their disciples until the second century AD, when Cheng Hsuan edited them into their present form: twenty chapters without any discernible order full of all sorts of oddities: "Girls and servants," the Master said, "are the hardest to deal with. If you're too familiar, they lose their humility. If you're too distant, they get upset." It wasn't hard to see where all the Confucius Say jokes came from.

My visit to Confucius' home, or the shrine halls that had overwhelmed it, ended just as the morning tour buses arrived. With his home out of the way, I proceeded to his grave. It was two kilometers north of town, which was a bit beyond my energy level. So I climbed aboard one of the pedicabs that plied the main road of Chufu. A few minutes later, I was in China's largest manmade forest park. The park covered 200 hectares of former farmland that over the centuries had been planted with 40,000 trees from all parts of China. There were more than 200 species in the park. In addition to Confucius' tomb, the park contained countless graves of his descendants. But even 200 hectares were not enough. Graves were constantly being dug up to make room for the newly dead. All of Confucius' relatives had the right to be buried in the park, and there were 130,000 people in Chufu who could trace their ancestry back to the Sage. The solution was to allow his descendants to be buried there temporarily and for their remains to be moved elsewhere when new grave sites were needed.

From the park entrance, it was a short walk to his grave. In keeping with Confucius' wishes, his tomb was a simple affair: a grass-covered mound with a stone tombstone hewn from the cliffs of Taishan. On it were inscribed the words Hsuan Sheng, Exalted Sage. After paying my respects, I visited the adjacent graves of his son, K'ung Li, and his grandson, K'ung Chi. After Confucius died, his disciple Tseng-tzu carried on the master's teaching, which Tseng-tzu conveyed in

the book known as the *Great Learning*. After the *Analects*, that was considered the second of the Confucian classics. Tseng-tzu also taught Confucius' grandson, and the grandson also became a prominent teacher in his own right. His interpretations of his grandfather's doctrines make up the third Confucian classic, the book called the *Doctrine of the Mean*. I was a big fan of K'ung Chi's book. It was so straightforward: "The Tao is what you can never leave. If you could leave it, it wouldn't be the Tao."

In front of K'ung Chi's grave, I paused to admire the twin statues of a general and a minister standing guard. They represented the twin virtues of the Confucian ideal: service to the state in times of peace and service to the state in times of war. After paying my respects, I decided to forego the pedicab and walk back to town. On the way, I visited a temple dedicated to Confucius' favorite disciple, Yen Hui, whose early death Confucius often lamented. And after another few blocks, I also visited a temple dedicated to the Duke of Chou. The Duke was the father of the first ruler of the state of Lu, of which Chufu was the capital. He was Confucius' hero.

After returning for lunch back at the Confucius Family Mansion, I hired another pedicab and this time proceeded several kilometers east of town to yet another grave. This one belonged to Shao Hao. Shao Hao was the son of the Yellow Emperor and ruled North China more than 4,500 years ago. His grave was a simple grass-covered mound, but in front of it was a large stone pyramid. The stones were as smooth as glass and defied my best efforts to climb to the top, where several children were congratulating themselves on their success. I gave up and returned to the Confucius Family Mansion.

After a repeat of the previous night's dinner of smoked tofu and assorted vegetables of the season, I walked out to the small store at the Mansion's entryway and bought a bottle

of Confucius Family Liquor. I thought certainly the Sage's family must have concocted a noble brew. But I was wrong. Confucius' family may have been expert in their great ancestor's Tao of behavior, but the Tao of liquor remained beyond them. After two shots, I gave up, put the cork back in the bottle and left it in a drawer for the next unlucky guest to find.

During his own lifetime, Confucius wasn't all that well known. His ascension to sagehood was due largely to the efforts of two men who lived south of Chufu. Their names were Hsun-tzu and Meng-tzu. Hsun-tzu's stomping grounds and grave were a hundred kilometers to the south and a bit too far for me, but Meng-tzu's old home was only twenty kilometers away in the town of Tsouhsien. And that was where I headed the following morning, this time in a local bus that operated between the two towns every half hour.

In the West, Meng-tzu was known as Mencius, which was how Jesuits in China first romanized his name. As we drove through the barren countryside still waiting for warmer weather, we passed a forested hillside. That was where Mencius' mother and many of his descendants were buried. His own grave was more remote, about ten kilometers to the east.

The reason Mencius' mother inevitably came up in stories about him was that she was so concerned with his education, both academic and moral, she moved her home three times before she found a suitable environment for him. The place she finally chose was Tsouhsien. The old house site was still there, along with a large temple complex built in her son's honor. There weren't any English guides or guidebooks, but it was built along the same lines as the Confucius Temple in Chufu with the usual archways and courtyards and shrine

Confucius' grave

halls, but on a smaller scale. And there weren't any tour buses lined up outside. I was practically alone.

Just west of the shrine halls was another complex of buildings known as the Mencius Family Mansion. Like the Confucius Family Mansion, it was built as the residence of the oldest direct male descendant and his family. But while Confucius' heir had fled to Taiwan, Mencius' seventy-fourth male heir was still there. His name was Meng Fan-chi. He was in his eighties, and he lived in a courtyard in back in an area cordoned off from visitors.

Mencius, or Meng-tzu, flourished in the 4th century B.C. a hundred years after Confucius. His writings were also compiled into a book that bears his name. It was the fourth and final member of the group of books known as the Confucian Classics. As opposed to the somewhat terse sayings that make up the other three classics, students of classical Chinese read the Mengtzu with much more pleasure. That was because Mencius usually couched his teachings in stories, like this one about human nature:

"Ox Mountain was once wooded, but because it was close to town, its trees were all cut down by wood collectors and builders. And as time went by, it was visited by herds of cattle and sheep that grazed on its grass until there was nothing left but barren rock. When people see the mountain today, they imagine that nothing ever grew there. But surely this wasn't the true nature of the mountain. The same might be said of human beings. We all possess feelings of kindness and justice. But day after day they are hacked away and destroyed by the way we conduct our lives. When this happens to us, we can't imagine that once our nature was different. But surely this is not our true nature. Confucius said, 'Hold fast to it, and you preserve it. Let it go and you destroy it.' Confucius was speaking of nothing other than this heart of ours, which

must be nurtured in order to protect it from woodcutters and shepherds. And in nurturing the heart, there is no better method than cutting down on our desires."

Give me Mencius any day.

There were many more sites around Tsouhsien and Chufu associated with Confucius and his disciples, and Chu-fu was the sort of town where travelers often stayed longer than they planned. Historical associations aside, it was a good place to recuperate or relax. But I wasn't there to recuperate or relax. After returning from Tsouhsien and pausing just long enough for lunch, I decided I needed an excursion to the countryside, and I had the perfect place in mind: Shihmenshan, or Stone Gate Mountain. It was twenty-five kilometers north of Chufu and just within bicycle range, and the Confucius Family Mansion had bicycles for rent. It took me nearly two hours to get there, but I finally made it. As its name in Chinese suggested, the mountain looked like a stone gate, whose two peaks faced each other across a narrow valley. The eastern peak was where the famous writer and recluse K'ung Shang-jen lived 300 years ago, and the remains of his hut were still visible. Visible, too, on the west peak was the spot where Li Pai and Tu Fu spent the night a thousand years earlier, and that was why I had made the effort to come there.

Li Pai and Tu Fu were China's two greatest poets, not only of their time, but of any time, and they came there one summer day in the year 745 AD. After chaining my bicycle to the railing at the entryway, I followed the stone steps that led up the mountain. The steps continued on to a Buddhist temple near the top, but just before the temple, I turned off on another trail that led to a rocky outcrop and a pavilion built at the spot where the two poets met. The view was grand, with the valley below and the entire ridge of Shimenshan's

east peak spread out like a painting. I could imagine the two poets sitting there watching the sun set and the moon rise. Apparently they brought along plenty of wine. They drank all day and into the night and finally fell asleep under the same blanket. It was their last night together. Although both men lived another fifteen years, they never met again. In a poem commemorating the occasion, Li Pai wrote: "like tumbleweeds drifting apart/let us drain this cup in our hand." I would have hoped what they drained was something more drinkable than the Confucius Family Liquor I had waiting for me back in Qufu, which is where I headed and where I arrived just as the sun was going down.

KAIFENG

It was time to move on and join the Yellow River again, which I planned to do in the city of Kaifeng. Maybe I should have taken the train. But the road looked shorter, so I took the bus. Big mistake. It took twelve hours to cover 300 kilometers, and that was the express bus. The problem was that there was so much road construction going on, the bus couldn't take its usual route, and the driver was unfamiliar with the new route. The only relief came at the halfway point just outside the town of Hotse. We passed acres and acres of peonies. Hotse, it turned out, was the peony capital of China. But it was early April, and the flowering season was still a month away. Still, the sight of so much green in an otherwise barren landscape at least made me feel better. But it didn't last long. There were so few passengers on the bus, I moved to the back seat and stretched out and tried to sleep. It was not a very successful sleep, but at least I didn't have to look out the window. Finally, the sun set, and the world turned dark, and I looked out the window again. But all there was to see was row after row of truck-repair shops and places where truck drivers could eat or sleep. It was ten o'clock when I finally checked into the Kaifeng Guesthouse.

Other than snacks, I hadn't eaten all day. Fortunately,

the Kaifeng Guesthouse was three blocks from Hsiangkuo Temple, which had one of the best night markets in China. It wasn't very big as night markets go, but the variety and quality of the food was exceptional. I had two memorable trays of *hsiao-lung-pao*, or steamed dumplings, and washed them down with, believe it or not, two cold beers. And for dessert, I had two dishes of steamed pears in a sauce made from rock sugar and cloves. My twelve-hour ride from Chufu was suddenly a distant memory.

The next morning I returned to the site of the night market. The stalls were gone, but the temple was still there. Hsiangkuo Temple had an ancient and distinguished history stretching back to the sixth century, but it was no longer a Buddhist temple. The monks were kicked out in the 1920s and hadn't been allowed back. Since then, it had been converted into a combination exhibition center and funhouse. The only remains of its Buddhist past were in the middle of an octagonal building that contained a huge wooden statue of Kuan-yin with a thousand arms and an eye in each hand and all of them gazing in bewilderment at the crazy mirrors in the funhouse next door.

It was so disappointing, I didn't spend more than five minutes there. I decided to go see the river. I was in Honan Province now. "Ho-nan" meant "South of the River," and the river was only fifteen kilometers away. I walked back to my hotel and rented a bicycle and decided to pedal out to the river and to visit a few sights on the way.

Kaifeng was the capital of six dynasties, all of them short-lived, except for the Northern Sung, which lasted 167 years, from the tenth to the twelfth centuries. That was the city's heyday, when it rose to become one of the largest and wealthiest cities in the world. At the Palace Museum in Beijing, there was a long scroll that extended the entire length of the exhibition hall depicting a spring festival in Kaifeng

during that period. It looked like life was good in Kaifeng a thousand years ago. On my way to the river, I stopped at the Kaifeng Museum to find out more. In addition to a copy of the famous painting, the museum also had displays of daily life in the Northern Sung as well as displays of that dynasty's two most famous technological innovations: gunpowder and printing, two inventions that a thousand years later continue to rule the world.

Just north of the museum, I pedaled past a lake named for a man who served as the city's magistrate during its hey-day. His name was Pao Kung, or Magistrate Pao, and such was his judicial prowess that novels were written about him. The Judge Dee novels of the Dutch Sinologist Van Gulik were modeled on the stories about Pao Kung. At one end of the lake, there was even a memorial hall dedicated to the city's famous judge. But I was focused on the river and kept pedaling.

An hour later, I was standing on top of the dike that held the river on its course and that kept it from flooding the city. Kaifeng was twenty-five meters below the river. I'll say that again. The bottom of the Yellow River was twenty-five meters higher than the streets of Kaifeng. When Chairman Mao visited Kaifeng in 1952, he called it "The Suspended River," because from a distance it seemed to stretch like an aquaduct above the surrounding countryside. When the river broke through the dikes – and it had broken through on numerous occasions in the past – the Yellow River turned Honan Province into a yellow sea, and millions of people died. The area where the breaks usually occurred was called Liuyuankou. That was where I was standing, at Liuyuankou. It was early April, when the river was normally at its low-est level. Summer rains were still months away, and cattle were grazing on sandbars that had emerged from the river during the winter. The river at Liuyuankou was only five

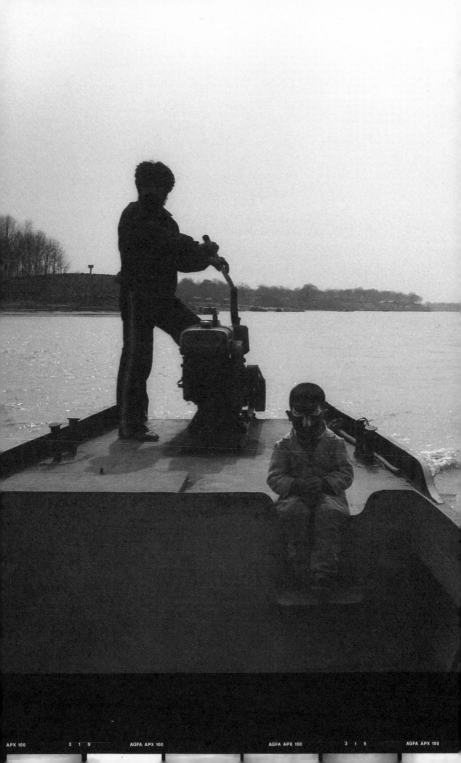

A man and his son with opera makeup on a Yellow River ferry boat.

kilometers wide, and both sides were lined with stone dikes that stretched for twenty kilometers. It was hard to imagine a flood breaking through such massive stoneworks, but the Yellow River had proven over and over that it took more than dikes to keep it flowing toward the sea.

There was no vehicle bridge connecting Kaifeng with the other side of the river in 1991, but at Liuyuankou people could board passenger or car ferries. The morning I visited, there were no prospective passengers, but there were several boats pulled up on the shore. I walked down and talked to a man who operated one of them, and a few minutes later I was dipping my hand in the river to feel the silt. During the summer, the river's silt content approached 50%, which was five times higher than any other river in the world. I could feel the grit between my fingers. As the boat's twelve-horsepower engine slowly moved us out into the middle of the river, we approached one of the sandbars where cattle were grazing. I asked the ferryman to let me get out there. It felt weird to be walking in the middle of the Yellow River. The ferryman said the sandbars would be underwater by July, when summer rains further upstream normally reached Kaifeng. I got back in the boat, and we headed back to shore.

The man had his son with him that day. He was about ten years old, and his face was made up as an opera mask. He just sat there like an ornament at the back of the boat next to his father. I asked him what opera character he was, but he wouldn't say. On the way back to shore, the ferryman slowed to help two boys who were having a hard time rowing across the river against the current. It was their day off, and they had decided to go fishing for carp. Yellow River carp was a specialty of Kaifeng, deep-fried and served in a sweet-and-sour sauce. The ferryman threw the boys a line and towed them behind us, and for his trouble the boys gave him one of their carp.

Back on dry land, I reclaimed my bicycle and began pedaling back to Kaifeng. It was still early in the day, and I retraced my route back to the city. When I was about halfway, I followed a side road through the city's northern suburbs to see Kaifeng's famous rhinoceros. It was an iron rhinoceros, and it had been sitting there on its haunches for over 550 years. It was put there to prevent the Yellow River from flooding. The reasoning, according to the Chinese theory of five elements, went like this: the rhinoceros was the king of all cloven-hoofed beasts, and cloven-hoofed beasts represented the earth element. And since the earth element could overcome the water element, a rhino was just the thing to drive off floods. And, of course, an iron rhino was even better, because an iron rhino stayed put, just in case it did flood. There must be something to the theory. When it was put there in the Ming dynasty, the Yellow River flowed right in front of the rhinoceros. Since then, the river had moved ten kilometers to the north. I imagine the citizens of Kaifeng were grateful. But if they were, they didn't show it. The rhino looked so forlorn. There was not even a caretaker for the site, just a lone rhino surrounded by farmland still waiting for another year of corn or cotton.

I patted his haunches and pedaled on to another of the city's iron landmarks: Kaifeng's Iron Pagoda, which I could see rising from the stubble of last year's cornstalks to the west. The pagoda wasn't actually made of iron, but the glazed tiles that covered its thirteen stories looked like iron. So everyone called it the Iron Pagoda. On closer inspection, I discovered that their glazed surface was covered with all sorts of celestial scenes. A caretaker said there were fifty different scenes depicting the heroes of Buddhist hagiography. But to see all fifty, I would have needed binoculars, and I forgot to bring mine that day. The pagoda was the highest tiled structure in China, fifty-six meters high. It was built more than 900

years ago, during the Northern Sung dynasty, when Kaifeng was the biggest city in the world. And it was built to house a piece of the Buddha's skull, which had since been moved to a temple south of Shanghai, the new biggest city in the world.

I pedaled back to the main road and back to the center of the old city and stopped once more. This time I visited the city's Lungting, or Dragon Pavilion. It was located just north of the center of the old town on the site of the imperial palace that stood there a thousand years ago. In front of the pavilion there were two lakes. According to the pavilion's caretaker, there were two generals who lived just outside the imperial palace where the lakes were now and who amassed incredible wealth in their respective homes. When nomad invaders brought the dynasty to an end, Kaifeng became a ghost town, and treasure seekers came there looking for anything that might have been left behind. The caretaker said the area where they did their digging eventually filled with water, and that was the story behind the two lakes.

In addition to the pavilion honoring the city's dragons, there were several halls, each of which contained a set of wax figures depicting famous scenes from the Northern Sung dynasty. One scene in particular caught my eye. It was the scene of a Jewish merchant being received by the emperor. It turns out that a thousand years ago, Kaifeng had a large Jewish community, which formed as a result of the silk trade. As recently as 350 years ago, there was still a synagogue in the city. But following a flood (apparently the iron rhino didn't do its job all the time) and a reduction in the number of faithful, the elders disassembled the synagogue and sold it to Muslims, who constructed a mosque out of its parts. I was told there were still 150 Jews living in Kaifeng. But all that was left of

the synagogue was a stone stele that had since been moved to the Kaifeng Museum.

From Dragon Pavilion, I followed the causeway that separated the two lakes into the northern part of the old city. Past the lakes, the causeway became Chungshan Road, and I found myself back in the Sung dynasty, as the buildings along both sides had all been rebuilt to resemble what they might have looked like a thousand years ago. It was already late afternoon, and suddenly I realized I hadn't eaten all day. Since I was there, I decided to stop at one of the Sung-dynasty-style restaurants that lined the road. I had no choice but to pass up the Fanlou. It was Kaifeng's most famous restaurant and served imperial banquets in the same manner as they would have been prepared during the Sung dynasty. My appetite and budget demanded something less sumptuous, and I found it right across the street from the Fanlou at the Taohsiangchu, which was equally famous for its *kuo-t'ieh*, or fried dumplings. The difference between *kuo-t'ieh* and regular steamed dumplings, known as *chiao-tzu*, was that *kuo-t'ieh* contained more meat. At least, that was what the cook told me. Whether they did or not, they took care of my hunger, and I went back outside and resumed my exploration of the old city.

From Chungshan Road, I pedaled to Shutienchieh, or Bookstore Street. It was only two blocks to the east, and its buildings were also constructed in accordance with Sung dynasty architectural styles. But unlike the restaurants, the bookstores were a disappointment. All façade. But at least my pedaling was not in vain. On a side street between Chungshan Road and Bookstore Street, I found the guildhall once used by merchants who came to the city from China's northwest provinces. It was first built as a private residence more than 600 years ago by the man who eventually founded the Ming dynasty. Three hundred years later, in the Ch'ing dy-

nasty, it was taken over by the merchants, who used its numerous halls for negotiating deals and entertaining clients. Its woodwork was exquisite, and I would have stayed longer, but the caretaker said he was getting ready to close the front gate, so I had to move on.

As I headed back to my hotel, I stopped one last time, at a park three blocks east of the train station. I wanted to visit Yuwang Terrace, which was in the middle of the park. On my way in, near a bronze statue of Sun Yat-sen, I stopped to watch a group of old men playing croquet on a dirt pitch. I had never seen anyone play croquet in China before. But these men certainly knew the rules, and I watched one old man send his opponent's ball careening into the bushes. He smiled, while the man whose ball was now in the bushes cringed. Ah, croquet. I could have stayed and watched longer, but I wasn't sure when the park would be closing, so I proceeded to the terrace. It wasn't nearly as interesting as the croquet. But I felt obligated to visit, since this was where Yu the Great lived while he was engaged in his monumental labors to stop the Yellow River from flooding – hence the name of the place: King Yu's Terrace. That was about 4,200 years ago. Ironically, his solution to the flooding of the river was not to build dikes but to dredge the silt. Apparently, his solution was ignored or forgotten. River control in China was once more focused on building dikes and dams.

When I returned to my bicycle, I saw a pagoda rising above the roofs just west of the park and decided I may as well have a closer look. It was called Fanta Pagoda. Unfortunately, I arrived just as the caretaker was closing the front gate. But he agreed to let me take a quick look around. The pagoda was built in 977. It was the oldest surviving structure in Kaifeng. Unlike other pagodas that were either round or square, this one was built in the form of a hexagon, and there was a smaller stupa rising from its flat roof. Like the city's

Iron Pagoda, the outside of the pagoda was covered by tiles imprinted with images of the Buddha. And inside, the walls were lined with carvings of several important Buddhist texts, including, according to the caretaker, the most complete version of the *Diamond Sutra*. He said three Malaysian Buddhists once spent a whole day there memorizing the text. Whatever the differences, the ending was still the same: "everything is like a dream."

I thanked the caretaker and pedaled back to my hotel and called it a day. After a bath, I didn't even have enough energy to go out for dinner – not that I would have. I was still full from the *kuo-t'ieh* I had eaten earlier. The next morning, though, I was ready for another excursion and decided I would venture even farther afield. The destination I had in mind was twenty kilometers to the south: Chuhsienchen, which was once one of the most famous towns in the region. That was where woodblock printing began a thousand years ago.

Most people took the bus to Chuhsienchen, but I decided to stick with my bicycle. I pedaled out the southwest corner of the city along Wuyi Road and continued south on the highway. It took me over an hour, but I finally made it – although I did have a little help. The last three or four kilometers, I hung onto the tailgate of a tractor and was thankful for the assistance. As I let go the tailgate and breezed into Chuhsienchen, I suddenly realized I would probably not be so lucky when it came time to return to Kaifeng. I already regretted my decision to stick with the bicycle instead of the bus. But there I was in the town where printing began. The authorities were not unaware of the tourist potential of the place, and on the banks of the half-dry river that cut

Croquet in Yuwang Park

the town in two, they had constructed a series of Sung-style facades. But all the doors were closed the day I arrived. I was told they only opened on weekends and holidays. But I was also told that there wasn't much behind the doors anyway, other than noodle stands and trinket shops.

Chuhsienchen had clearly been left in the dust by the modern age, and despite the Sung dynasty facades, it was a town with little to justify a visit. Still, since I was there, I decided to look around. There were a few signs from the past. One such sign was a shrine dedicated to Yueh Fei, the Sung dynasty general who defeated the army of invading nomads that eventually laid waste to Kaifeng. Yueh Fei's victory, though, was for naught. He was assassinated by traitors, and the imperial forces had to flee south across the Yangtze all the way to Hangchou, where they finally buried their unfortunate general. Next door to Yueh Fei's temple was another temple that was originally dedicated to another general, Kuan Kung, the one with the red face and the long black beard. But the temple had been taken over by the town's woodblock society. When woodblock printing began, Chuhsienchen was its center. That was a thousand years ago. The town was still famous for its New Year prints, and I bought a pair of them so I would be ready to greet the next year in style. Afterwards, I pedaled back to Kaifeng, but I had to do it all by myself. No tractors or trucks slowed down enough for me to grab hold of their tailgates. Fortunately, I arrived back at my hotel just as the stalls in the night market were setting up. And after a repeat of my earlier dinner there, I wanted to do nothing more than to take a bath and go to bed. I was even too tired to dream.

CHENGCHOU

I was planning to leave Kaifeng the next morning. But the next morning I could barely move. My legs were so sore. I resolved not to ride a bicycle again, at least not again on this trip. So I took another hot bath and got back in bed and waited until the last possible minute to get back up and check out of the hotel. And before I left the hotel, I had lunch. I certainly didn't feel like traveling. But there was nothing left for me to see in Kaifeng, and it was time to move on. I took a taxi to the long-distance bus station and thirty minutes later, I was on another bus heading west, this time for Chengchou, the provincial capital of Honan. From Kaifeng it took less than ninety minutes to reach the capital's eastern suburbs. But Chengchou was so big, there were bus stations in each of the city's four quarters, and travellers had to change to local buses before they could reach the downtown area. I was tired and grabbed a taxi instead and proceeded to the Chungchou Hotel on Chinshui Road right next to the new International and about half as expensive. About the only advantage to staying at the International was that was where the local travel services had their offices. But such services were available to non-guests as well. So I opted for the Chungchou, which was built forty years earlier in the 1950s, and which had that Sino-Soviet joint-venture look.

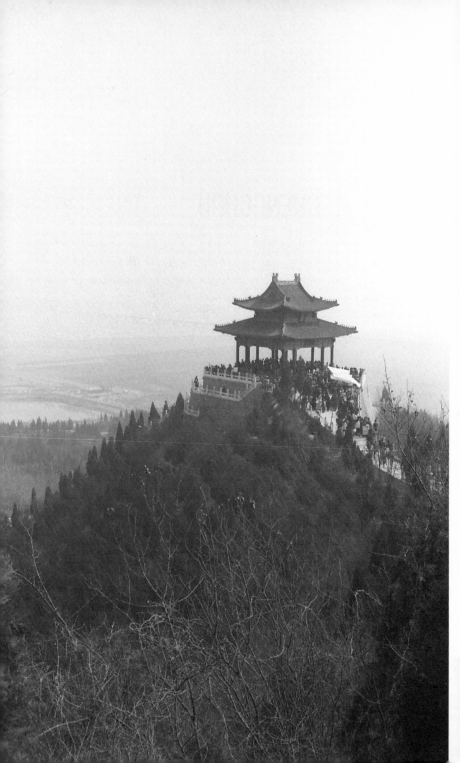

After I dropped my bags in my room, I opened the window and looked down on a small garden filled with cherry trees in bloom. A quick trip back downstairs produced a couple of beers and a few bags of spicy rice crackers, or *kuo-pa*, and a hotdog-shaped stick of bologna, all of which I took with me as I stepped outside my window onto the meter-wide cement ledge that ran along the edge of the building. I sat down and welcomed spring. Down in the garden, three girls were playing hide and seek. Every time they ran past the cherry trees, petals showered onto their hair, and they laughed like birds. By the time I finished my second beer, the last rays of sunlight had turned the garden into a temple of light. Finally, the caretaker entered the garden, and the game came to an end. The girls put their coats back on and grabbed their book bags and ran home, still laughing. Even in a city as dismal as Chengchou there were signs of sping.

Chengchou was a city most travelers only visited on their way somewhere else. It was halfway between Beijing to the north and Wuhan to the south, and halfway between Shanghai to the east and Sian to the west. But underneath its urban sprawl of roads and cement were the remains of one of China's first cities. It was built there over 4,000 years ago, just a few blocks from my hotel. I made it my first stop the following morning. The site was enclosed by a long wall, and there was a small museum inside the wall that contained a few sections of rammed earth and a few clay pots but not much else. It hardly compared with the ruins from the same period found at Anyang a couple hours to the north. But Anyang was too far afield for me, and I continued on to the provincial museum.

Yu the Great Shrine, dedicated to the man who first tamed the Yellow River

It was within walking distance of my hotel. And it was easy to spot. There was a huge statue of Chairman Mao outside. But the place was closed for renovation. Actually, it was no great loss. I was more interested in another museum, namely, the Yellow River Museum. Unlike the provincial museum, I had to search for it before I found it. It turned out to be in a lane across the street from the provincial museum. But it took me thirty minutes of wandering around before I finally wandered into the right lane. The reason I was so interested in visiting this museum was because it was the only museum in China devoted to the Yellow River. Once inside, I took my time. It contained a wealth of information about the river and some surprisingly good audiovisual displays. While I was there, I also met the museum's director, Liu Ch'eng-hsuan. Mr. Liu helped me make some revisions to my Yellow River itinerary and told me about several places worth visiting. He also told me about a temple dedicated to the God of the Yellow River. He had never been there himself, but he told me it was on the other side of the river, an hour or two north of Chengchou.

That was all I needed. I walked back to my hotel and hired a taxi from the hotel's taxi pool. Of course, the driver hadn't been to the temple either, and once we were on the other side of the Yellow River, we had to do some zigging and zagging across the countryside. But after two hours, we finally found it just off the road to the town of Wuchih near the village of Yangchuang. The temple was built just beyond the northern bank of the Yellow River directly across from the Mangshan Hills on the southern bank. As we got out of our car, even the driver was impressed. It was magnificent. What made it even more magnificent was that it was in the middle of nowhere, a huge temple complex, and we were the only visitors. But because we were the only visitors, the front gate was closed. We had to bang on it for five minutes before

the caretaker finally appeared and showed us inside. He was as surprised to see us as we were to see the temple. He said the only time anyone ever visited was during holidays.

The temple, he said, was built over 200 years ago, which was fairly recent for something like that in China. Given its location, just north of the Yellow River, I thought it must have been built to keep the Yellow River God happy so that he wouldn't flood the central plains. But the real reason, according to the caretaker, was that court geomancers had convinced the emperor that the founder of a new dynasty would appear in that very area unless sacrifices were made to the river god. The emperor came there himself four times just to make sure.

The buildings were in superb condition, and their ceilings were minor masterpieces, many of them covered with dragons. According to the caretaker, that section of the Yellow River was where the dragon motif originated, and he showed me photographs of archaeological sites with dragons made of thousands of seashells dating back 6,000 years ago. Of course, the idea that there were dragons in the river was easy to understand when you realize that there used to be dolphins, and their remains have been found in areas flooded by the river. Just to make sure I was on good terms with the dragons in the river, as well as with its resident diety, I lit some incense and rang the bell in the bell tower.

Having seen what there was to see, I thanked the caretaker for showing us around, and we headed back and recrossed the bridge that spanned the Yellow River. But instead of continuing back to Chengchou, I asked the driver to turn west. I wanted to visit the Mangshan Hills that rose on the southern bank directly across the river from the temple we had just visited. On the northern slope of the hills was a shrine to Yu the Great, the first person to control flooding on the Yellow River. That was where the river finally left

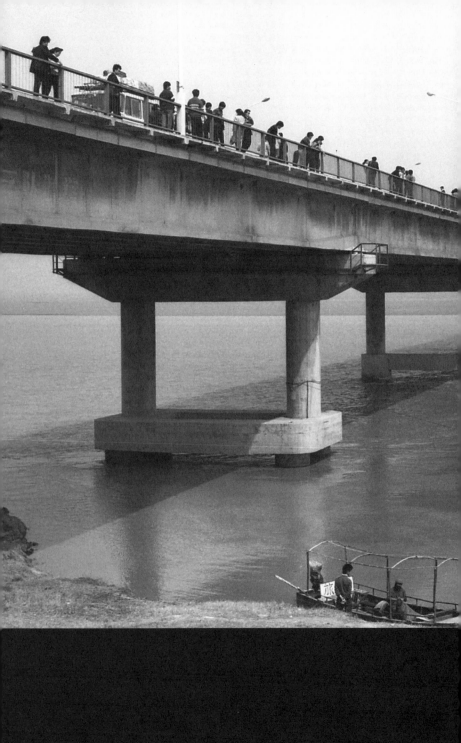

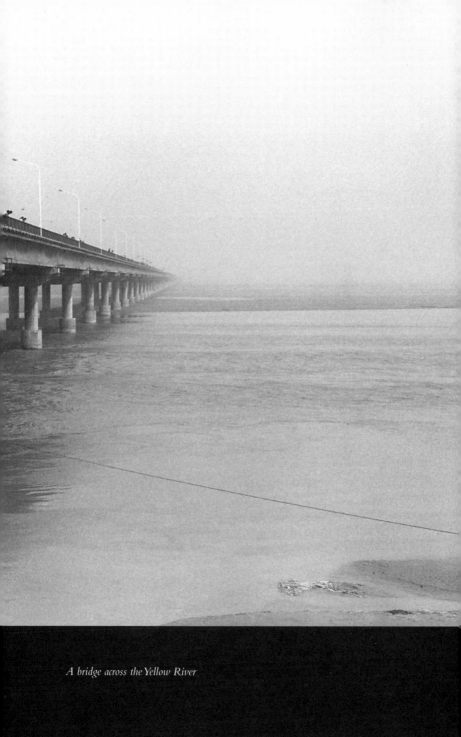

A bridge across the Yellow River

the confines of gorges and hills that held it in check all the way from the Tibetan Plateau. And it was there, between Chengchou and Kaifeng, that most of the floods occurred that caused the Chinese to call the Yellow River the River of Sorrow.

But Yu the Great's shrine was now part of a large recreation area, and I decided to pass it by. I asked the driver to stop instead at a place just east of the hills. It was known as Huayuankou. As if natural floods weren't enough, that was where Chiang Kai-shek dynamited the river's dikes in 1938. Chiang wanted to stop the advance of the Japanese Army, so he decided to flood the area through which it was marching. It was a great idea, if you happened to be a military strategist unconcerned with the welfare of your own people. The only thing Chiang succeeded in doing was to kill a million of his own people and to leave another twelve million homeless. The Japanese simply detoured around the inundated areas and proceeded to drive Chiang out of central China. Later, after the war was over and the Nationalists regained control of the plains, Chiang refused to close the breach in the dikes because of the Communist sympathies of the people in that area. It was only after international pressure forced him to do so that he repaired the dikes in 1947. And so, between 1938 and 1947, the Yellow River entered the sea south of the Shantung Peninsula, instead of to the north. Standing atop the new dikes at Huayuankou, I could only sigh at man's inhumanity to man. Back at my hotel, I stepped out once more onto the cement ledge outside my room to enjoy another round of beer and crackers, but it wasn't the same. The cherry blossoms were still floating in the air, but in vain. The girls who were playing there the day before didn't return. Images of beauty are so brief.

SUNGSHAN

twelve

Having paid my respects to the river, along with its gods and dragons, I decided it was time for another sacred mountain, and Sung-shan didn't look that far away on my map. But distance on a map doesn't mean much in terms of actual travel. First I had to catch a bus. And anytime you take a bus in China, you run the risk of arriving with less than you left with. With the advent of economic reforms that made the accumulation of personal wealth not just okay but glorious, pickpockets were everywhere, and it was on the bus I took from Chengchou to Sungshan that I said goodbye to my faithful camera. I fell asleep, and when I woke up I noticed my bag had been opened. When I looked inside, I discovered my camera was gone. It was a Nikon, too. I dutifully got off at the next stop and reported the theft to the local police. They assured me the culprit would be apprehended and I would have my camera back, in a month. Maybe that would have happened a few years earlier, but thieves were getting smarter as well as more numerous, and I knew I would never get my camera back.

But the real problem with losing something like a camera, at least for a foreigner in 1991, was that because I had declared it among my possessions when I entered China, I

needed a police certificate attesting to its loss before I could leave the country. And I could only get that certificate in the capital of the province where the loss occurred. Alas, I had to turn around and go back to Chengchou on the next bus, find the provincial police station, get the certificate, buy another camera, and spend another night drinking beer and eating snacks on the ledge outside my hotel window, waiting in vain for the laughter of girls among the cherry trees.

The next morning I boarded another bus headed for Sungshan. But this time, I decided not to take the regular bus. I boarded a tour bus, a bus with an itinerary. And this time I didn't fall asleep. This time I kept one eye out the window and the other eye on my bag. The reason I opted for the tour bus was that not only was it more likely to be pickpocket-free than a public bus but that halfway to Sungshan it stopped just outside the town of Mihsien to visit two Han dynasty tombs that I had read about in a Chengchou travel brochure the night before.

When the tombs were first discovered in 1960, their walls stunned the Chinese art world. No one had seen such brilliantly colored murals from so long ago. The tombs dated back two thousand years. Unfortunately, the rapid deterioration of the paint following its exposure to air had led to the closure of one of the tombs. We were limited to visiting the second tomb, whose doors and walls were decorated with less perishable stone carvings. Still, it was a good thing I had my flashlight with me. Otherwise, much of the detail would have gone unseen. And it was the detail that was important.

Since they were discovered, these carvings had provided important evidence for dating certain technological developments, even something as simple as tofu making. Of course, the traditional date of tofu's invention was 300 years earlier and was credited to Liu An, the Taoist uncle of the Han dynasty's Emperor Wu. But here was evidence carved in

stone that within 300 years of its reputed invention, people thought enough of tofu to insist on taking it into the afterlife.

According to historians, both tombs were built by a mere local magistrate. One can well imagine the richness of the imperial Sung dynasty tombs forty kilometers to the west, just north of Sungshan. Unfortunately, none of the Sung tombs had been opened to the public, and all visitors could do, I was told, was walk around and have their picture taken next to the huge stone statues of officials and mythical animals that lined the way to the tombs. Also, there was no public transportation to the Sung tombs, so I gave up the idea of going there almost as soon as I thought about it.

From the tombs, the tour bus continued on and an hour later made another stop at the foot of Sungshan. In ancient times, emperors bound for the summit of Sungshan all stopped there to pay their respects at Chungyueh Temple. Like its counterpart at the foot of Taishan, the temple was huge, in keeping with its use as a place for imperial sacrifice. Emperors came there to worship as early as 3,000 years ago, but the construction of a permanent structure dated back a mere 1,500 years to the Northern Wei Dynasty, when the temple was built on the open-air site previously used for sacrifices.

Sacrifices to mountain spirits formed an important part of the set of rituals developed by the shamans who controlled the fate of early Chinese civilization. The role of shamans depended upon their ability to communicate with the spiritual world, which they did by means of visions. And mountains were better for that than towns, not only because mountains were free of the distractions of social life, they were also where shamans collected the plants that helped induce the trances that made their visions possible.

As Chinese civilization developed, its early rulers, all of whom were shamans, selected certain mountains as de-

Cedar at Sungshan Academy

serving of special veneration. And about 2,000 years ago, not long after the Chinese developed the concept of five elements into which they divided everything – the five colors, the five musical tones, the five branches of government, and the five directions – they came up with the idea of five sacred mountains. Taishan, which I had already visited, was selected as the eastern member of the five mountains, and Sungshan was chosen as the central member. Of course, it was already a sacred mountain. But from that time on, it was one of only five mountains where emperors came to worship.

The old trail to the top of Sungshan – the one that emperors once climbed, or at least were carried up – began just behind Chungyueh Temple at the eastern outskirts of the town of Tengfeng. But for the past thousand years, most visitors preferred the trail that began west of town. And, as soon as we finished our tour of the temple, and our tour bus dropped us off in the middle of town, and I dropped my bag off at a nearby hotel, that was where I headed, but this time on a motorized three-wheeler, which consisted of a motorcycle and a covered carry-all. About two kilometers west of town, we left the old highway that continuted over the mountain and on to Loyang, and we turned onto a dirt road that ended halfway up Sungshan's eastern peak.

But before we got to the end, I made a few stops. For anyone with an interest in Chinese history, the Sungshan area has more to see than anywhere else in China. The problem is deciding which of its many sights one has time to see. I began with the Sungyang Academy. The Academy was first built in the fifth century as a Buddhist temple, but its most famous role was as a center for the study of the teachings of Confucius. This was where the Ch'eng brothers taught in the eleventh century when they developed the basic teachings of what would later become known as Neo-Confucianism. And when Neo-Confucianism later became all the rage

among scholars and philosophers, the Academy on Sungshan was its first center. For the past few decades, the academy had been taken over by a teacher's college next door, but visitors still had access to most of the old buildings. I had seen enough old buildings, though, and was more interested in the huge stele just outside the front gate. It was nine meters high, making it one of the biggest steles in China. It was erected in the eighth century by Emperor Hsuan-tsung long before the Ch'eng brothers started talking about the Tao. And it was inscribed by Hsu Hao, one of the most famous calligraphers of the T'ang dynasty. It was impressive. But even more impressive were the two cedars on the other side of the front gate. When Emperor Wu visited the mountain 2,100 years ago, these cedars were already ancient, and he gave them the rank of general: like General Grant and General Sherman in California's Sequoia National Park. I didn't light any incense, and I'm not sure I would have been allowed to, as incense was always burning things down. But I paused long enough to sigh in admiration before returning to my motorcycle-driven carriage.

Just past the Academy, we came to a fork in the road and took the road to the left. Shortly afterwards, we arrived at the oldest pagoda in China. It was known as Sungshan Temple Pagoda, and it was built in the year 520 AD by the ruler of the Northern Wei dynasty. He built the pagoda next to his summer palace. To gain merit, he later turned the whole place over to Buddhist monks who converted his palace into a temple. The pagoda was still there, all fifteen stories of it, and it was in fairly good condition. But the temple was gone, as were the monks. And so I continued on.

We returned to the fork in the road and this time took the road to the right. It led across a low ridge and to the site of another temple. This was Fawang Temple, the oldest Buddhist temple in China. If records could be believed, it was

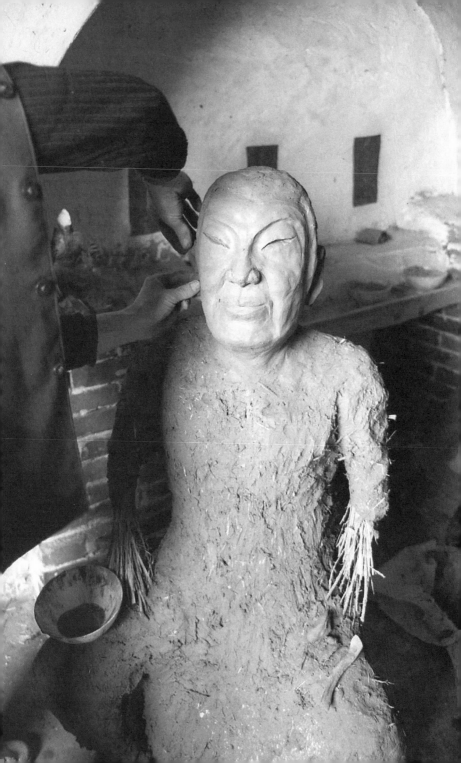

first built in 71 AD. Actually, Loyang's Paima Temple dated back three years earlier to 68 AD, but Paima Temple wasn't really a temple at first, simply a residence used by the first Buddhist monks to arrive from India.

Fawang Temple was built as a monastery, and it was still an active place of practice and worship. It also enjoyed the unusual distinction of being one of the most famous places in China to spend the Autumn Moon Festival. On that auspicious evening, the moon's silver disk was said to rise between a cleft in the mountains, as if it were a mirror rising in the middle of a stone gate, and people came there to watch its passage from the temple's immense courtyard. But I visited in April and had to make do with the perfume and falling petals of the apricot trees in the temple cemetery.

A few whiffs were enough. I returned to my three-wheeler, and we continued on. A few minutes later, we finally reached the end of the road and the shrine of Laomutung, which honored the deity in charge of the Big Dipper and thus the bestowal of old age. Inside one of the halls that made up Laomutung, I watched the caretaker making a new statue of a Taoist deity from mud and straw. He was obviously expecting better times and more donations. I did my part to help him out and arranged for my driver to meet me there three hours later. On the other side of the shrine, I started up the trail.

Along the way, I passed a rock face into which someone had chiseled a poem written by Li Pai during one of his visits to the mountain in the eighth century, and further on I passed a poem by Mao Tse-tung also chiseled into the rock. Just past Mao's ode to the mountain's revolutionary spirit, I paused at Laochun Temple, which was dedicated to Lao-tzu,

A statue of a Taoist deity under construction.

author of the *Taoteching*. Inside, in addition to a statue of Lao-tzu, was the portrait of another famous visitor: Hsu Hsia-k'o. It caught me by surprise. I hadn't expected to meet him on my trip. He was one of my heroes and a hero to anyone in China who enjoyed traveling or who enjoyed reading about traveling, especially to mountains. Hsu lived in the seventeenth century and left behind a set of travel diaries that have become classics. When he visited Sungshan, he left the trail at Laochun Temple and hired a wood collector to take him up by a more dangerous route. I sighed in admiration of his temerity. The main trail looked dangerous enough. From Laochun Temple it went pretty much straight up to the ridge that led to the summit. It took me an hour of zig-zagging back and forth and climbing iron ladders and pulling myself up on chains to reach the ridge. After that, it took another half hour to work my way past several ramshackle huts to the final shrine dedicated to P'an-ku, the creator of the universe, whose belly was, in fact, the very mountain whose summit I just reached. I stood on P'an-ku's navel and searched the horizon for the Yellow River.

On a clear day, the Yellow River was said to be visible fifty kilometers to the north. But all I saw were clouds. I headed back down and was glad to find my driver waiting for me. I returned to Tengfeng and my hotel and asked my driver to pick me up the next morning. The next day, I ventured forth again. This time I traveled fifteen kilometers south of town to the village of Kaocheng and the site of the oldest celestial observatory in China, which included its own version of the sundial. This particular version measured seasonal differences in the length of the noontime shadows cast by the sun. The original device was placed there 3,000 years earlier by the Duke of Chou, Confucius' hero.

The observatory itself was in the rear courtyard. It was designed and built by Kuo Shou-ching in the thirteenth cen-

tury. That was when the Mongols ruled almost all of Asia. With their assistance and under their direction, Kuo set up similar observatories at twenty-seven sites between Siberia and Vietnam. Of the twenty-seven, this was the only one still standing. By means of observations recorded by officials at his twenty-seven observatories, Kuo was able to determine the length of a year as consisting of 365.2425 days, which differs from modern estimates by a mere twenty-six seconds.

Kuo and the Duke of Chou weren't the only ones who liked this spot. The village of Kaocheng was also the location of one of China's earliest known cities, if not its first: the city of Yangcheng. This was where Yu the Great established his capital 4,200 years ago. When I looked down from the top of the observatory, I could see the place where he once held court. The site was several hundred meters to the east, and as soon as funds were available, excavations were expected to reveal the secrets of ancient Yangcheng and the capital of the man who tamed the Yellow River.

After returning to Tengfeng for lunch, I considered my next foray. In China there have always been people who preferred to spend their lives in the mountains, cultivating roots of the spirit. Ever since the Chinese began recording stories about their past, they recorded stories about hermits.

One of the most famous of these early hermits was Hsu You. According to the account recorded by Chuang-tzu around 300 BC, one day four thousand years earlier, Emperor Yao asked Hsu You to take over his throne. Hsu You answered: "When the sun or moon is shining, what use is lighting a torch? When the rain is falling, what use is watering the crops? You, sire, already rule the kingdom. Were I to replace you, it would be in name only. Name is the guest of reality, and I have no desire to be a guest. Even in a deep forest, the wren uses only one branch for its nest. Even beside a deep river, the tapir drinks only enough to fill its stomach. I

have no need for a kingdom. If the cook fails to keep order in his kitchen, the shaman does not stop the ritual to take his place." Then to rid himself of any residue that such talk might have left behind, Hsu Yu walked down to a nearby stream and washed out his ears and spent the rest of his life living in the seclusion of Mount Ch'i. Mount Ch'i was only twenty kilometers south of Tengfeng. But when I told the driver of my three-wheeled taxi that was where I wanted to go, he said there were no roads other than those used by farmers to haul their produce to town on carts. I would have to wash out my ears elsewhere. And elsewhere turned out to be Sungshan's western peak, which was not exactly a place a hermit would choose to dwell nowadays.

The popularity of Sungshan's western peak wasn't due so much to the scenery as it was to one particular Buddhist temple, namely, Shaolin, known far and wide as the home of kung-fu. Actually, the *ch'i-kung* exercises essential to all martial arts were developed much earlier by Taoist masters. And in the past, whenever martial-arts competitions were held between Buddhists and Taoists, the Taoists of Wutangshan invariably defeated the Buddhists of Shaolin. But Shaolin Temple had better PR, and it was located within a few hours of two major population centers, namely Chengchou and Loyang, whereas Wutangshan was in the middle of nowhere.

As expected, when I arrived at Shaolin aboard my trusty three-wheeled taxi, I was not alone. Shaolin attracted such a crowd of visitors that taxis and buses had to let their passengers off a kilometer away, and an active pony-cart business had developed to ferry visitors back and forth. I decided to walk. On my way past the gauntlet of trinket stands that lined the road to the temple, I passed a Chinese-style set of new buildings that housed the Shaolin Temple Martial Arts Training Center. As far as I knew, that was the only such center in China run by Buddhists – there were other centers on the

mountain, but they were private enterprises and not run by the monks. The Shaolin Temple Center was set up to provide visitors, including foreigners, with courses of training. And the courses lasted anywhere from a week to several years – or until you broke a few bones.

Most people considered Shaolin Temple not only the home of martial arts but also the home of Zen. The word "*zen*," or *ch'an* in modern Mandarin, meant meditation. But Zen was more than meditation. Exactly how much more was hard to say. Zen was brought to China at the end of the fifth century by an Indian monk named Bodhidharma, who arrived in Kuangchou after a three-year boat trip. Eventually, he headed north, and he finally settled on Sungshan. It was there, on Sungshan's western peak, that the monk from South India was said to have spent nine years in meditation facing the rock wall of a cave halfway up the mountain behind Shaolin Temple.

There was such a crowd of visitors at the temple, I decided to pass it by and visit Bodhidharma's cave instead. On the way, I could hear the old blue-eyed barbarian haranguing one of his disciples who dared to ask him what he meant by the mind: "You ask. That's your mind. I answer. That's my mind. If I had no mind, how could I answer? If you had no mind, how could you ask? That which asks is your mind. Whatever you do, that's your mind, that's your buddha. Beyond this mind you'll never find another buddha. The reality of your own self-nature is what's meant by mind."

An hour later, I found myself at his old cave. There was a Buddhist nun sitting inside chanting, and I contented myself with standing outside and enjoying the view of the surrounding valley from the terrace in front of the cave. Fifteen hundred years earlier, this was where Bodhidharma's first disciple also stood. His name was Hui-k'o, and he was a very determined student. When he came to see Bodhidharma and

asked to be instructed in the mysteries of Zen, Bodhidharma refused to pay him any attention and went right on meditating on his rock wall. But Hui-k'o continued to stand there, waiting for instruction. He stood there all night and all the next day, and after a while it began to snow, and still Hui-k'o stood outside Bodhidharma's cave, and still Bodhidharma refused to pay him any attention. Finally, Hui-k'o cut off one of his arms and presented it to Bodhidharma, and the blue-eyed barbarian finally agreed to teach him. Thus, Hui-k'o became the Second Patriarch of Zen and the first Chinese Zen master. Historians have debated this story, especially the part about Hui-k'o's missing arm. Did he really cut it off? Or was it cut off by bandits? Or maybe he was born with only one arm? Who knows? The point was that Hui-k'o was the first person in China able to understand the sound of one hand clapping.

As usual, all I heard was the wind and headed back down the trail. Once more I walked past Shaolin Temple. The crowds and especially the tour leaders with their megaphones were too much for me. I returned to Tengfeng aboard my three-wheeler and took the next bus to Loyang.

LOYANG

In some towns I'm not lucky in my choice of hotel, and on this trip Loyang was such a town. To bring in more revenue, many hotels had added nightclubs, and my room was right above one. Even with earplugs I could hear the karaoke, which didn't end until long after midnight. I would have slept late to make up for the loss of sleep, but I wanted to arrive early at one of China's most famous tourist sites, before the tour buses arrived. I stumbled out onto the street in front of my hotel while the sun was still thinking of getting up and caught what must have been the first bus heading for the Lungmen Caves.

The caves were fifteen kilometers south of Loyang on the west bank of the Yi River and were one of China's greatest artistic treasures. Between the fifth and eighth centuries, thousands of Buddhist statues of all sizes were carved out of the rock cliffs just above the river. And despite the theft of many statues by foreign museums and private collectors, there were still some very impressive statues left. I arrived at seven o'clock, just as the first light of dawn came over the hills on the east side of the river and illuminated the cliffs, and just as the front gate was opened and tickets went on sale.

When Silk Road caravans stopped to give thanks to the gods for a safe passage, the first place they stopped once they

entered Chinese territory was Tunhuang, and the Buddhist art they helped finance there remains one of the world's great repositories of ancient religious art. From Tunhuang, the Silk Road divided. Some caravans headed due east to Tatung and left behind the art of the Yunkang Caves. But most caravans continued southeast on their way to Ch'ang-an and Loyang. They left behind similar collections of art at the Pingling Caves near Lanchou and the Maichishan Caves near Tienshui. But they saved their greatest legacy to the Chinese art world for the end of the road at the Lungmen Caves outside Loyang.

Despite the ravages of time, thieves and unscrupulous art collectors, the Lungmen Caves still contained more than a hundred thousand statues in 2,000 niches and caves along a two-kilometer stretch of the Yi River. Most of the statues were of modest size, many only a few inches high. And many had suffered from vandalism and the weather. But one statue stood out as the most magnificent in all of China, if not the world: the seventeen-meter-high statue of Vairochana, the Buddha at the center of the universe. It was hewn out of the surrounding cliffs back in the seventh century, and it was still in perfect condition. It was stupendous, as were the accompanying statues of two bodhisattvas, Avalokiteshvara and Mahasthama, who welcomed the faithful to the Pure Land, and statues of two monks, Ananda, whose perfect memory ensured the transmission of the Buddha's teachings, and Kashyapa, the first patriarch of Zen in India. Illuminated by the early morning light, the scene was impressive. I was almost the only person there. The tour buses weren't due for another hour.

Most people who visited the Lungmen Caves limited their sight-seeing to the west bank of the Yi River. But after taking in the buddha statues carved out of the cliffs, I walked back to the entrance and crossed the bridge to the other side of the river. On the other side of the Yi River Bridge, there was

a landscaped park that contained the grave of one of China's greatest poets. His name was Pai Chu-yi, and he lived there in the ninth century. Instead of writing in the refined style only understood by his fellow literati, Pai Chu-yi wrote for everyone, and his poems were read by people from all walks of life: school children and peasants, courtesans and palace ladies, monks and merchants. They were even written on the walls of temples and inns, and copies were sold in the marketplace.

What Chinese hasn't sighed upon first hearing his "Song of Everlasting Sorrow" about the tragic death of Yang Kui-fei, the star-crossed concubine of the T'ang dynasty emperor, Hsuan-tsung. Alas, as Pai Chu-yi's health and fortune waned, he also had to let his own two concubines go: she of the willow waist and she of the cherry lips. And he spent his final days in the company of monks, at a small temple just beyond his grave, where I paused to pay my respects and then sat down at a stone table overlooking the Yi River and the great buddhas of the Lungmen Caves. The table was covered with cherry blossoms. The caretaker said the cherry trees were gifts of the Japanese, who admired Pai Chu-yi's poems almost as much as the Chinese. In fact, most of the poems quoted in the Japanese novel The Tale of Genji are those of Pai Chu-yi.

I sat there until I could see the crowds of tourists arriving on the other side of the river then walked back across the bridge and boarded the next bus headed back to Loyang. Halfway there, I got off and walked down a side road to another grave. This one didn't belong to a poet, but to a general. His name was Kuan Yu, or Kuan Kung (Lord Kuan), as he was also known. Kuan Yu was born in neighboring Shansi Province, and I was planning to visit his hometown, but this was where he was buried, or at least this was where his head was buried.

Kuan Yu lived during the early third century, when China was split into three states, and Kuan Yu fought in the

cause of the state headed by Liu Pei, who hoped to re-unite the country and restore the Han dynasty. Kuan Yu was a huge man with a ruddy complexion and a long black beard. He was unstoppable in battle. His exploits were recounted in the historical novel *The Romance of the Three Kingdoms*, where he is depicted as a man who honored justice and loyalty above all else. In fact, when he was finally captured and beheaded, Ts'ao Ts'ao, the ruler of the enemy state, was so impressed with Kuan Yu, he had his head brought to Loyang and buried with honors befitting a king.

Ever since then, Kuan Yu has come to symbolize the virtues he displayed, and shrines in his honor could be found in every town in China, where his red-faced, black-bearded statues were worshipped by soldiers, policemen, merchants, officials, even by criminals, anyone who valued loyalty, if not justice. Naturally, I paid my respects, too, in front of the stone tablet that marked the place where his head was buried.

Afterwards, I walked out to the highway and caught the next bus heading back to town. At the train station, I caught another bus; this one was heading east, on the highway that led out of town. In 68 AD, emissaries sent by the Han dynasty's Emperor Ming to make contact with the West returned to Loyang with two Buddhist monks and a white horse loaded with Buddhist scriptures. The monks were housed in a guesthouse just outside the capital's western gate, and the guesthouse's name was changed to White Horse Temple. The ancient city of Loyang was long gone, and the new version had been relocated ten kilometers to the west. So the temple that was once outside the city's west gate was now a dozen kilometers east of the city.

Less than an hour after heading in its direction, I walked past the statues of the white horses that brought the first monks to China and visited the temple's shrine halls. The rear shrine hall was also where the first Buddhist sutras were

edited and translated into Chinese, including the *Sutra in Forty Two Sections*, which was an early Buddhist catechism that introduced the religion's essential concepts and practices to the Chinese.

When Buddhism first arrived in China, people thought it was just another form of Taoism. It wasn't until translations of its scriptures were made that the difference was noted and the two religions parted company. Back near the front gate were the graves of the two monks who brought these scriptures to China and who made the first translations. Their names were Matanga and Dharmaraksha. The forsythia that covered their grave mounds was just beginning to bloom, and, being a translator myself, I added some incense.

I didn't wait for it to burn down and walked back outside the front gate to the main road. There was one other sight I wanted to see. It was not the twenty-four-meter-high Chiyun Pagoda in the adjacent nunnery. I was interested in something else and walked further down the road for about half a kilometer. When I reached the spot, I crossed the highway and slid down an embankment and crossed a set of railroad tracks to get a better view of a flat-topped mound on the right. It was the former site of Yungning Temple and the biggest pagoda ever built in China. The twenty-four-meter Chiyun Pagoda certainly looked high. But the Yungming Pagoda was five times higher at 130 meters, and its construction nearly exhausted the imperial treasury. Twenty years after it was built, it was a pile of ashes, and the dynasty that built it disappeared with it. Now, even the ashes were gone.

I walked back to the main road and flagged down the next bus heading west, back to town. After pausing for lunch at a noodle stand near the train station, I hired a taxi and this time headed north. In ancient China, people had a saying: "to be born in Hangchou, to be buried on Mangshan." Hangchou was west of Shanghai and was the cultural capital

of China for much of the past thousand years, during which time it would have been a fine place to live. Mangshan, on the other hand, was a long ridge of undulating hills between Loyang and the Yellow River. This was considered the best place in China to be buried. And the best section of Mangshan to be buried was the section of low hills just north of Loyang called Peimang. In addition to their good feng-shui, or geomantic position, the reason for the popularity of these hills was their proximity to the city that served as the capital during many of China's most glorious dynasties, beginning with the Chou dynasty in 771 BC. In fact, so many people were buried there, there was another saying in Loyang: "On Peimang there's not room for a cow to lie down." The whole hillside was nothing but graves, graves, or traces of graves, as far as anyone could see. But years prior to my visit, the city officials decided to take advantage of the fame of this endless cemetery, and they opened a unique museum right in the middle of Peimang. It was a museum of tombs. And since the day was still young, I couldn't resist. It was just beyond one of the runways of the city's airport.

For the past several decades, archaeologists had been excavating tombs in the Loyang area dating back as much as 2,000 years. And what they had done at the museum was to reconstruct a number of the more important tombs using the original materials they found there. Most of the early tombs were pretty much alike in terms of architecture and funerary items, but the later ones showed great artistry, especially those from the Northern Sung dynasty a thousand years ago. One especially memorable Sung tomb had a stone doorway carved with the face of a girl looking out, as if she were peeking outside at the world of the living. She seemed to be calling me inside. But I liked the world of the living better and returned to my waiting taxi and Loyang.

In addition to its historic remains, Loyang contained

other attractions, paramount among which were the city's peony flowers that bloomed during the latter half of April and early May. Ever since the T'ang dynasty, Loyang had been called China's Peony City. Exactly when the city became associated with this flower or how was unclear. The peony was first cultivated in China as early as the Han dynasty 2,000 years ago, and Loyang was one of the Han dynasty's capitals. So it was only natural that the city and the flower would be associated with each other. Over the past 2,000 years, the peony had become a favorite of painters as well as gardeners, and Loyang's annual peony festival was a big deal. It marked the height of the city's tourist season. Fortunately, I was a month too early. Otherwise I wouldn't have been able to find a hotel room, not even a room above a karaoke nightclub.

In addition to its peonies, Loyang had several other famous products. It was famous for its T'ang-dynasty-style figurines with their distinctive three-color glaze of white, brown and green. But nowadays Loyang was more famous as the home of China's Number One Tractor Factory. I couldn't think of anything that epitomized China's road to modernization more than these omnipresent, all-purpose family vehicles that filled, if not clogged, every road in China. And Loyang's Number One Tractor Factory was king of them all, producing the famous East Is Red tractor, which was now, as if in tune with current economic reforms, painted bright orange.

I thought about visiting the factory, but I decided instead to head for the countryside and a sight overlooked by almost all visitors to Loyang. Twenty-five kilometers north of town was the tomb of one of China's most famous rulers. His name was Liu Hsiu, and he led the revolt that toppled the man who had usurped the throne of the Han dynasty. Liu re-established the dynasty with himself as Emperor Kuang-wu, and he made Loyang his capital. That was in 25 AD, which was also about the same time that the first peonies showed up in the city.

When he died thirty-four years later, he was buried north of his capital on the banks of the Yellow River. Despite the river's predeliction for flooding, it has shown the emperor great deference and has not only left his tomb untouched, the river has actually moved north a kilometer out of respect.

The tomb wasn't that hard to reach. It was just on the other side of the Mangshan Hills. Still, my driver did have to stop several times to ask farmers along the roadside for directions. It was in the countryside. And he was a city driver. Just before the road crossed the Yellow River on what was apparently a new bridge, we turned west at the village of Tiehhsieh. The tomb was waiting for us one kilometer down a dirt road.

The reason I had a certain fondness for Kuang-wu was that not long after he ascended the throne, he traveled to the coastal province of Chekiang to ask one of his boyhood companions to join him at court. His friend told him he would rather spend his days fishing, and he fell asleep with his feet stretched out on the emperor's stomach. The man's name was Yen Tzu-ling, and he had since become almost as well known as the emperor, but as a recluse. The Chinese liked to tell this story, though, not to praise Yen Tzu-ling, but to praise Kuang-wu for his tolerance. Still, even though they still might praise him, they didn't visit his tomb – at least not the day I was there. The only other person besides me and my driver was a girl who raced around tying strips of white cloth to the cedars, of which there were hundreds, as if they were so many prayers she expected the wind to take to Heaven. I sat and watched her and was about to walk over to ask her what she was doing when my driver honked his horn. He was bored and ready to go back to Loyang. And that was what we did.

THE PASS

I had an early dinner and decided I would try to fall asleep before the karaoke singers got going in the hotel nightclub. It worked. I slept all night and woke up ready to resume my westward journey following the yellow dragon upstream. My immediate destination was the city of Sanmenhsia. The train would have been preferable to the bus. But train tickets were so hard to buy. And a ticket didn't always guarantee a seat. Besides, my hotel was only a few blocks from the bus station. So I took the bus, which followed the old highway out of town and wound its way through the easternmost edge of China's loess region – loess being the fine soil that blows down from Mongolia every winter.

Halfway to Sanmenhsia, I got off at the town of Mienchih and flagged down a local taxi. There was another place I wanted to visit. And it was so close. I asked the driver to take me to the village of Yangshao. It was only a few kilometers to the north, and it didn't take long to get there. Somehow I expected more. There were only two small buildings, and I was the only visitor. In fact, the caretaker was asleep and looked surprised that anyone would want to come there. The reason I had made the effort was that this was the site of China's first significant discovery of Neolithic remains. The discovery was made in the 1920s by a Swedish archaeologist by the name of Anderson, and the village's

name had since been applied to similar remains unearthed at sites elsewhere in China.

It turned out that the Yangshao Culture, as it was now known, included settled communities extending along most of the length of the Yellow River and its tributaries 6,000 to 7,000 years ago. According to inferences made from settlement and burial practices, women played the dominant role in these communities. They were matriarchal. It wasn't until the Yangshao Culture was replaced by the Lungshan Culture 2,000 years later that men began playing the dominant role in society. What changed things was war. As long as the focus of life was on reproducing and finding enough food to eat, women were more important than men. As soon as enough children survived long enough to become adults and there was a surplus of food, men started going to war, not because they had to, but because they could. Testosterone. Men have been controlling societies around the world ever since.

There wasn't much to see at the Yangshao site. The caretaker said most of the remains unearthed by Anderson were in the Museum of Far Eastern Antiquities in Stockholm, and other remains unearthed during a second excavation conducted by the Chinese in the 1950s were in museums in Chengchou and Beijing. I was told that plans were under way for the construction of a larger building and that some of the items found there might be returning. But I had to agree with the caretaker. Why would anyone visit such an out-of-the-way place? I let him go back to sleep and returned to the highway.

The highway was the only major east-west road in that part of China, and it didn't take more than a few minutes to flag down another bus headed west. It was headed all the way to Sian. And it took its time, as the road weaved back and forth through the heavily eroded loess landscape. It was already late afternoon when I got off in the town of Sanmenhsia.

The town was named after the last gorge through which the Yellow River passed before it spilled out across China's northern plains on its way to the sea. The name meant "Three-Gate-Gorge." The three gates referred to the passageways formed by three huge rocky outcrops that once stood in the middle of the gorge. The only gate that could be used by boats was the Gate of Men, near the river's north shore. The Gate of Ghosts and the Gate of Spirits were too dangerous for boats to pass through. But all three gates were gone, blown to smithereens. They were dynamited to make way for the first dam ever constructed on the Yellow River. The dam was built in the late 1950s. Unfortunately, the Sino-Russian design on which it was based was a disaster. The designers failed to account for the river's incredible silt content, which at its peak reaches 750 kilos per cubic meter of water. Add 750 kilos of mud to your average jacuzzi, and you get a good idea of the problem. During the 1960s, two major changes in the design were carried out, and the dam had since functioned as planned, though with considerable reduction in its power-generating capacity.

The dam itself was twenty-eight kilometers northeast of the town of Sanmenhsia, and there were buses that went there. But after spending the night in Sanmenhsia, I decided to take one of the boat tours, which left every morning from the reservoir at the edge of town. The best part about the boat tour wasn't the dam or the reservoir but the crew. They were all musicians, and while somebody steered, the rest of the crew played Chinese musical instruments and sang traditional songs. They also sang a few Western numbers. Since the passengers included a group of four Australians, the crew sang what they said was an Australian folk song. It began "Obladi, Oblada, life goes on, yah." Indeed, it does.

As our boat glided toward the dam, we passed hundreds of trees, or at least tree tops. The trees were submerged

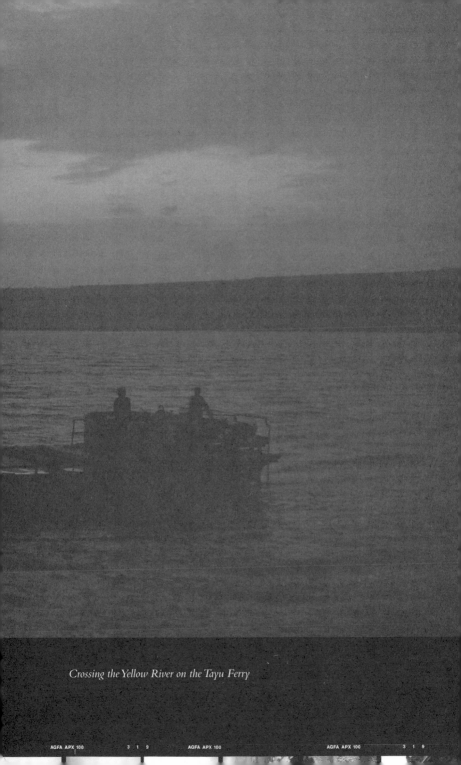

Crossing the Yellow River on the Tayu Ferry

whenever the dam was used to impound water, which it did every year just before the farming season began. An hour after leaving Sanmenhsia, we pulled up alongside a set of cement stairs and began our tour of the dam.

When it was first built in the 1950s, the Sanmenhsia Dam was the Yellow River's first dam. It was 800 meters across and 100 meters high, and inside its cement walls were five generators capable of cranking out over a million watts of electricity. However, they only reached that level during the summer, when runoff from flashfloods upstream turned the resevoir from a placid lake into a surging torrent.

Looking down from the top of the dam, I could see a single huge rock still sticking out in mid-stream. That was all that was left of the three much larger rocks that made this passage the most feared section on the Yellow River. Eighty percent of the boats capsized if they missed the passage known as the Gate of Men near the north shore. The reason the Chinese braved such dangers was that for most of their history, the capital of China was west of there, near Sian, and grain had to be hauled by boat from the central plains to support the huge administrative center and the armies that guarded China from invasion by nomads. Since overland transport of such large quantities through the mountains on either side of the river was next to impossible, the Chinese had no choice but to construct a means of negotiating their way through the gorge. The way they did this was ingenious. They lowered workmen down the cliff-face on the north shore so that they could hollow out holes into which they placed wooden posts that supported a walkway of planks. When the walkway was still in use, hundreds of men would tie ropes from a single grain barge to their waists and trudge upstream. Traces of the plank walkway were still visible on the cliff just below the dam and provided a better idea of who shouldered the burden for the glories of China's imperial past.

After returning to Sanmenhsia and waving goodbye to the minstrels aboard the tour boat, I went back to my hotel and collected by bag and took the next bus heading west. I didn't have far to go. My next stop was only an hour away: the town of Lingpao. The bus let me off in the middle of town, but once again my destination was outside of town. As was the case with my visit to Yangshao, I wanted to go to a place most people in China had heard of but for which there was no public transportation. The place was the Hankukuan Pass.

In ancient times, anyone traveling between the twin capitals of Loyang and Ch'ang-an had to negotiate this east-west defile between the Yellow River and the Chungnan Mountains. According to early Chinese historians, whoever controlled this pass controlled China. The strategic importance of the pass went back nearly 2,400 years, to when it was first hollowed out of the loess plateau that stretched between the Chungnan Mountains to the south and the Yellow River to the north. And its importance has continued into modern times. This was where the Chinese Army finally stopped the advance of the Japanese Army in 1944.

But the importance of the pass was not limited to its strategic significance. One day shortly after it was created, Lao-tzu arrived there in his ox cart after quitting his post in Loyang. Some months earlier a Taoist named Yin Hsi had seen signs indicating a sage would soon be coming from the east and arranged for himself to be appointed Keeper of the Pass. When he saw Lao-tzu, he knew this was the sage he was expecting and asked for instruction in the Tao. The result was the text known ever since as the *Taoteching*. Although it is only 5,000 characters long, it has remained the most important of all Taoist texts. And everyone in China, Taoist or not, knew its opening line: "The Way that becomes a way is not the Immortal Way."

Lao-tzu was long gone, but the pass was still there. Since

there was no public transportation, I hired a taxi to take me. It was seventeen kilometers north of Lingpao on a very rough dirt road, and it took nearly an hour to negotiate all the ruts from recent rains. When we finally arrived, I was surprised to see a lot of construction going on. Apparently, the trucks were responsible for the ruts. I soon found out that the local authorities had decided that the Hankukuan Pass was ready for sightseers. And, of course, that was why I was there: to see the sights, or the sight. But other than the construction workers, I was the only sightseer there. The sight I wanted to see was not hard to find. It was just past the newly paved parking lot.

The pass was simply a very narrow dirt road that wound through a deep gully for fifteen kilometers from east to west. The gully walls were at least fifty meters high, and in some places the passage between them was only two meters wide, just wide enough for a single ox cart. I walked past the stone stele on which were carved the words Han-ku-kuan. The Hanku Pass. The words han-ku meant "tunnel-valley," and kuan meant "pass." It was so narrow it would have only taken a handful of soldiers to defend. I walked inside the pass just to get a feel for it. The dirt cliffs on both sides blocked out all but a narrow strip of sky. It was noon, but already the pass was dark. Since there really wasn't much else to see, I walked back to my waiting taxi. Once the construction work that was under way was finished, I expected there would be the usual exhibition halls and maybe a place to light some incense to Lao-tzu and his Immortal Way. But I was surprised how such a simple place had been glorified by historians and artists, who often depicted it as a rocky, snow-covered mountain pass, instead of just a cart trail through a loess plateau.

With my historical curiosity satisfied, I headed back to Lingpao and waited in the middle of town for the next bus heading west. Since there was only one road, I didn't have to

wait long. Another bus heading for Sian soon stopped to pick me up. Sian was over 200 kilometers away, but I had no intention of going that far. I got off fifteen minutes later in the next town, which was about as small as a town could be and still be called a town. Its name was Wenhsiang. The reason I got off there was that there was a road leading from Wenhsiang down from the plateau on which the town and the highway were located to the Yellow River, which was only a few kilometers to the north. It was my lucky day. In less than five minutes, I managed to hitch a ride on a truck that was going to the same place as me, namely, to the Tayu Ferry. The ferry was named for Yu the Great, tamer of the Yellow River. The truck driver said the ferry didn't have a schedule, but it ran every couple of hours. That was still quicker than trying to drive to the next bridge, which meant driving back to Sanmenhsia or on to Tungkuan, either of which would have involved a detour of about four hours. It was easier to wait for the ferry, which was already there on the south shore. There was also a tent at the edge of the river where people could drink tea while they waited. But it was, indeed, my lucky day. The sun was going down, and the ferryboat captain was anxious to make his last crossing while there was still enough light to see. Less than thirty minutes after I arrived on the south shore, I found myself on the Yellow River's north shore and said goodbye to Honan Province and hello to Shansi.

I could have hitched a ride with the truck driver into the nearby town of Juicheng, but I decided instead to check into the Tayu Guesthouse, which overlooked the landing where I disembarked. The guesthouse was only a single-story building. But it was built with great expectations, and it had at least two dozen rooms. The manager said I was the only guest he had seen in two weeks. The room was spartan, and although there was a shower in the bathroom, there was no

hot water. There was also no restaurant. Fortunately, I had some peanuts and crackers, and the manager sold me two bottles of beer, all of which I enjoyed while I sat outside alone on the guesthouse's huge cement veranda and watched the sun set and the crescent moon go down right behind it. I went to sleep that night listening to the steady sound of the Yellow River flowing east toward the sea.

THOSE IMMORTALS AGAIN

After a night of listening to the Yellow River just outside my room, I walked back to the ferry landing the next morning. There was a line of motorized three-wheelers waiting for disembarking passengers from the next ferry. For 10RMB, or two bucks, one man gave up his place in line and took me to Juicheng, twenty kilometers to the north.

I asked the driver to drive through town – it wasn't much of a town – and drop me off at Yunglokung Temple at the north edge of Juicheng. Yunglokung was one of the most famous Taoist temples in all of China, but there wasn't a Taoist priest in sight. The temple used to be below the guesthouse where I spent the night. But during construction of the Sanmenhsia Dam, the temple was taken apart and moved piece by piece to Juicheng in the early 1960s. Its former site was now under water. The reason the government went to so much trouble to save this temple, when the Red Guards were busy demolishing thousands of religious sites elsewhere in China, was that its walls were covered with the country's oldest and most exquisite Taoist murals. They were painted in the early fourteenth century, when Kublai Khan ruled the Middle Kingdom from his Pleasure Dome in Xanadu.

I paid an extra 10RMB at the gate for a guide and found her in the main shrine hall, her voice soaring on the wings of a Taoist aria, or so I imagined – maybe it was just a popular love song. I would have gladly let her sing on, but she preferred to show me the murals, and I

didn't object. On the walls of the main hall some immortal had painted 300 celestial beings paying homage to Genghis Khan, founder of the Yuan dynasty. The paintings were, as advertised, exquisite, and so were the ones in the second shrine hall depicting events in the life of the tenth-century Taoist master, Lu Tung-pin, the leader of the Eight Immortals who I had met earlier in the coastal town of Penglai. The murals in yet a third shrine hall recounting the life of a twelfth-century Taoist master, Wang Che, were no less amazing. Wang Che, also known as Wang Ch'ung-yang, was the founder of the monastic order of Taoism and one of the most famous Taoists in Chinese history. I walked through on a cloud. The finest Taoist murals in all of China, and I was the only visitor that day.

The temple's fame rested not only on its murals of Taoist immortals but also on its buildings. They were the oldest examples of Taoist temple architecture in all of China, and they were well known among students of architecture for their noble, yet austere lines. After tearing myself away from the art and the architecture, I proceeded to a side hall that contained a display of photographs and other materials showing the disassembly and re-assembly of the temple thirty years earlier to save the temple's buildings from the rising waters of the Yellow River caused by the construction of the Sanmenhsia Dam. The entire process took seven years, and it was a great success. The temple looked as ancient and perfect as it ever did.

In the same side courtyard, I also visited a small shrine hall that contained statues of Lu Tung-pin and two attendants. Lu was born near Juicheng, which was why the temple was built in that area in the first place. After failing the imperial exams, Lu met a Taoist immortal who taught him the secrets of immortality. And after practicing in the mountains south of Ch'ang-an, Lu returned to his hometown and even-

tually achieved the Taoist goal of immortality on Chiufeng Mountain, twenty kilometers to the north of Juicheng. In fact, the statues inside the shrine halls of Yunglokung were brought there from a temple on Chiufeng Mountain after Yunglokung had been put back together.

Before leaving, I stopped to pay my respects at Lu Tung-pin's grave at the rear of the temple grounds. Rising behind his grave to the north were the Chungtiao Mountains. I wondered which was Chiufeng Peak where Patriarch Lu joined his fellow immortals. The mountains stretched like a jagged, unpainted wall. My next destination was on the other side. Since there were no other visitors that day, there were also no taxis or three-wheelers waiting outside Yunglokung. I had to walk back to the highway that ran through Juicheng and wait for the next bus. When I got there, I asked a fruit seller if there were buses that went over the mountains. He said there was one every hour or so. And, indeed, within the hour I was on a bus that worked its way up and over the barren shoulders of the Chungtiao Mountains to the Fen River Plain on the other side.

As we came down into the plain, I could see the outline of the great salt lake of Hsiehchih in the distance. That was where Huangti, the Yellow Emperor, defeated the leader of the confederation of Miao tribes 4,700 years ago in one of the most significant battles in Chinese history. Salt was the most important of all the commodities that enabled Neolithic settlements to make the transition to early towns and cities. People who had salt could preserve food, which allowed them to stay in one place during the winter and to form armies and to fight for extended periods far from home. Hsiehchih was the single major source of salt in the middle and lower reaches of the Yellow River watershed. And it was the Yellow Emperor's victory and control over access to salt that first established the ancestors of the Han Chinese as the

dominant ethnic group in North China – and eventually in all of China. According to archaeologists, the salt works discovered along the edges of Hsiehchih were the oldest in the world, dating back over 6,000 years, not coincidentally to the time of the Yellow Emperor.

Once we hit the salty flatlands, it was only four kilometers to the town of Chiehchou. Chiehchou, and not the salt lake, was the reason I wanted to cross the Chungtiao Mountains. Chiehchou was the hometown of Kuan Yu, the God of War. I had met Kuan Yu before at his temple in Loyang, where I lit a stick of incense before his buried head. Kuan Yu's military exploits as well as his loyalty earned for him posthumous enfeoffment as Kuan-ti, or Emperor Kuan. He had become, in fact, the symbol not only of loyalty but of martial vigor as well, a veritable God of War, and Kuan-ti shrines with their ubiquitous long-bearded, red-faced statues were everywhere in China. They probably outnumbered all other shrines put together. And since Chiehchou was Kuanti's hometown, I thought I would see what the descendants of his boyhood friends and neighbors had done to honor him. The bus driver let me off as close as he could and pointed me down a side road, while he continued on to the smokestacks of Linfen.

Of all the hundreds of thousands of Kuan-ti temples in China, the temple in Chiehchou was reportedly the biggest and best of them all. Five minutes after getting off the Linfen-bound bus, I walked inside the gate and discovered that people were right. This had to be the biggest and best of all the Kuan-ti shrine halls in China. It was built in the Sui dynasty, or nearly 400 years after Kuan-ti's death. And it had been rebuilt many times since then with funds and artisans supplied by various emperors. As a result, the architecture and craftsmanship was second to none, and in some respects, it had no peer in all of China.

Unfortunately, or fortunately, Kuan-ti's shrine hall was in the middle of nowhere, and the caretaker said few people visited, other than local couples, who came there to be alone. In fact, the only other people there during my visit were two such people walking hand in hand through the temple's garden. Since he wasn't busy, the caretaker showed me around. First, he showed me the pagoda. When Kuan-ti was a young man, he acted as the local Robin Hood, righting wrongs and beating up evildoers. One evildoer he happened to kill was a friend of the governor, and the order went out for Kuan-ti and all of his relatives to be executed. All of Kuan-ti's relatives fled, and, according to the caretaker, even today there was no one in Chiehchou surnamed Kuan. But Kuan-ti's parents were too old to run, and they jumped into the village well. The pagoda was built over the well to commemorate their deaths, and the temple to their son was built around the pagoda.

Behind the pagoda was a large garden of ornamental plants and flowers. And beyond the garden was a shrine hall, which contained some of the most exquisite woodcarvings I had seen anywhere. And behind the first shrine hall was another hall that was even more magnificent. It was a masterpiece of architecture. The wings of its roof rose above the huge cedars that guarded its entrance, as if they were those of a bird taking flight. The scene reminded me of the first lines of the Taoist allegory known as *Chuangtzu*: "In the North Sea there is a fish whose name is K'un and whose body is countless miles long and which changes into a bird whose name is P'eng and whose body is also countless miles long and which rises in flight on wings as vast as the clouds in the sky." The roof of this shrine hall looked as if it might disappear into the sky at any moment and leave behind the trees planted in Kuan-ti's honor shortly after his death nearly two thousand years ago. All in all, I think the God of War would have been pleased at such a memorial.

The biggest and best Kuan-ti shrine hall in China

I had already lit a stick of incense before the mound in Loyang where his head was buried, and I lit one more. Kuan-ti, afterall, was not only the God of War, he was also the patron saint of all professions that valued honesty, loyalty and justice, which included writers. I didn't wait for the stick to burn down. I thanked the caretaker for showing me around and retraced my steps to the main road and waited for the next bus to take me back toward the Yellow River.

A few minutes later, I waved down a bus headed for Sian, which I was very happy to see. It meant I didn't have to return to Juicheng but could bypass the Chungtiao Mountains by skirting their western end. An hour later, just before it reached the Yellow River, the bus passed through the town of Shouyang. The town was named for the hillside just outside town where two brothers retired 3,000 years ago. Their names were Po-yi and Shu-ch'i, and they came there to escape what they considered was the unrighteousness of the men who founded the Chou dynasty. They refused to eat the produce of the flatlands, and they tried to survive on a blameless diet of doe's milk and ferns. Eventually they starved to death. As late as the Ming dynasty, historians say there was still a shrine in front of their grave mound and a statue of a doe. If I had more time, I would have stopped to see if anything was still there. But I had a long way to go to reach the town where I hoped to spend the night. I watched Shouyangshan slide by. A few minutes later, we re-crossed the Yellow River where it came down from the north and turned abruptly east. This was the most famous of the Yellow River's many bends, and in ancient times it was the location of one of its most famous ferries, known as the Fenglingtu Ferry. Now there was a bridge.

As we crossed the bridge, I said goodbye to Shansi Province and hello to Shensi Province. On the other side, the road turned west, toward Sian. This was where the ancient

military stronghold of Tungkuan was once located. But like Yunglokung, it too had been located to higher ground following the building of Sanmenhsia Dam downstream. It was now on the bluff overlooking the river, where it still commanded the old route to the ancient capital of Ch'ang-an.

As we drove past, the sun was going down behind the bluff. I suppose I could have gotten off in Tungkuan, but I wanted to go a little further, just to make the next day easier. An hour later, I got off in Weinan. Weinan, as its name suggested in Chinese, was on the south (nan) bank of the Wei. The Wei was the biggest tributary of the Yellow River, which it joined just north of Tungkuan. I asked the bus driver to drop me off at what looked like the biggest building in town. It was five stories high, but it still looked smaller than Kuan-ti's shrine hall. And it didn't look like it was flying anywhere, which was good. I just wanted a place to sleep.

HISTORIANS AND SAGES

Early the next morning, I walked across the street from my hotel to the Weinan bus station and caught the next bus heading north. It was bound for Hancheng, 100 kilometers to the northeast. As we left Weinan and crossed the Wei River, I looked out the bus window in the direction of the rising sun. About seventy kilometers to the east, where the Wei joined the Yellow River, the rulers of ancient China set a maiden adrift on a bed of sedge every year as an offering to the Lord of the River. I've never understood why humans did that, why humans alone among all creatures treated their own kind with such cruelty. I didn't have an answer. I don't think anyone else did either.

Two hours later, I got off ten kilometers south of Hancheng and walked down a paved road to the right. It led downhill toward the Yellow River. Halfway there, I stopped to ask directions from a farmer, just to make sure the road led to where the bus driver said it did. The farmer put down his mattock and insisted on leading me the rest of the way, until the road ended at a parking lot at the base of a hill that looked out on the river. He then spent the next hour showing me the shrine built in honor of China's greatest historian, Szu-ma Ch'ien.

Ssu-ma Ch'ien was born in Hancheng in 145 BC. He later followed his father to the capital of Ch'ang-an, where he became an attendant to Emperor Wu and travelled extensively throughout the empire. When his father died, Ssu-ma Ch'ien succeeded him as court astrologer and thus gained access to nearly all documents of an historical nature. Over the next few decades, he fulfilled a task that his father had begun: the compilation of China's first comprehensive history. When he died in 85 BC, this was where he was buried, on a hill overlooking the Yellow River.

When Ssu-ma Ch'ien died, he left behind a work of some 130 chapters detailing the lives of the famous and the infamous together with his judgments about them. Ever since it first appeared, his *Shihchi*, or "Records of the Historian," has been the principle means by which the Chinese have assessed their past. Over the centuries, the esteem for his book grew, as did the number of visitors to his tomb. A shrine was built there as early as the fourth century. My guide led me up a series of stone steps that followed the spine of the hill past an archway erected a thousand years earlier in the Sung dynasty. On our way up the steps, we also passed a small shrine hall to Ssu-ma Ch'ien's father who began the monumental history his son finished.

Behind Ssu-ma Ch'ien's own shrine hall, my guide pointed out the Grand Historian's grave mound. It was a small mound covered with stones, except for an opening on top where an ancient cedar was still flourishing: Ssu-ma Ch'ien's lone companion from the past. From the balcony that encircled his grave mound, I had a fine view of the Yellow River one kilometer to the east. One of the reasons Ssu-ma Ch'ien's historical records were still respected for their accuracy was that he traveled all over China gathering and double-checking his information. In ancient China, most transport was river transport, and this was the river he

followed into the plains where he visited many of the sights I had visited myself. If he lived today, though, I think he would have taken the bus.

Although Ssu-ma Ch'ien did have a head start, thanks to the preliminary work of his father, he didn't have an easy time compiling his history. Things got especially difficult when he made the mistake of supporting a general who surrendered to the Huns. The emperor insisted the general had betrayed the country, and when Ssu-ma Ch'ien suggested otherwise, the emperor ordered him castrated and imprisoned, thinking that would teach him to open his mouth. It was a difficult period for the Grand Historian. But while he may not have opened his mouth, he did have the last word.

After I paid my respects at Ssu-ma Ch'ien's grave, the farmer who was acting as my guide led me back down the steps to a small store at the foot of the hill. Inside the store's long glass case I saw a rubbing of the Yellow River as it passed through Lungmen Gorge just north of Hancheng. I had been looking for something like that since beginning my journey, and I asked the salesgirl the price. She said it was 20RMB for Chinese and 50RMB for foreigners. Somewhat taken aback, I asked my guide if he would buy it for me. I saw no reason why I should pay the higher price. The salesgirl, though, refused to sell the rubbing to the farmer, and we stood there in a stalemate for at least ten minutes.

The farmer, though, surprised us both with his determination and sincerity. He insisted he wanted to buy the rubbing and give it to me as a present, and the salesgirl finally relented. Afterwards, true to his word, the farmer refused to accept my money, and the rubbing of Lungmen Gorge remains the finest present I received on my Yellow River odyssey.

The grave was situated at the northeast corner of a dirt

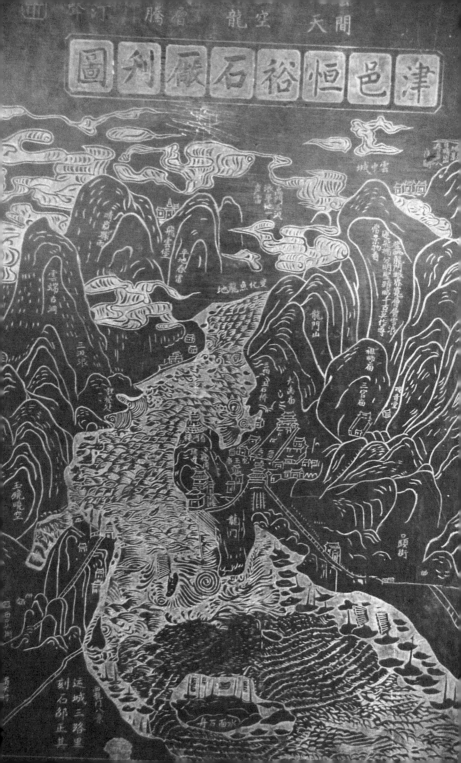

ridge, and if I had had the time, there was another site I would have liked to visit near the southeast corner of the same ridge. It was the wall built by the state of Wei in 352 BC to protect it from the state of Ch'in, which was encroaching from the south. The wall was built of rammed earth, and its traces extended for nearly twenty kilometers to the west and included several fire beacons as well. According to my guide, the section of the wall a kilometer or two from Ssuma Ch'ien's grave was still nearly eight meters thick and five meters high. Thousands of soldiers died on either side of that wall, and I thought there must be quite a treasure trove of broken and discarded weapons buried in the fields where the state of Wei once battled the state of Ch'in. Despite the wall's ancient importance and the size of its remaining sections, I decided to pass it by. I thanked the farmer for his help and for his endearing present and walked back out to the highway and caught the next bus to Hancheng.

Unlike the ancient wall of the state of Wei, I had no intention of passing Hancheng by. Hancheng was the capital of Wei. Nowadays people called it "Little Beijing." The reason for the nickname wasn't the town's political importance but its architecture. Hancheng was a city of narrow lanes fronted by the backs of houses that faced inner courtyards, a form of architecture popular in the *hutongs*, or narrow alleys, of Beijing. According to local officials, there were still more than a thousand of these old-style houses, and guides were available to arrange visits to any number of them.

I didn't feel like barging into someone's home, even with a guide, so I settled on visiting the city's museum, which was located inside the town's Confucian Temple, which was also the oldest building in Hancheng. After asking directions,

I found it by walking down the street that formed the axis of the old city. The street was closed to vehicles and began where the bus dropped me and everyone else off before it turned and entered the bus station.

The pedestrian-filled street ended at a martyr's shrine on the hill that overlooked Hancheng. About halfway there, I turned into a side lane on the right. There weren't any signs, but I've never been shy about asking directions. The Confucian Temple and city museum were about 200 meters down the lane. Along the way, I passed a number of wooden doors that opened onto private courtyards. This was the old section of town, the section for which the town was famous. But I refrained from knocking on any doors and finally entered the front gate of the Confucian Temple. It was one of the best-preserved Confucian temples I had ever seen, and most of its buildings dated back to the fourteenth century. Unfortunately, it was lunchtime, and I had to wait for someone with the key to return. Fortunately, there was a garden and some grass. So I lay down and took a nap.

At home I take a nap every day, so I had no trouble falling asleep. But when I woke up an hour later, I was still the only one there. I got up and walked around and tried to look inside the windows of the different buildings. But they were too dusty to see through. Finally, about three o'clock, one of the museum's three attendants returned with her keys. But even then, I had to content myself with only two of the museum's six exhibition halls. The other two attendants never returned from lunch with their keys to the remaining halls.

Inside the two halls that I was able to visit, there were dozens of buddha statues and a very fine marble statue of Confucius. There were also sections from the old city wall, a mastadon tusk, vestiges of human habitation dating back 50,000 years, and an iron deer. But the most wonderful piece of all was a huge walnut root. It was a carving of the Yellow

River, including Lungmen Gorge, with boats and swirling eddies, and, of course, a dragon. It was marvellously done, and the attendant said it was the largest such carving in China. It dated back, she said, to the Yuan dynasty, or eight hundred years ago. I was even more impressed.

Hancheng was not without other attractions, but after seeing the walnut root, I felt the pull of the river and walked back to the main road and boarded the next bus heading north. On the way, I declined to get off at the village of Tangchia, where a whole village had been preserved as it looked a hundred years ago. A few minutes later, I also passed up Puchao Temple and its four-meter-high bronze buddha and its equally famous ceiling panels. The river kept pulling me north. An hour later, the driver let me off just short of the bridge.

The bridge spanned the place depicted on the rubbing the farmer bought for me at Szu-ma Ch'ien's grave. It was called Lungmen, or Dragon Gate. From the road, I walked down the embankment to the river. I was still in Shensi Province, but just barely. On the other side of the Yellow River was Shansi. When people pronounced their names, I couldn't tell the two apart. But the Yellow River could. As it came down from the north, Shansi was on its left toward the rising sun, and Shensi was on its right toward the setting sun. And between the two was the yellow dragon. As the river reached Lungmen, the opening between the two cliffs was less than 400 meters apart.

Another reason the Chinese called this place Lung-men, or Dragon Gate, was that every March, millions of carp swam through this gorge on their way to spawn upstream, and they gave the impression of small dragons moving beneath the waves. The gorge also had another name: Yumen, the Gate of Yu. This was where Yu the Great was said to have begun his flood-control project that extended all the

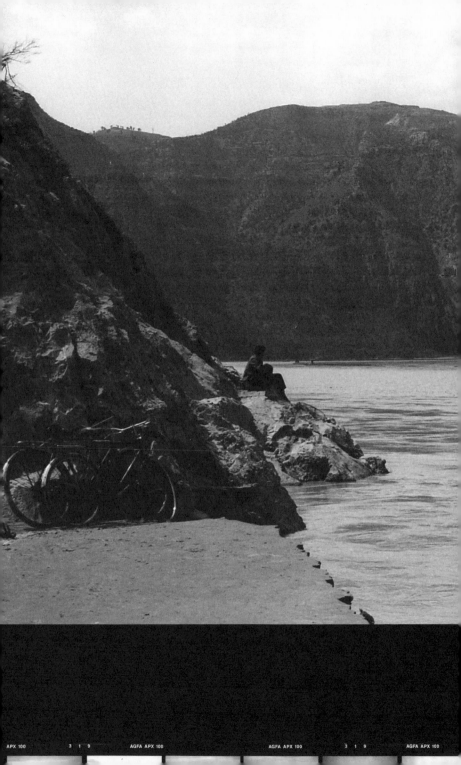

Lungmen, or Dragon's Gate

way to Chengchou, where the river finally left the protection of the Mangshan hills and spilled across the flood plain that was North China. Yu lived over 4,000 years ago, and in honor of his efforts, there had been shrines to him on both sides of the gorge for the past 2,000 years and probably long before that. Unfortunately, the shrines were blown up by the Japanese during World War II, and they hadn't been rebuilt. Meanwhile, I sat beside the river on last year's mud and looked for signs of passing dragons. Apparently the annual carp migration had already taken place a month earlier, and all I saw were clouds of dust rising where workers were blasting away the cliffs further up the gorge. They were mining aluminum ore.

In the past, travelers had to be rowed or winched across the river at this point. Now there was a bridge. After watching some boys fishing, presumably for dragon carp, I walked across the bridge to a small pavilion on the other side. It was all that remained of the shrine to Yu the Great, the man who tamed the Yellow River. Yu the Great's father was executed by the emperor for failing to prevent the river from flooding, but the son succeeded. The secret of Yu the Great's success was that he never tried to control the river with dikes or dams. He dredged the river. Ironically, his descendants had forgotten this. They were not only building bigger dikes, they were also building dams on both the Yellow River and the Yangtze to help prevent floods as well as to generate electricity. Apparently, they didn't read their own history books anymore or they would have known that sooner or later they would suffer the same fate as Yu the Great's father. Dredge, don't dam. That was Yu the Great's secret.

Meanwhile, I turned my attention to the pavilion and in particular to a stele depicting the river as it swirled through Lungmen. The carving on the stele differed from the rubbing of Lungmen I had been given earlier by the farmer at Szu-

ma Ch'ien's grave, and I took several photographs for future reference. Just then, the officer in charge of guarding the bridge came over. Oh, no, I thought. Another restricted area. But he turned out to be friendly, especially when I told him I was following the river all the way to its source. To make sure I got there, he flagged down the next passing truck, and off I headed to my next destination.

Twenty kilometers later, the truck driver let me off in the town of Hochin. Since the sun was on the verge of going down, I flagged down a motorized three-wheeler and asked the driver to take me to the best hotel in town. He turned around and headed back the way I had come. I tried to stop him, but he told me not to worry. We must have gone halfway back to Lungmen. Finally, he turned off at a huge aluminum plant. I was really concerned that he had misunderstood what I wanted. But I was helpless. I breathed a sigh of relief when we drove past the plant and another sigh when we approached another set of buildings, one of which was a hotel. I still didn't know why he hadn't taken me to a hotel in Hochin. But as I waved goodbye to my driver and walked inside the lobby, I soon learned that this was the only hotel in the area where foreigners were allowed to stay. At least it wasn't expensive. It was only 40RMB a night, and I was just in time for a hot bath. I even washed my clothes. Afterwards, I walked back out to the lobby and had dinner in the hotel restaurant, where I met three foreigners. They were engineers from Denmark, and they were working as foreign experts at the aluminum plant. It turned out they liked beer as much as I did, and I accompanied them back to their rooms, where we polished off a case of their private stock, while I listened to their stories about sailing Viking ships. Viking ships, they said, were built in such a way that they snaked through the waves rather than meeting the waves head on. One of the engineers belonged to a club back in Denmark

that built old-style wooden boats, and he sailed them every summer. Halfway through the second case of beer, I finally reached my limit and thanked my hosts for providing such an unexpected and enjoyable oasis.

The next morning, I did not feel like a Viking ship. I felt more like a garbage barge. Fortunately, I didn't have to walk out to the highway to flag down a bus. One of the hotel staff had to drive into Hochin and gave me a ride as far as the town's bus station. Considering that Yu the Great once established his capital not far from there, Hochin was a poor excuse for a town. Of course, a lot can change in 4,200 years, and it obviously had. Since the next bus heading north wasn't due for another hour, I decided to visit the local museum. But it was not only closed, workers were busy tearing it down. I walked back to the bus station, and the northbound bus left on time and with me on it.

I was back in Shansi Province just north of where the Fen River joined the Yellow River. Among the Yellow River's tributaries, the two most important were the Wei and the Fen. The Wei, which I had already crossed at Weinan, flowed through the center of the Chou dynasty, when Chinese civilization first entered the gate of history. But the Chou was preceeded by the Shang and the Hsia dynasties as well as by the period of the Five Sage Emperors. And during that earlier stage of Chinese civilization, the Fen River was the river along which they built China's first permanent capitals.

As we reached the town of Houma, the bus I was on began following the Fen upstream, and it continued following the Fen for two more hours all the way to Linfen. According to the officials in Chengchou in charge of monitoring the Yellow River, the Fen was one of the most polluted rivers in China, and the town of Linfen was the reason why. Instead of listing historical sites in the area, the back of the Linfen city map listed its factories and industrial products.

Most tourists had good reason to pass Linfen by, but there was one sight I wanted to see. After we arrived, I stashed my bag at the bus station's luggage depository and flagged down a taxi to take me to the temple of Emperor Yao. Yao ruled north China some 4,300 years ago. He was one of China's five sage emperors, and he inherited the kingdom from Emperor Shun, who was another sage emperor. It was Yao who passed the kingdom on to Yu the Great, the sage emperor who tamed the Yellow River.

Linfen was Yao's capital, and the place where he held court was three kilometers south of the city's bell tower. A few minutes later, I was there, walking between the ancient site's two huge tottering shrine halls, one of which dated back 1,300 years ago to the T'ang dynasty. The shrine halls built in Yao's honor got so few visitors, there wasn't even a caretaker. Or maybe there was, and he was off somewhere eating lunch. Although the main shrine hall was locked, from outside I could see a statue of Emperor Yao sitting on a throne inside discussing affairs of state with statues of his four famous ministers, one of whom was Hsi Ho.

It was Hsi Ho who traveled throughout China observing variations of sunrise and sunset, of day and night, and of celestial bodies at different locations and who concluded that a year consisted of 366 days. This formed the basis of China's first calendar, which included an extra month every forty years to adjust for the discrepancy with the actual solar year. Astronomical studies were very important for these early agricultural societies. According to the Yaotien chapter of the *Shuching*, or "Book of History," when Yao turned over his throne to Shun, he is reported to have said, "O, Shun, the responsibility for observing the stars and the seasons is now falling upon you." And Shun is said to have said the same thing when he passed on the throne to Yu the Great. The caretaker, assuming there was one, never returned to unlock

Yao's shrine hall. And according to my own observations, it was time to call it another day. The taxi that I hired to take me there took me back to Linfen, where I found a cheap hotel close to the Linfen bus station and where I went to bed much earlier than the night before.

THE YENAN SPIRIT

I wanted to spend the night close to the bus station because I wanted to catch the six o'clock bus heading west, back across the Yellow River. There was only one bus a day, and I wanted to be on it. I not only managed to get up in time, I even got a seat.

From Linfen we headed back south. Then, just as the sky was beginning to grow light, we turned west and entered the Luliang Mountains and started climbing. It was a coal-mining area, and we travelled through a barren world until suddenly there was a cherry tree in bloom and then occasional patches of forsythia as we wound our way over the mountains.

I was traveling through the edge of what even Chinese farmers had a hard time cultivating. But it was also beautiful: niches of green winter wheat and yellow rapeseed and every once in a while a pool of clear mountain water and the rare village of mud huts. Around nine o'clock, we stopped for noodles in the farming town of Chihsien. Then we headed up the final brush-covered ridge and entered a strange landscape of eroded canyons and uninhabited plateaus.

Finally, we started down, switchbacking our way into the rock canyon the Yellow River had carved out of this land over the past million years. Suddenly we were there, at the

river. As soon as we crossed it, the bus stopped, and I got off. So did one other passenger. The bus continued on to Yenan, another five hours away.

The place where I got off was called Hukou Falls. Not many people visited Hukou Falls, and I was surprised to have a companion. We both stashed our packs in a workers' hut and started walking north along a rocky road that teetered on the edge of the river. My companion turned out to be a professor of environmental science at Hopei University. He was in his eighties, and this was his first trip to the falls. He said these mountains were forested as recently as a thousand years ago. But as we walked toward the falls, there wasn't a tree in sight. Too many wars.

From the bridge where the bus let us off, it was more than three kilometers to where the river suddenly dropped forty meters and sent as much as 9,000 cubic meters of water every second crashing into the rocks below. This was the biggest waterfall on the Yellow River and the second biggest waterfall in China, second only to Huangkuoshu Falls in Kueichou Province. Still, few people visited. It was two hours from the nearest town, and there was only one public bus a day either way. Most people contented themselves with viewing the falls on the Bank of China's 50RMB bill. But I wanted a closer look.

From the bridge, the approach was along either side of what was called Dragon Trough. This was a four-kilometer-long channel gouged out of the river's basalt bed over the past million years, which was about the time the Yellow River finally carved its way through the mountains and reached the sea. According to my companion, due to the pounding of the water, the edge of the falls was moving further upstream at the rate of four centimeters a year, or one meter every twenty-five years, four meters every century, and forty meters since the Sung dynasty. Except for the area near the

river's source, this was its narrowest section, and it almost looked like you could jump across. Evel Knievel, in fact, once planned such a jump. But I'm not sure he would have made it. It was forty meters from one side to the other.

It was late April, when the river was usually at its lowest level. Still, the sound of the falls was already audible where we got off the bus, nearly four kilometers away. On either side of the river, the barren mountains looked like so many ancient kings sitting on their earthen thrones keeping silent watch over the river's never-ending plume of mist. I spent over an hour taking in the spectacle and reluctantly returned to the bridge and the problem of catching a ride to the next town.

It was early afternoon, and my only option was to try hitching a ride. The next bus wasn't due until noon the following day, and the lone sorry-looking hostel at the other end of the bridge hadn't seen visitors in months. It was a long wait. Every thirty minutes or so, an oil truck passed by, but always in the wrong direction. Further up the road, I saw an inspection station. The professor also returned from the falls, and together we walked up the road and poked our heads inside. Two policemen were eating noodles. I asked them what the chances were of hitching a ride. They invited us to join them and promised to flag down the next truck headed our way. A couple more hours went by.

While I was waiting, the policemen checked the papers of the tankers carrying oil from Yenan to Linfen. They caught one driver without the proper papers, and a two-hour negotiation began. They were still going at it when a private tour bus approached. I went outside and flagged it down. It was full of geology students who had just returned from the falls. It was not only headed our way, the driver agreed to take both me and the professor.

Two hours and a very bumpy ride later, the bus finally reached the town of Yichuan, which was the first sign of civi-

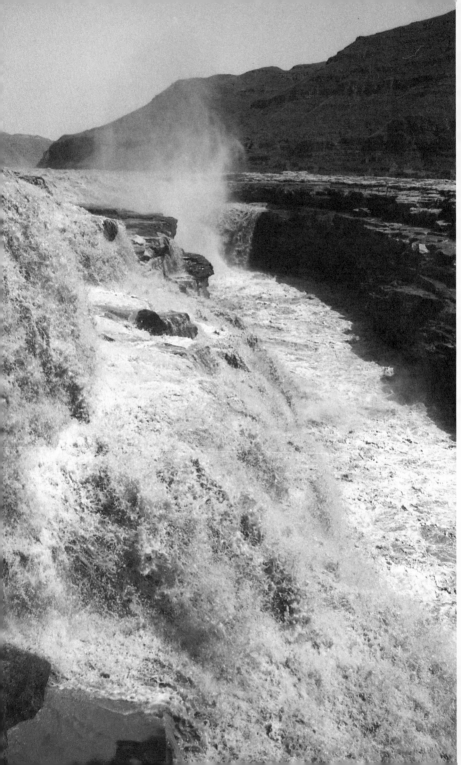

lization since leaving the falls. I decided I had had enough. The sun was going down, and it was time to find a place to spend the night. While the tour bus continued on to Yenan, another three hours away, I got off and looked around for lodging. Yichuan barely qualified as a town, and it didn't take long to find its one and only hotel. I checked in and paid for the best room, which was 9RMB, or less than two bucks.

I was just beginning to unpack my bag and think about dinner when the police officer in charge of foreign affairs knocked on my door. He asked if I had visited the falls. When I told him I had, he said they were off limits. That was strange. The authorities in Linfen told me they weren't off limits. The problem, it turned out, was that the waterfall was claimed by two different provinces, and there were two different rulings on access by foreigners. I pleaded ignorance, paid a small fee of 20RMB, and was told to be on the seven o'clock bus out of town the next morning. Afterwards, I walked back out to the street and found a place that served homemade noodles. That was all I wanted. Well, actually, I also wanted a hot bath. But that was not going to happen in Yichuan. I had to make do with a cold shower. But at least there was no nightclub below my room, and I went to sleep as soon as I lay down. The next morning, I had no problem getting up in time to catch the bus. The town's loudspeaker system began playing music at 6:20. Although I had a good night's sleep, I woke up with a strange dizziness and took an aspirin, which didn't seem to help at all. Maybe it was the music. It was all martial music. No Mozart, not even any "High Mountains" or "Flowing Waters." I walked to the town's bus station, which was one block away, and got on one of the two buses that were waiting in the dirt parking lot. And right on time, at

Hukou Falls

seven o'clock, I left Yichuan on a paved road lined with copper-tipped poplars and rows of tobacco plants growing under long sheets of plastic. Spring was just around the corner.

Two hours later, we reached the main north-south highway, and I got off at the bus-stop village of Chafang and flagged down the next bus headed south. Two hours after that, I got off again as we passed a thickly forested hill, which was a surprising sight in that part of China. The name of the place was Huangling, and it was where Huang-ti, the Yellow Emperor, was buried.

A few days earlier, I had passed another site that claimed to be his grave. It was just outside the town of Wenhsiang, where I took the Tayu Ferry across the Yellow River. In China lots of famous figures had multiple graves, but Huangling was where most Chinese have been coming for the past few thousand years to honor the man they considered the patriarch of their race and culture. In fact, every year in early April on the day set aside for honoring ancestors, government and party officials still came to Huangling to light incense to Huang-ti.

Huang-ti's ascension to the pantheon of heroes occurred around 4,700 years ago, when he led a confederation of tribes that defeated the Miao for control of the great salt lake I had passed earlier near Chiehchou. It was as a result of that battle that the Han Chinese had been able to extend their control over the entire Yellow River watershed. Apparently Huang-ti also learned the secret of immortality, as he ruled for a hundred years. And when his time finally came to join the immortals, he mounted a dragon that came to carry him off. But before he could disappear into the clouds, his followers managed to catch hold of his robe and shoes. And they buried them there at Huangling.

As I walked along the paved road that led up the hill from the highway, I couldn't help notice that none of the

other hills in the area were forested, only the one on which Huang-ti's grave was located. It was illegal to cut trees down anywhere on his hill, but apparently not on the other hills. Halfway up Huang-ti's hill, I stopped at a shrine. For the past two or three thousand years, that was where officials had been coming to pay their respects to Huang-ti. But more impressive than the shrine itself were the cedars that filled the courtyard. One especially huge cedar was said to have been planted there by Huang-ti himself. Another one was said to be ancient when Emperor Wu of the Han dynasty came there to pay his respects 2,100 years ago.

From the shrine, I followed the road another kilometer until it ended just short of Huang-ti's grave. At the entrance, I met a girl selling hemp seeds, which she was able to crack with ease. I had trouble with melon seeds and passed up the chance to embarrass myself with hemp seeds. Along with several other pilgrims, I climbed the final steps to the grave mound. In front was a small open-air shrine, where a group of students stood at attention, while their teacher lit incense. They all bowed three times, took a group photo and left. I wasn't Chinese, but I did have some Indian blood, and who knows, maybe our tribes were related. I lit some incense too, then returned to the highway, flagged down a tour bus headed north, and, three hours later, ended another long day where the Red Army ended its Long March: in the town of Yenan.

Once again, I chose the local government guesthouse for my lodging. I don't remember what I had for dinner, but I do remember the hot bath. It put me to sleep immediately. But for the second morning in a row, I woke up feeling dizzy. And the dizziness was now joined by a fever. Fortunately, the local hospital was right across the street from the guesthouse. I registered before the daily nine o'clock deadline and was full of drugs in no time. I floated through the rest of the day

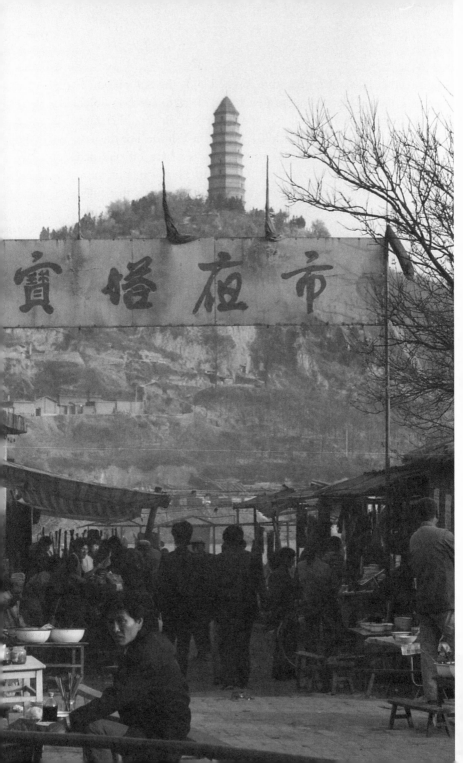

while I visited the sights associated with the city's revolutionary history.

The first stop on my itinerary was the Yenan Revolutionary Museum. It was in a big building at the north edge of town and included exhibits that recounted the founding of the Communist Party in the province and the rise of what was now known as the Yenan Spirit, when Yenan was a communist sanctuary in a sea of money-grubbing Chinese Nationalists and blood-thirsty Japanese Imperialists.

My favorite exhibits were Mao Tse-tung's stuffed horse and the scale models. There was one model that showed how Red Army soldiers created underground tunnel networks in farming villages under their control, much like the Viet Cong did in Vietnam. There were entrances under cooking pots and haystacks and even underneath buddha statues. The museum also had a bookstore that sold a number of hard-to-find works on the revolutionary period. Like all revolutions, not everything turned out the way its planners anticipated. It's hard to plan anything that involves people. Even when ideas make perfect sense, people rarely do.

Next on my itinerary were the caves north of town outside the villages of Yangchialing and Wangchiaping. That was where the Red Army holed up for ten years, while Nationalist and Japanese airplanes tried to bomb them out of existence. Many people in the Yenan area still lived in similar caves, and after visiting a few, I had to wonder why anyone would want to move into town. The caves were much cooler in the summer and easier to heat in the winter than cement apartments. And talk about soundproof. It was in these caves that the leaders of the Red Army lived from 1937 to 1947.

The caves were all open to the public and provided an

interesting glimpse of some of the personal habits of China's Communist leaders. Mao's bedroom, for example, was full of bookshelves. My guide said Mao read himself to sleep at night. That was also where Mao wrote many of the essays that were later included in his famous little red book. In the dirt courtyard outside was the pavilion where he read in the summer and where he received visitors. My guide said that was where Mao told Anna Louisa Strong that all reactionaries were paper tigers. Inside Jen Pi-shih's cave was a spinning wheel, symbol of the Self-Reliance Movement. And outside Chu Te's cave was a stone chessboard. But what surprised me most was a photo in Chou En-lai's cave showing him at his desk, and in front of Chou was a bronze statue of Maitreya, the buddha of the future.

Ironically, the symbol of Yenan and its revolutionary history was also a Buddhist symbol. It was the 44-meter high pagoda at the south edge of town. It was built in the T'ang dynasty, over 1,300 years ago, and it was in such good condition people were still allowed to climb the stairs inside to the top. In a separate pavilion near the base of the pagoda there was a bell that was rung by the monks to announce morning and evening services. But after the arrival of the Red Army, it was used to announce air raids and important meetings.

In addition to providing the revolution with one of its most famous symbols, Yenan also supplied the Communists with their most famous song. It was a local folk song about 700 horses, and it was the message China's first satellite broadcast to the world. But it wasn't called "Seven Hundred Horses" anymore. The name was changed to "The East is Red."

Although Yenan was in the middle of nowhere, a train line from Sian had recently been completed, just in time, as far as Chinese leaders were concerned. Yenan was where the Red Army took sanctuary at the end of the Long March and

where the first successful communes and the basic themes of Maoist thought were established. And this was the beachhead from which the Red Army poured forth in 1947 in its successful drive against the Nationalist Army. In many ways, this was where modern China was born – in Yenan, in the middle of nowhere. It was no coincidence that this was the first place Chiang Tze-min visited after he was appointed head of the Communist Party in the fall of 1989.

Chiang came there, as hundreds of thousands of party members did every year, to re-awaken in themselves the Yenan Spirit. With the completion of the rail link, I expect more party members will be making the pilgrimage to Yenan. Even now students were being encouraged to join others who had begun retracing the route of the Long March that ended there in 1936. This periodic attempt to re-awaken the Yenan Spirit was apparently an attempt by leaders to return to simpler days. This was understandable. Its simple ways were what I remembered most about Yenan. It was the first city where I saw people sitting at tables on the sidewalk sipping tea and chatting. Even in the bus station there was a special area near the front door reserved for those who wanted nothing more than tea and conversation. In Yenan the talk was invariably about tobacco, for which Yenan was also famous.

But there was more to Yenan than revolution and tobacco. There was a mountain fifteen kilometers southwest of town called Wanhuashan. It was covered with wild peonies – millions of wild peonies – and I hired a taxi to take me there. But it was April, and there were no blooms in sight. I was a month too early. But it wasn't the peonies that attracted me. On the hillside directly across from Wanhuashan was the grave of Hua Mu-lan. Mu-lan was a girl, and her family name was Hua. Most records say she lived sometime before the T'ang dynasty, about 1,500 years ago, and one day the order came down for males in the village to report for mili-

tary service, and by some bureaucratic oversight her father's name was on the list. An order was an order, and even though her father was well past his prime, the officials refused to release him from duty. So Mu-lan dressed up as a man and reported in her father's place. Twelve years later, she returned. And afterwards when she died, she was buried across from Wanhuashan on the hillside of Huachialing.

When Chinese were still required to study classical Chinese, they all memorized the Ode to Mu-lan:

> Alas and alas again
> Mu-lan weaving at her window
> try to hear the shuttle's sound
> above her constant sighs
> ask her about the future
> ask her about the past
> she says it's not the future
> she says it's not the past
> last night I saw the army's order
> they want to raise new troops
> the list went on for twelve long pages
> and in it was my father's name
> my father doesn't have a son
> and I don't have a brother
> I'm going to be a horse's groom
> and serve in place of my old dad.

Beside her grave there was a simple stone marker that said "The Grave of Hua Mu-lan."

YULIN

After spending two days in Yenan trying to re-awaken the Yenan Spirit, it was time for me to push on. The Yenan Spirit aside, I still wasn't feeling well. But I needed to keep going if I was ever going to reach the source of the Yel-low River. Yenan was located in the middle of China's Loess Plateau, which was known for its incredibly eroded landforms and a landscape that became increasingly barren as one went north. That was where I was headed next. At the Yenan bus station, I boarded a bus for Yulin, a nine-hour bus ride to the north. Unfortunately, there was no closer option. All the towns in between Yenan and Yulin were off-limits to foreigners.

The first two hours, the bus passed through a world of brown on brown. There were more oil derricks than trees. It was a forbidding landscape, and even if foreigners were wel-come, there was no reason to get off. At the four-hour mark, the bus stopped briefly in the town of Suite so that people could use the WC. Suite was a sad excuse for a town, and it was the scene of a particularly sad tale. When the first em-peror of the Ch'in dynasty died in 210 BC, the chief eunuch arranged for the emperor's youngest son to succeed him and issued false orders for the emperor's eldest son and his chief general to commit suicide. Well, the eldest son was a filial son.

He obeyed the order, and his grave was in Suite. The general's name was Meng T'ien, and he suspected the order was false. Meng T'ien was a man of unusual accomplishments. It was Meng T'ien who was in charge of building what later became known as the Great Wall. It was also Meng T'ien who was credited with inventing the Chinese writing brush. Although the recent discovery of brushes dating back several hundred years earlier has deprived him of that second honor, he was still admired for his work on the Great Wall and also for refusing to obey the order to kill himself. Still, once the old emperor's youngest son was enthroned, the new emperor had Meng T'ien poisoned, and his grave was also somewhere in Suite. As for the new emperor, he too was forced to commit suicide two years later. Life expectancy near the tiger's mouth was uncertain and invariably short.

As the bus continued on from Suite through China's Loess Plateau, the word "erosion" took on a new meaning. Nothing but dirt in all directions. Even the Wuting River that the road was following was nothing but dirt. Then, just past the town of Michih, the dirt turned to sand. We had reached the edge of the Maowussu Desert. Then suddenly the Wuting River was full of water, at least a foot of water, and it was clear. In Chinese, "Wu-ting" meant "Uncertain." Apparently, it must have rained upstream from Michih. The sight of the river relieved an otherwise monotonous landscape. Finally, nine hours after leaving Yenan, the bus pulled into Yulin. And for 3RMB, a pedicab pedalled me from the bus station all the way to the Yulin Guesthouse near the north edge of town. The guesthouse turned out to be full – not of foreigners (I was the only one in town), but of party members on a junket. Still, since the Yulin Guesthouse was the only hotel where foreigners were allowed to stay in Yulin, a room was finally found, and I stretched out on my bed to consider the long ride. Although it was late afternoon, it was still sunny

outside my window. Then suddenly the wind began to blow, and the sky turned dark. In a matter of seconds, the town was enveloped by sand. From my window I watched people on the street trying to walk. They had to bend and lean into the wind to make any progress. Suddenly they disappeared, swallowed by the sand. Half an hour later, the storm ended just as quickly as it had begun, and the people reappeared again, as if they had returned from a dream.

Then there was a knock on my door. It was the local foreign affairs police. The officer's name was Wang, and he asked me what I was doing in Yulin. Foreigners didn't come there very often, he said. I told him I was following the Yellow River and wanted to visit the area where it picked up most of its silt. According to the officials I talked with at the Yellow River Museum in Chengchou, most of the river's silt came from tributaries in the Yulin area. Two places on the river I had hoped to visit were Chiahsien to the southeast of Yulin and Fuku to the northeast. Both towns were on the Yellow River near the mouths of tributaries. Wang said Chiahsien was off-limits to foreigners, but he wasn't sure about Fuku. He said he would check. Then he left.

I was so tired, I barely had the energy to walk to the hotel dining room, where I ordered the simplest meal I could: fried rice and egg and tomato soup. Afterwards I walked back to my room, took a bath in lukewarm water and tried to sleep. It was the beginning of a long night. The party cadres in the adjacent rooms were attending a "conference," which was basically a vacation, and they stayed up past midnight drinking. And, of course, they left their doors open. During the night my dizziness and fever were joined by chills. The next morning I called the front desk and asked to see a doctor. I had been on the road without a break for six weeks and was tired. I always tried to limit my trips in China to three weeks, or four at the most. Obviously, I had ignored my own

The Chenpeitai fort

advice. An hour later, a doctor came to my room and gave me a couple of shots. I didn't ask what they were. I didn't care. He told me to stay in bed for at least two days. Not long after he left, the fever and chills subsided. I still didn't know what made me so ill. I was grateful to be feeling better, instead of worse. But the next day I still felt weak and dizzy every time I got up to go to the bathroom. I decided to take the doctor's advice.

During the next two days, the doctor came by once every day, as did Officer Wang, and three times a day someone brought me the simplest of meals – mostly soups and meat-filled buns. If the hotel or the setting had been more restful, I probably would have spent a couple more days in bed, but two was all I could handle. The noise from the people attending the "conference" – I never found out what the conference was for – made me feel like I was somewhere between purgatory and hell. So when Officer Wang came by the morning of the third day, I told him I wanted to see some of the sights in the Yulin area, and he agreed to make the arrangements. An hour later, he returned with a jeep and became my defacto guide. I had to pay for the jeep, but the guide service was free. Obviously, he wanted to make sure I didn't get into any trouble. But I still didn't feel very well, and I was thankful to have a guide.

In ancient times, Yulin was a border town. It was just inside Meng T'ien's Great Wall, and it marked the limit of Chinese control in that region. There were still traces of the wall in the desert a few kilometers north of town, and that was where we began. Not only was the wall itself still intact, this section included a large fort. The fort was called Chenpeitai, and it was built in 1607 with stone blocks on the outside and tamped earth on the inside. It rose like a truncated pyramid thirty meters above the surrounding desert and served as a beacon tower as well as a watchtower. We fol-

lowed the caretaker up to the top of the pyramid and looked out. He said in the past there used to be a market just outside the wall where herders brought horses to trade for Chinese goods. But the market was long gone. Stretching across the horizon on all sides were sand dunes. It was hard to imagine a market, or anything else, in such an inhospitable place. But in the distance beyond the dunes, I could see fields of green. According to Officer Wang, what I was looking at was one of the most successful land-reclamation projects in China.

Of an estimated 200,000 hectares of desert in the Yulin area, 100,000, or half, had been brought under cultivation since 1950. That was a stupendous achievement, and to see a field of green next to a sand dune was an unforgettable sight. Officer Wang told me the best place to see how the recla-mation process worked weren't the fields near the fort but Yulin's Desert Botanical Garden. It was one kilometer west of the fort, and it included more than 170 kinds of plants being tested for use in the desert. It also included sections where I could see how ground-cover plants were gradually introduced until small bushes and eventually trees could be planted. While I was walking through, a ring-necked pheas-ant whirred out of the bushes and disappeared into the trees and brightened my day.

Despite the pleasure of seeing land reclamation in ac-tion, I still wasn't feeling that well and suggested we go back to the guesthouse. But Officer Wang wanted to show me one more place. On our way back to town, we turned off the main road and drove a kilometer or so to a place called Hungshihhsia, or Red Rock Gorge. It was even better than the sight of green fields next to sand dunes. The walls of the gorge were red sandstone, and between them was a river of clear water. The shrines and calligraphy along both cliffs were even more impressive. The gorge was a warren of niches and caves filled with carvings of buddhas and heav-

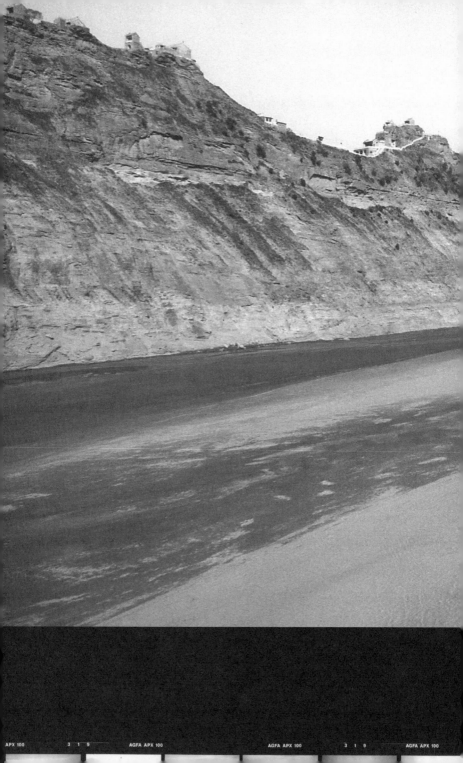

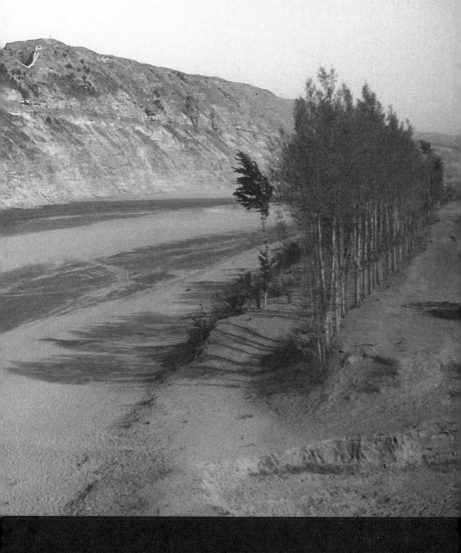

Kuyeh River and Shenmu Ridge

enly attendants. And the gorge walls were covered with calligraphy, some of it dating back to when the first temple was built there a thousand years ago. The setting was wonderful, like an oasis in the desert, which I guess it was. It was only three kilometers north of Yulin, and I was surprised there weren't more visitors. But according to Officer Wang, there were no public buses that went there. Still, young couples, I noticed, weren't shy about riding out on their bicycles. If I had been feeling better, I would have lingered longer, but I was feeling dizzy again.

We returned to Yulin, and I returned to my room, hoping that an afternoon nap would help me recover from what must have been the Yellow River flu. It was just as well. Except for the few sights I had visited with Officer Wang, everything in the surrounding area was off-limits to foreigners. There was, however, one place I regret not being able to visit. It was 120 kilometers west of Yulin in the middle of nowhere. When the Huns were raping and pillaging in Eastern Europe in the fifth century, their counterparts, known to the Chinese as the Hsiung-nu, established their own state, known as Tahsia, and built their capital west of Yulin. Their capital was called Tungwancheng, and it was built in 413 AD, about the same time Rome was being sacked. This was a period when China was divided into a number of competing kingdoms, and this particular kingdom lasted less than twenty years. But the ruins of their capital were still intact. In fact, they constituted the most complete sets of such ruins in China, probably because they were so hard to reach. The area was so dry, years sometimes passed between rainfalls. But despite the constant dust storms that whipped across that barren region, the city's inner walls, judging from photographs I had seen, looked almost new: they were ten meters high and 500 meters on a side. And at each of the four corners there were thirty-meter-high towers. There were also traces of a drum tower and

a bell tower. The city may have been ruled by the Huns, but it was modeled on those of their Chinese neighbors. According to archaeologists, the palace included enough rooms for several thousand officials and 10,000 attendants. And today it was completely deserted, surrounded on all sides by the endless sands of the Maowussu Desert, which made up the southern half of the Ordos Desert.

Although foreigners were not allowed to visit Tungwancheng, Officer Wang told me he had checked, and foreigners could visit the town of Fuku, which was a hundred kilometers to the northeast and which also involved driving through parts of the Maowussu. Since public transport between Yulin and Fuku was almost non-existent, Officer Wang once again agreed to arrange for me to hire a jeep. And so, the next day I resumed my northward journey with Officer Wang as my escort.

As soon as we left Yulin, the road was immediately surrounded on both sides by the Maowussu Desert. And it definitely looked like a desert. According to my map, it stretched 100 kilometers from north to south and 400 kilometers from east to west. "*Mao-wu-ssu*" was Mongolian for "bad water." But despite the bad water, or lack of water, and despite the infrequency of public transport, the road was good and mostly paved.

Halfway to Fuku, we crossed the Kuyeh River, and I asked our driver to stop. Somewhere upstream some of the wildest storms in China occurred, which was why the Kuyeh carried more silt than any other river in the world. When it rained, it rained like it was the end of the world. In consideration of such a distinction, I stopped long enough to photograph the river, which actually had some water in it – and it looked like good water. I also photographed the dirt ridge that funneled it past the nearby town of Shenmu and into the Yellow River to the east. But it was April, and the river

was dreaming of summer storms that were still months away.

The ridge that funnelled the river past Shenmu was called Erlangshan. It was lined with a series of shrines and temples dating back to the Ming dynasty. But the entire ridge was off-limits to foreigners, as were the other sights around Shenmu. And so I continued across the Kuyeh River and past the town of Shenmu, escorted by my good friend, Officer Wang, who had taken an interest in seeing that I not visit anything I shouldn't. It was like being chaperoned to a dance. He could have saved his effort. I still had a fever and was almost too dizzy to walk. As soon as we reached Fuku, I checked into the only guesthouse in town and collapsed into bed and didn't move for three days, except to receive the occasional shot in the rear and bottle of glucose. On the third day, I got up long enough to walk down to the Yellow River, where I photographed some boats tied up along the embankment. But I felt so weak, I walked back to the guesthouse and went back to sleep. All I remember about Fuku was leaving it the next day, on the daily bus to Tungsheng to pay my respects to Genghis Khan.

MONGOLS

From Fuku the road to Tungsheng took me back toward Shenmu and past the world's eighth-largest coal mine at the edge of the Ordos Desert. I thought maybe we would bypass the desert, but not long after we passed the coal mine, we turned northwest and headed directly into it. The sand and *gobi* (which is what the Chinese called a flat, rocky desert) stretched as far as I could see in all directions. After three hours, we finally entered an area where grass began competing with the sand and *gobi*. An hour later, the bus driver dropped me off in the middle of nowhere. I had told him earlier I wanted to get off at Genghis Khan's tomb. And there it was, in the middle of nowhere. Except for the caretaker, I was the only one there.

When Genghis Khan died in 1227, a coffin containing his remains was first kept in Mongolia. Fifty years later, when his grandson Kublai completed the conquest of China and established the Yuan dynasty, the coffin was moved to this area just south of the northernmost bend of the Yellow River to make imperial visits more convenient. During World War II, the coffin was moved again to Kansu and then to Chinghai provinces for safekeeping, and it was finally returned to this area south of Tungsheng in 1958. Scholars, however, think his real remains are somewhere else, somewhere as yet

undiscovered – and meant to remain undiscovered, and that the "coffin" that has been moving around is merely a memorial coffin – sort of like the grave of Huang-ti that supposedly contains his robe and his hat.

In any case, since the return of the "coffin," the authorities had erected a tile-covered building to house not only the "remains" of Genghis Khan but also those of his wives and his eldest son. It was certainly different from anything I had seen in the rest of China. It was built to resemble three Mongolian-style tents. Inside were a number of items said to have belonged to the Great Khan, including his sword and his saddle. Although the building interior gave the impression of a museum, it was, in fact, a mausoleum. Inside the central hall were three tents containing the coffin of the Great Khan flanked by those of his wives and his eldest son. When I visited, the marble floor in front of his tent was covered by cedar fronds and other items brought by Mongolian pilgrims for the Great Khan to enjoy in the great beyond. I counted a dozen bottles of beer. Outside, I counted two apricot trees in bloom and overhead two snow geese headed back north. That was where I headed too, after flagging down what was the last bus of the day bound for the town of Tungsheng.

Two hours later, I arrived in Tungsheng just as the sun was going down and checked into the Tungsheng Guesthouse. For 50RMB, or less than ten bucks, I stayed in a suite of rooms – not just one room but a suite of three rooms. The bedroom had a bed as big as my entire bedroom at home. When I laid down in it after dinner, I felt like a pasha and went to sleep within minutes. I was still exhausted from whatever illness I had contracted and didn't move all night.

The next morning, I left on the eight o'clock bus to Paotou. Tungsheng was another town that woke everyone up at six-thirty to the sounds of music and news over loudspeakers. They were still blaring at eight. Two hours

later, we crossed the Yellow River on the only bridge that spanned the river's northern bend. After another hour, we reached the city of Paotou. Since the day was only half over, after I checked into the Paotou Guesthouse, I decided to visit the temple complex of Wutangchao and hired a taxi to take me there.

Wutangchao was on the other side of the Yinshan Mountains, but we We were there in less than ninety minutes. Wutangchao was once one of the major centers for Tantric Buddhism in China. As with Tantric temples elsewhere, its architecture was distinctly Tibetan, betraying the origin of that sect of Buddhism: thick walls, small windows painted larger than they were, multistoried construction and flat roofs. Inside, the walls were covered with murals dating back to the temple's original construction 300 years earlier. It was a good thing I didn't forget my flashlight and my binoculars. The artwork was exquisite, but the shrine halls were so dark, I wouldn't have been able to see much if I hadn't brought my own light. The halls themselves were supported by dozens of pillars that had been wrapped in thick red carpets to improve the acoustics and also to provide a little more warmth in winter. I expected to see more monks than I did and thought maybe they were meditating or doing something else. But in the patriarch's hall, one of the lamas told me that the government restricted the number of monks who could live there and most of the older lamas had moved away. He also said that their sect had been without a spiritual leader since the Liberation of Tibet in 1951. After the last rimpoche died, the government refused to let them seek his incarnation for fear that he might be found outside China.

After seeing what I could see, I returned to Paotou and my usual day-ending routine of eating dinner, washing clothes, taking a bath and going to bed early. The next morning I was up early once more, this time without the musical

The tomb of Genghis Khan

accompaniment of loudspeakers on the street. In the drier air of Inner Mongolia, my clothes dried fast. Usually they were still a bit damp in the morning, but not in Paotou. I was originally planning to follow the Yellow River upstream from Paotou by taking a train to Yinchuan. But when I went to the train station, I discovered the next train was not due until the afternoon. I wasn't about to take the bus, which took ten to twelve hours to reach Yinchuan. So I decided that since I was in Inner Mongolia, and the provincial capital of Huhohaote was only two hours away, I would change directions and head east instead. Although the next train to Huhohaote was also not due until the afternoon, buses left every half hour from in front of the train station, and I was on the next one.

Just outside of Paotou, the bus began following the bony spine of the Yinshan Mountains, which I had crossed the previous day on my way to the Tantric Buddhist complex of Wutangchao. This time I stayed on the southern side of the mountains, as the bus kept following them east. Halfway to Huhohaote, we passed the small Buddhist temple complex of Meitaichao at the foot of the mountains. Seven hundred years ago, it was the residence of a descendant of Genghis Khan who ruled all of China, but I never did find out which one. Despite the imposing architecture of the temple's walls and roofs, no one on the bus even glanced outside. Their eyes were focused on the Taiwan soap opera on the closed-circuit TV.

Huhohaote sounded odd in Chinese, like a name that was being pronounced backwards. But it wasn't Chinese. It was Mongolian, and it meant "blue wall." The area where it was located had been home to China's nomadic tribes for half a million years, and there had been large-scale encampments there since the Warring States period 2,500 years ago. Most tourists who visited Huhohaote came to join the gov-

ernment-run tours to the grasslands north of the capital for a glimpse of the pastoral life. But I had yet to meet anyone who enjoyed the tours. Most of their time was spent in a jeep interrupted only by the occasional stop to visit a typical Mongolian family – no doubt, the same family the people in the earlier jeep visited. A better idea would be to hire a car with a Mongolian-speaking driver and to strike off into the grasslands without a guide or even a plan. Let life take care of itself.

The trip from Paotou was so fast, I arrived in Huhohaote before noon. Since the bus dropped everyone off at the train station, I went inside and deposited my bag in the bag-storage room and considered the alternatives to the grassland tour. After looking at a map of the city, I decided to indulge my sentimental nature with a visit to the resting place of one of the most famous women in Chinese history. Her name was Wang Chao-chun.

When Chinese think of the heartbreak that comes with being separated from their native land, Wang Chao-chun's name is never far off. She came to Huhohaote to marry the chieftain of the Hsiung-nu tribe that ruled this area 2,000 years ago. She was a lady in waiting at the Han dynasty court in Ch'ang-an, and she had no choice but to obey the imperial order that sent her here at a time when Julius Caesar still ruled Rome. She was a pawn of a government anxious to reduce tensions on its borders. She was still a pawn. Chinese authorities talked about Wang Chao-chun as if she were the best thing that ever happened to their relations with the various ethnic groups that still inhabited their border regions. Meanwhile, Chinese writers and artists portray her as a tragic figure – that last look back, never to see her hometown again, much less her family or friends.

I hired a taxi to take me to her grave, which was located in Huhohaote's southern suburbs. It was a huge, man-made

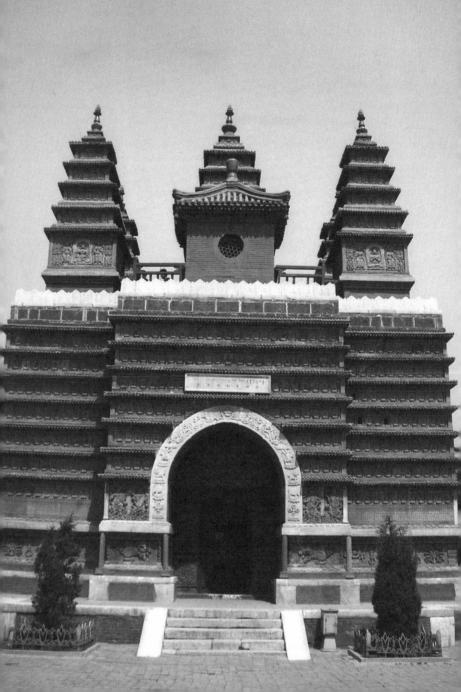

mound surrounded by a small park and several halls containing a few artifacts from the period. It was early May when I visited, and the top of her grave was covered with the small pink blossoms of *kan-ssu-mei* bushes, and an old lady sold me the creamiest popsicle I had ever tasted. She said she made it herself from goat milk.

On my way back from Wang Chao-chun's tomb, I also visited a series of three Buddhist temples, each with its own unique architecture. The first and most famous was Wuta Temple. *Wu-ta* meant "five pagodas." What was so unique about this temple was that instead of having the pagodas spread around the grounds, the pagodas were on the roof of the temple's solitary shrine hall, which was all that was left of the original temple. This odd-looking structure was built in the eighteenth century, and its walls were covered with thousands of bricks carved with buddha images that somehow escaped the Cultural Revolution.

Behind the temple were several steles no visitor should miss. One portrayed the Buddhist vision of the Wheel of Life and Death around which we all spin endlessly until we gain release through the cultivation of wisdom and compassion. A second stele depicted Mount Sumeru, around which Buddhists believe the whole universe turns. And a third stele was engraved with a detailed atlas of the sky, with the names of stars and constellations in Mongolian. The artistry was sufficiently arresting that I was surprised they hadn't been carted off to some museum.

From Wuta Temple, I abandoned my taxi and walked a few blocks west to Hsilitu Temple. It wasn't very big, but its white pagoda, its roof ornaments and even its courtyard were sufficiently impressive to warrant a stop. But more impres-

Wuta Temple

AGFA APX 100 3 1 9 AGFA APX 100 AGFA APX 100 3 1 9

sive was the third and final temple on my tour. It was Tachao Temple, and it was only a few blocks west of Hsilitu Temple. It included a number of beautifully renovated halls outfitted with huge lanterns and hundreds of small bells that made a delightful sound in the wind. At the temple entrance was Jade Spring Well. The well was once one of the most famous wells in northwest China. Alas, it was dry. But its name lived on in Huhohaote's Jade Spring Beer, which I sampled later that night at the train station while waiting for the night train to take me west.

YINCHUAN

twenty

Although I was able to buy a ticket on the night train, it was for a hard seat and not a berth. Still, once on board a train in China, it was always possible to upgrade one's ticket at the conductor's cubicle next to the dining car. The reason sleeping-berth tickets were so hard to buy was because each station was only allotted so many, and they liked to keep them in case important party members or government officials showed up. But at least I had my ticket, and the train left right on time. And, as I expected, it was not difficult to upgrade my ticket to a soft sleeper, which was much better than a hard sleeper. There were four berths per room in the soft-sleeper section and six in the hard-sleeper section. And the hard-sleeper section didn't have a door. Apparently, no one was interested in spending the extra money for a soft sleeper on the train to Yinchuan. In fact, there were so few people in the soft-sleeper section, I had an entire compartment to myself. I guess it just wasn't the time of year to be traveling that route, or maybe just not the right night. In any case, I thoroughly enjoyed lying in bed rocking with the train as it sped through the night, following the Yellow River upstream.

When I was in Chengchou, the scientists in charge of monitoring the river told me the stretch of the river south

of Huhohaote was where the upper reaches ended and the middle reaches began. The basis for making such a distinction had to do with the river's volume of water and silt. The middle reaches were where the river turned yellow. And the middle reaches, they said, extended south from Huhohaote all the way to Tungkuan and as far east as Loyang. The stretch from Loyang to the sea was the river's lower reaches. I was finally following the river's upper reaches – not that I could see anything out the window. But I knew the river was out there and it wasn't yellow. And I went to sleep rocking back and forth along the river of steel that took me all the way to Yinchuan, where I arrived the next morning at six o'clock, just as the sun was coming up.

Yinchuan was the capital of the Ninghsia Autonomous Region. If you look at the Chinese flag, in the upper left-hand corner, you will notice one large star and four smaller stars. The large star represented the Han Chinese. The smaller stars represented the country's four other major ethnic groups: the Tibetans, the Mongols, the Manchus and the various Muslim groups spread throughout China's northwest and southwest provinces. Among these groups, the Uigurs of Hsinchiang Province and the Hui of Ninghsia accounted for 90% of all Muslims in China, and Yinchuan was the home of the Hui. The ancestors of the Hui came there as early as the Sung dynasty a thousand years ago. They came from Persia, Arabia and Muslim kingdoms in Central Asia. Some were merchants or artisans in search of new opportunities, but most were refugees who came there to escape the Mongols. During the Yuan and Ming dynasties, these diverse groups of refugees developed a common culture centered on their belief in Islam. And today, the Hui, as they now called themselves, made up one-third of the province's population.

I had such a good sleep on the train, I felt energetic for the first time since getting sick in Yenan. After checking into

a hotel near the train station and dropping my bag in my room, I rented a bicycle at the front desk and went to see a few sights. On the city map I found in my room, I saw that there was a Muslim college nearby. So that was where I pedaled. It didn't look that impressive. Just a few concrete, tile-covered buildings surrounded by *gobi*. It turned out that this was China's one and only Muslim college. When I walked inside, I met its director, Mr. Chang. He was walking down the hallway and invited me to join him in his office. Construction of the college, he said, was financed by Saudi Arabia and the Islamic Development Bank, and there were 400 students enrolled at the time of my visit. They were sent there by Muslim communities all over China to learn how to conduct religious services in their local mosques. The courses of study, he said, lasted anywhere from two to eight years, and some of the graduates also went to Saudi Arabia for further study. Mr Chang asked if I wanted to visit one of the classes, but I demurred and decided to continue my tour of the city.

From the college, I pedaled to the city's biggest mosque. It was Sunday, which wasn't the normal day of worship, but the place was still filled with worshippers. Being a heathen, I wasn't allowed inside the main hall, but through the doorway I could see several hundred men kneeling in prayer, and at least a hundred women doing the same in a screened-off section reserved for their use. Meanwhile, the *ah-hung*, or religious leader of the mosque, intoned passages from the Koran in Arabic.

One of the caretakers of the mosque showed me around and made sure I didn't do anything that might annoy anyone. While he was doing this, he told me that Friday was the principle day of worship, but the faithful came there to pray whenever they could, and the mosque now had special services on Sunday for people who couldn't come on Friday. And if they couldn't come to the mosque, they still

stopped whatever they were doing and prayed five times a day, he said. It seemed to me that being a Muslim involved a lot more prayer than other religions, and also a lot more attention to purification. In the mosque's small bookstore I bought a book that detailed the intricate process of washing that preceded prayer. The mosque itself was disappointing. The tiles were already falling off the main building, and the layout of the courtyard and adjacent buildings had little in common with a traditional mosque. I would have thought that in such a major Muslim population center like Yinchuan the main mosque would have been more, how shall I say, Muslim. Where was the beautiful tile work for which Islamic cultures were famous? Not in Yinchuan.

I thanked the man who showed me around and continued on my tour of the city. The Ninghsia Autonomous Region, of which Yinchuan was the capital, was the most productive agricultural region in all of northwest China. And the reason for the productivity wasn't hard to find. It was, of course, the Yellow River. But it wasn't just the river. The river flowed through other regions of northwest China that were barren. The difference in Ninghsia was an irrigation system that was first developed 2,000 years ago, long before the Muslim migrations.

During the Ch'in and Han dynasties, the Chinese government established agricultural colonies at different places along the Great Wall. The colonies in the Ninghsia region were more successful than the others, and the reason for their success was the development of a canal system. In fact, a canal that was first dug in the T'ang dynasty still cut through the western part of the city, which was where I pedaled next. When I got there, I was not surprised to see that the canal was full of water. But a man who was walking beside the canal told me it wasn't always full. He said it was drained every winter to remove accumulated sand and then refilled the fol-

lowing spring. I was there in late April, and the water was so clear I could see the bottom. After the man left, I also walked along the canal wondering where to go next. I decided it was time to see the source of all the water that made Ninghsia so productive.

I pedaled back to my hotel and hired a taxi to take me to the Yellow River ferry. The ferry was fifteen kilometers east of town. I'm not sure why the town was set so far back from the river. Maybe it was because of floods. Or maybe it was because it made more sense to be closer to the fields fed by the canals. Whatever the reason, it didn't take long to reach the river. We pulled up behind a line of a dozen cars and trucks and two buses. Thirty minutes later, we were aboard the ferry, which was simply a metal barge with an engine attached to a cable. Instead of trying to battle the current, the ferry simply pulled itself from one side to the other. And it only took ten minutes.

Once across, we headed north and drove past several pumping stations that fed the river's water into another irrigation system on the east side of the river. Two kilometers north of the ferry, I asked the driver to stop so that I could visit the remains of the Great Wall, which stretched eastward into an endless sea of sand dunes. It was part of the same wall I had seen near Yulin on the other side of the Ordos Desert. My driver told me a group of Americans were planning to walk along that section of the wall in the fall as far as Yenchih. He said there was an article about their forthcoming walk in the local newspaper. The Yuanchih section, he said, was still in perfect condition. The section I visited near Yinchuan had been reduced to a vague shadow of a wall. He said it was due to floods. From the wall, it was a short walk to the remains of an ancient fort that overlooked the river. Looking back to the other shore, I saw the purple ridges of the Holan Mountains rising in the distance.

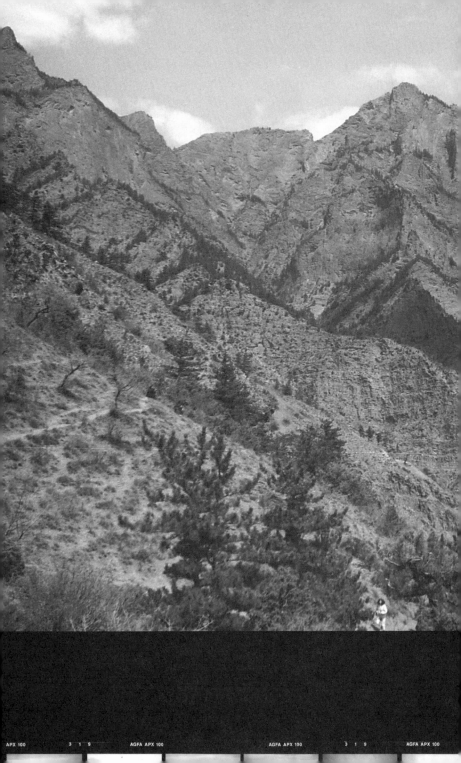

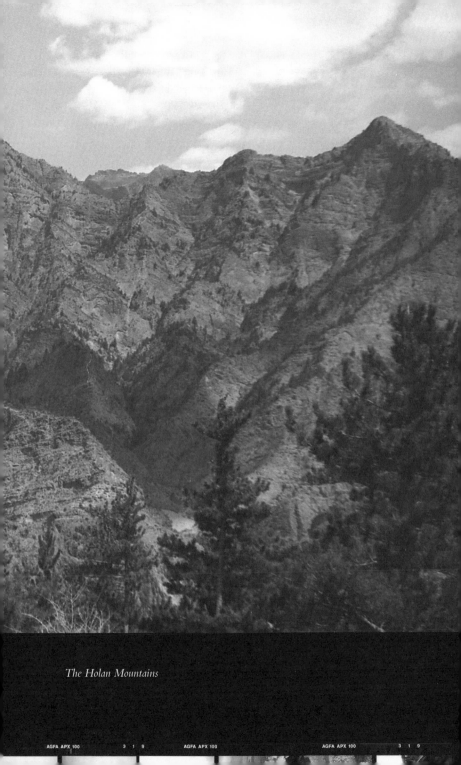

The Holan Mountains

It was just past noon, and I decided it was time for a picnic. We returned to Yinchuan by the same ferry and stopped at a street market, where I bought some bread, some tomatoes and onions, cucumbers, and, of course, some peanuts and beer. I put it all in my armbag and headed for the purple ridges thirty-five kilometers to the west.

The Holan Mountains were among the most unusual mountains in China, yet they were seldom visited, except by local herders. They rose right out of the desert floor and formed a towering north-south wall of rock that extended for more than a hundred kilometers and that protected the area along the Yellow River from the sands of the Tenggiri Desert on the other side. The highest peak was over 3,500 meters, and it was still growing. Ever since the Chinese started keeping such records, they have located the epicenter of one-sixth of all major earthquakes in China in the Holan Mountains. There was even an earthquake monitoring station on the summit to help scientists predict new quakes.

There was no direct road, but my driver knew the way. And forty-five minutes after leaving Yinchuan, we arrived at the entrance to Hsiao-kou-tzu Gorge. Just outside the gorge there was a fenced off area on the right and a small building. My driver walked over to the building and talked to someone inside and arranged for them to open the gate. We drove inside what turned out to be a protected area and headed north along the foot of the mountain. After about fifteen minutes, we stopped at the mouth of another gorge.

Inside the gorge was some of the most ancient rock art found to date anywhere in China. According to my driver, there were more than twenty gorges in the Holan Mountains with rock art, but this was the best and the most accessible one. It also looked like a good place for a picnic. Water was scarce in that region, but the few farmers who managed to eke out a living had channeled a mountain spring into an

acqueduct that ran along one side of the gorge. As we walked into the gorge, we passed a family of herders leading a dozen cattle into the mountains for the summer.

After a few minutes, my guide began pointing out different rocks, and we clambered up the gorge walls to inspect them. Some were carved with characters developed by the Western Hsia dynasty that ruled that area a thousand years ago. Another carving that probably dated from the same period was that of a buddha face with rays of light surrounding it. Another recurring design was that of a goat face. And one rock showed what appeared to be a woman giving birth. Doubtlessly, the gorge and its rocks were once the scene of religious ceremonies aimed at ensuring the fertility of those who lived nearby and their flocks. My driver said some of the designs dated back more than 5,000 years. I was surprised he knew so much. He said he had been coming there since he was a boy and that he sometimes brought his own family there. When I asked him why they came there, he pointed to my armbag. Indeed, it was a perfect place for a picnic, and there was no reason to delay. I had seen enough. I put the two beers I brought with me in the ice-cold water of the acqueduct, and we found a sandy area among the boulders to sit down. By the time I had made us both flatbread sandwiches with slices of tomatoes and cucumbers and onions, the beer was as cold as the water coming down from the 3,500-meter peaks. When I offered one of the beers to my driver, he waved it away. I forgot. He was Muslim. And so I drank both beers, and he drank his tea, and we both ate our sandwiches and stretched out and enjoyed an afternoon nap.

We woke up an hour later. My driver was restless and wanted to show me more of the mountain. We returned to the checkpoint where we had left the main road earlier. When we told the officer in charge that we wanted to continue up the road, he asked me to leave my lighter. Neither

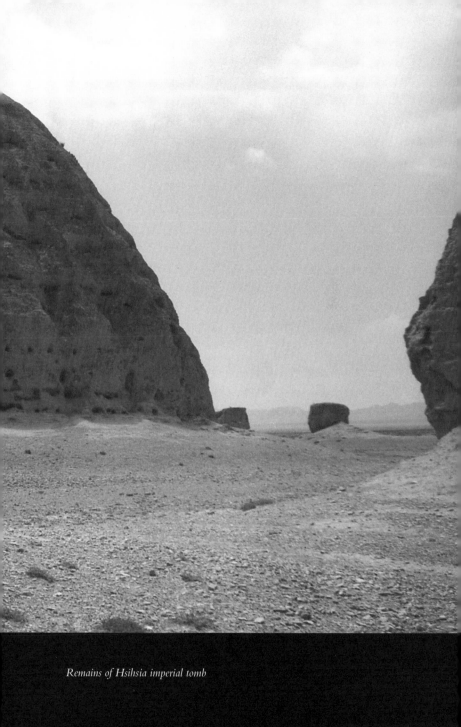

Remains of Hsihsia imperial tomb

matches nor lighters were allowed past the checkpoint. Apparently, the authorities were making a concerted effort at reforestation. I left my Zippo and entered another gorge. But this one included a road, and the road was surprisingly good. Twenty minutes later, we arrived at a jumble of buildings that had been built near the ruins of villas that once housed the kings and ministers of the Western Hsia dynasty. That was where they spent their summers, and I couldn't blame them. The shade of pine-covered slopes, the breeze from snow-capped peaks, the water of high-mountain springs. In a land that consisted mostly of *gobi* and sand dunes, that must have been a welcome retreat, indeed.

My driver led me up a trail, and we huffed and puffed for about thirty minutes until we reached the top of a ridge. The view of the surrounding peaks was awesome, and we spent an hour taking it in. But we weren't alone. It was a Sunday, and there were several busloads of people from Yinchuan who were also enjoying the mountain, throwing glass bottles off a cliff to watch them break below or tossing plastic bags into the breeze to see how far the wind would carry them. Considering the trouble to which the authorities went to keep lighters and matches off the mountain, I had to wonder why they didn't restrict idiots as well. As we left the gorge behind, my driver reminded me that one-sixth of all major quakes in China occurred in these mountains. Maybe the next one, I thought, would occur on a Sunday.

After coming down from the Holan Mountains, we headed back to Yinchuan. But on our way there, my driver turned off on a side road and took me to a place four kilometers west of the city. On the desolate *gobi* plain that stretched between Yinchuan and the Holan Mountains were nine tombs belonging to the kings of the Western Hsia dynasty. Nine hundred years ago, they wrested all of northwest China from Chinese control and established their capital at

Yinchuan, and this was their burial ground. It consisted of nine tombs unlike any other royal tombs in China. Instead of the usual earth-covered mounds, the tombs of the Western Hsia kings consisted of pyramids of adobe bricks. Before they were destroyed by the hordes of Genghis Khan, the bricks were also covered with green tiles, and the ground was still littered with their shards. In the slanting light of late afternoon, the tombs looked like giant anthills.

My driver said all the artifacts uncovered from the site had been removed and placed on display at Yinchuan's West Pagoda, where we arrived a few minutes later. Fortunately, it was a Sunday, which turned out to be the only day the place was open to the public. According to my driver, it had only recently been re-opened. It seemed that several months earlier, a group of Buddhist monks forced their way inside and occupied the grounds, insisting it was a Buddhist site and should be used for religious purposes. The authorities finally forced them out, and they were now being very careful about letting anyone in who looked like a monk. As we entered the front gate, I put away my prayer beads, which I normally carried on my wrist. But it didn't really matter. The pagoda was another disappointing attempt at displaying the past. On either side of the courtyard, there were several dusty buildings with dusty glass cases full of dusty artifacts with little or no explanations. Five minutes after I walked inside the gate, I walked back out. I had seen enough. Besides, the sun was disappearing behind the Holan Mountains, and it was time to call it a day. I returned to my hotel, and after a bowl of noodles and a plate of mutton, I washed my clothes and went to bed early again. The end of another full day.

THE DESERT

After visiting the sights around Yinchuan, it was time to continue my journey upstream. I felt like a fish looking for a place to spawn. I could have taken the bus or even the train. But I wanted to stop along the way and decided to hire a car – the same car and the same driver as the previous day. From Yinchuan, we headed south on the highway that connected Beijing with Lhasa, which explained why the road was in such good condition. An hour later, we arrived in the town of Wuchung. Since about ninety percent of the city's population was made up of the Muslim Hui minority, my driver stopped long enough to introduce me to the local tea ceremony at a friend's house. Considering how dusty that part of China was, the house was immaculate with white-washed walls and simple wooden furniture. Our host brought us bowls filled with tea leaves, rock sugar, nuts, raisins, dates and a jam made from rose petals. To this was added boiling water and conversation about the land reform of 1981, when farmland was re-distributed among local residents. Our host's family had already accumulated several acres by reclaiming formerly undeveloped land.

It wasn't a long conversation. I had a long way to go to reach my next destination before sunset. After a few bowls

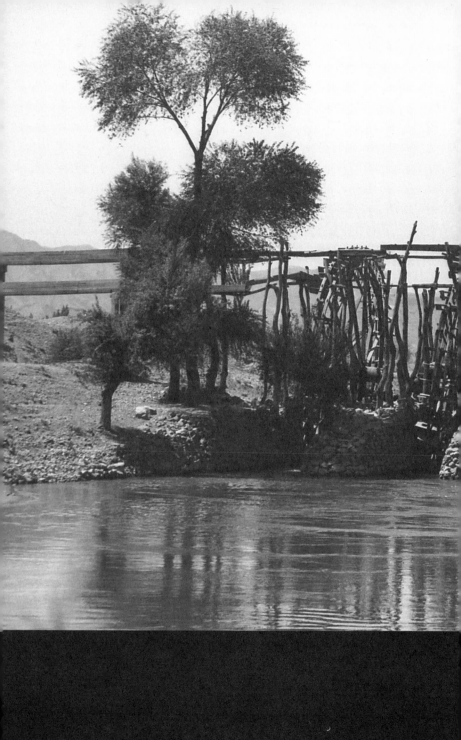

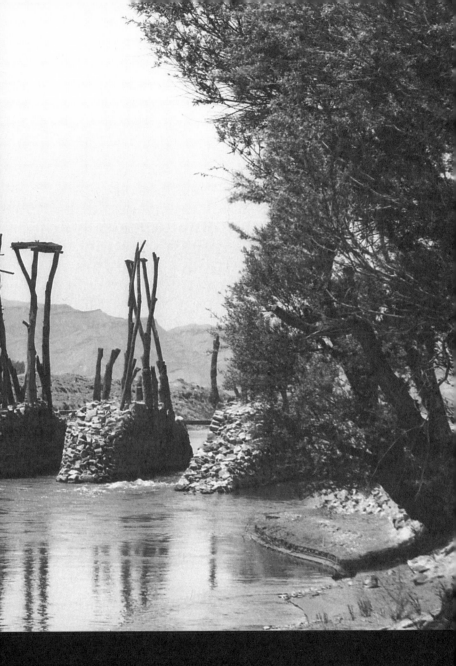

Water wheels on the Yellow River

of sweet tea, I thanked our hosts, and we continued heading south. After another thirty minutes, we arrived at Chingtung Dam. I was just in time for the twelve o'clock cruise upriver. While my driver waited by the dock, I boarded an open-air boat that had room for a dozen passengers, and off we went. Two kilometers south of the dam we passed 108 white stupas on the west bank of the river that were arranged on the hillside in the shape of a pyramid. The captain of the boat, who also served as the guide, said they were placed there 900 years ago to remind travelers of the 108 troubles that beset all creatures. A few minutes later, we entered the Chingtung Gorge, and the river narrowed to about 200 meters. In places where the gorge opened up, shepherds were tending herds of sheep. When I asked the captain how much farmers sold their sheep for, he said a sheep sold for about 100RMB, or twenty bucks, which included the skin, the meat and the organs.

An hour after leaving the dam, we finally left the gorge and entered an area where the river made a 180-degree bend. The captain stopped long enough on the west bank for passengers to get out and climb to the top of a series of huge sand dunes. The panorama was stunning. The Yellow River cut through a landscape of red mountains and yellow dunes, and inside the bend was a huge marshland where hundreds of thousands of migratory birds stopped every spring and fall. After our sand-dune interlude, we continued upriver alongside the marshland for another hour. But it was mid-May, and all we saw were a few late-arriving ducks. Finally, we turned around, and two hours later, arrived back at the dam. That was also where the Chinese constructed the first canal in the region 2,000 years ago, and the area remained a major center of rice production. After disembarking, I resumed my southward journey and along the way saw dozens of signs advertising rice for sale. My driver said the rice grown in

that region was called "pearl rice" and was among the finest in all of China.

After about an hour, we turned off on a dirt road and visited a Buddhist temple that had recently been dug out of the encroaching sand dunes. The dusty statues were first-rate, and the old monk in charge of the temple took great delight in showing me around. I lingered until I noticed the sun was beginning to dip behind the adjacent dunes. We drove back to the main road and continued south. Fifteen kilometers later, we stopped for an early dinner in the town of Chungwei. The area's pearl rice lived up to its reputation, but the beer failed miserably – which was to be expected in a Muslim area. After dinner, we continued south another fifteen kilometers to the sand dunes of Shapotou. There was still some light in the sky when I said goodbye to my driver and checked into the hostel that overlooked the place where the dunes slid down into the river. Once again, I spent the night listening to the Yellow River outside my window. And once again, I was the only guest.

Shapotou was barely inside the Ninghsia Autonomous Region. It was where the river opened up for the first time since coming down from its source in Chinghai Province. In the morning, I walked outside the hostel gate and down to the river and hired a camel. It was just like hiring a taxi outside the train station. I had to bargain for twenty minutes and still had to pay 10RMB per hour, twice the normal rate. I also had the option of paying 50RMB for the whole day. But I settled on a three-hour excursion.

Shapotou was surrounded by the sands of the Tenggiri Desert, which was the world's third-largest desert, after the Sahara and the Taklamakan, and it had become the scene of a concerted effort at land reclamation. I wanted to see how the effort was progressing, and the only way to do that was on a camel. My camel obliged by kneeling down so that I

could climb aboard, and off we went. While I rode, the camel driver held the reins, and the camel climbed the dunes that surrounded the hostel and then crossed the railroad tracks. It was the railroad that initiated land reclamation in that area in the first place. But I had to wonder why the sand hadn't simply swallowed the tracks.

Once across, we followed a fence to a gate. Outsiders weren't allowed inside areas where land was being reclaimed, but the gatekeeper knew the camel driver and agreed to make an exception. The land looked like a giant chessboard. The sand dunes in that area were covered by a grid of wheat straw. The straw held down the sand long enough for small plants to develop and retained sufficient water to keep them alive. The camel driver said eventually small shrubs and trees would be planted. It was very similar to what I saw earlier near Yulin. But this time, I continued beyond the wheat straw and entered the desert. It was a sea of sand, and the waves were huge. Some dunes were so steep, I couldn't ride straight uphill or downhill. It would have been too dangerous. I had to zig-zag instead along the ridges. After about an hour we stopped, and my camel driver pointed to the mountains twenty kilometers away. Inner Mongolia, he said, was on the other side. He said if I came back between July and October, he could take me there and show me the ruins of several ancient towns and temples. But it was May, and he said the nights were too cold to sleep out in the open.

After another hour among the dunes, we headed back to Shapotou, where I cooled my heels in the Yellow River mud and talked with several men who were inflating goat skins and lashing them to wooden frames to use as rafts. Sheepskins, they said, were useless. Goatskins were the only skins that held air long enough, and they had to be coated on their insides with sesame oil to keep them from cracking and to maintain their flexibility. Fifteen skins were lashed to

the bottom of each raft. I asked one of the men what they charged to take people downriver as far as Chungwei, where I had stopped for dinner the previous night. He said 60RMB, or twelve bucks. It wasn't cheap, but I liked the idea of being on the river again. I went back and checked out of the hostel, and ten minutes later I was running the rapids that marked the start of a three-hour trip downriver to Chungwei.

The rapids only lasted several hundred meters. After that, we glided the rest of the way on a river of glass. The only sound was that of the rocks at the bottom of the river knocking against each other in the current. After an hour, the man stopped to let me inspect several old water wheels. They were once used to raise water from the river to an aqueduct that then channeled the water into an irrigation system. The wheels and aqueduct were in shambles. Farmers used gas-operated pumps nowadays. We returned to the river, and all too soon, the voyage ended.

The boatman deflated the fifteen goatskins that kept the raft afloat, then lashed them together with the raft's wooden frame onto a bicycle that he also brought on board the raft. While he began pedaling back to Shapotou, I grabbed my pack and began walking into town. Chungwei was five kilometers, or an hour, away, and there was no public transportation into town from the river. By the time I got to the train station, I was already too late for the 2:40 express to Lanchou, which was my next destination, and the next train wasn't due until midnight.

I stashed my pack at the train station baggage-storage room and walked to Chungwei's principle attraction: Kaomiao Temple, which was only a few blocks away. The temple was first built in the early fifteenth century. It was definitely worth visiting, if only because of its unusual architecture. After paying the usual special admission price charged foreigners, I entered the courtyard and climbed one set of steps after

another, as I ascended through a series of buildings built one behind and above the other. It was like climbing a small hill. Kaomiao meant "high temple," and it certainly was that. In the final shrine hall, I had to climb through a trap door to reach the highest balcony, but the view was worth the effort. The soaring winged roofs of the other shrine halls rose from below like so many phoenixes taking off. It was an impressive sight and one that represented the most compact use of space I had ever seen at a Buddhist temple. In addition to its architectural features, Kaomiao also boasted some of the finest wall paintings, wood carvings and statues in the region. I still didn't understand why Yinchuan was so disappointing. Then it occurred to me. Yinchuan was the political and administrative center of the province, and why would people who work behind desks have been interested in preserving or restoring sites that had no political or administrative value. Later, back at the train station, I stretched out on a bunk in the baggage-storage room and waited for the midnight train to Lanchou, which was right on time. And once again I was able to upgrade my hard-seat ticket for a berth in the soft-sleeper section.

A goatskin raft on the Yellow River

AGFA APX 100 3 1 9 AGFA APX 100 AGFA APX 100 3 1 9

KANSU

The conductress woke me at five-thirty the next morning. She said we would be in Lanchou in thirty minutes. And we were. Lanchou was the capital of Kansu Province and was spread out along the Yellow River and hemmed in on both sides by mountains. It was a very narrow and a very long city. Outside the train station, I took a taxi to the west end of town and checked in at the Friendship Hotel. After I went up to my room and took an early morning cold shower, I came back downstairs and joined the other guests for breakfast. The hotel actually had coffee, and I needed some. Even though I slept on the train, I could have slept a lot longer and was still tired. After breakfast I relaxed in my room and waited for the Kansu Provincial Museum to open.

It was a huge colonnaded building and was right across the street from the hotel. At nine o'clock I walked through the front door just as they were opening it. It felt eerie walking through the halls. Other than the guards, I was the only person there. On the third floor, I paused to admire the world's largest mammoth skeleton. It was found along the Yellow River in 1973 not far from Lanchou. But I was more interested in the exhibits on the second floor, where the museum housed its prehistoric pottery.

The painted pottery of Kansu represented the earliest art unearthed to date anywhere in the Far East. The first pottery in China started showing up between 7,000 and 8,000 years ago. But it was monochrome utilitarian ware with little or no artistic embellishment. The pottery uncovered in Kansu was made about two thousand years later, between 5,000 and 6,000 years ago, and it represented China's earliest examples of graphic art. Most of the pots on display were huge and would have held several gallons of water, and their surface was covered with all sorts of patterns, many of them apparently developed by watching the current and whirlpools of the Yellow River.

Since the museum didn't see too many foreign visitors, one of the guards went to tell the museum's curator. Her name was Yen Kuei-ti, and she offered to show me around. Most of the pots, she said, were found in graves and were intended for use in the afterlife. One of the pots even contained charred buds of marijuana, which was used by Chinese shamans to communicate with the realm of spirits. The curator also showed me the small bronze knife found in the same ancient village. It was apparently used by village shamans in conducting sacrifices. With a carbon date of 5,000 years ago, it represented the earliest bronze artifact found to date in China. Apparently, the thieves thought it was someone's paring knife and left it behind. Did I say thieves? Well, I guess the cat is out of the bag. Yes, this was the scene of the big museum heist.

While the curator was showing me around, I noticed several dark sections on the floor, as if several cases had been removed, and I asked what happened. What happened was that one day around noon, when most of the museum staff were either eating lunch or napping, a van drove up to the museum entrance and a gang of men jumped out with shotguns. They didn't stay long, but they did stay long enough

to cart off a number of the museum's most valuable pieces, including a jade money tree. Strangely enough, the thieves also left behind some very famous pieces worth a lot more. In addition to its world-class collection of neolithic pottery, the museum also housed an excellent collection of bronzes, the most famous of which was the Han dynasty bronze horse unearthed in the Silk Road oasis of Wuwei, to which the artist added a wisp of cloud above the horse's head and placed one of its hooves on the back of a swallow to give it a feeling of movement. It was a lovely piece, and since its discovery, the Flying Horse, as it was now called, had become a national treasure and a symbol of the Silk Road. It was still there on display, and I hope it remains there for others to see.

I thanked the curator for showing me around and returned to my hotel room and made myself a cup of instant coffee. Usually I didn't have time for such an indulgence, but I wanted to look at a local map and consider my next move. Lanchou itself was also a Silk Road entrepot, but the main road didn't go through Lanchou in the past; it crossed the Yellow River a few hours to the west, and where it did, it left behind some of the best Buddhist art in China. On the map, the place was called the Pingling Caves, and I decided that was where I would go next. But when I went downstairs and asked the staff at the front desk about bus transportation to the caves, they said I couldn't go there unless I first arranged travel insurance. Yes, travel insurance. In Kansu Province, foreigners, they said, couldn't travel outside the city of Lanchou without it. The travel insurance was sold by China Travel Service, and fortunately they had an office in my hotel. It only cost 25RMB for a fifteen-day policy, and bus stations were not allowed to sell foreigners tickets without asking to see proof of insurance. Their argument for squeezing what amounted to five bucks from all foreigners was that several years earlier two Germans died

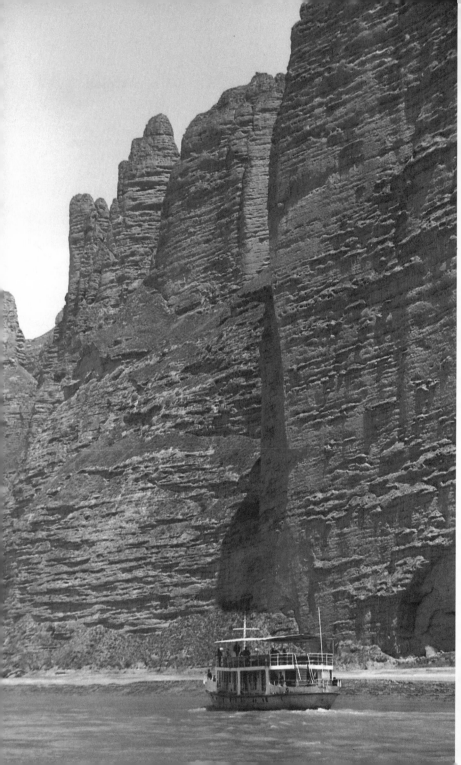

while traveling in the province, and the cost for repatriating their remains eventually had to be paid for by the provincial government. The insurance was to make sure they didn't have to pay for that again. And so I paid for the insurance. But when I asked about transportation to the caves, they told me there was only one bus a day, and it had already left. I suppose I could have spent the afternoon visiting some local sights, but since I was still feeling a bit tired from such a long trip, I did what I almost never do. I took the day off and spent most of it in my hotel room just reading and napping and washing my clothes.

The next morning I took a taxi to the city's West Bus Staton and boarded the daily seven o'clock bus to the Pingling Caves. I even managed to get a seat. The trip took two and a half hours and passed through hills noteworthy only for their barrenness. But the bus didn't go to the caves. It only went as far as the Liuchiahsia Dam. We had to get off and walk several hundred meters to a pier where boats left every half hour or so. The round-trip to the caves cost 25RMB and took five hours, and it was a good thing I didn't forget to bring some food, which I had bought the night before at the night market near the Friendship Hotel. Among the gauntlet of market stalls, I found one that sold potato-and-parsley-filled pastries, and they were delicious. Washed down by a couple bottles of suds, which they sold on the boat, it was the perfect Yellow River picnic food.

So there I was again, gliding along the Yellow River on a motorized launch with twenty other tourists. As was the case with the Sanmenhsia Reservoir, the river's water in the Liuchiahsia Reservoir was also clear. But after an hour and a half, just as our boat entered a gorge, the water suddenly

Sheer cliffs and rocky pinnacles near the Pingling Caves

turned brown again. The captain said the Pingling Caves were two bends up the gorge.

It was mid-May, which was low-water time on the river, and the final approach was a bit tricky. Despite traveling the same route every day, the captain misread the river, and we got stuck on one of the submerged sandbars that were constantly changing location. We had to wait there for thirty minutes until the next boat came along and finally pulled us free. As we continued into the gorge, we were surrounded on both sides by sheer cliffs and rocky pinnacles unlike any other landforms along the entire length of the river. It was an awesome sight. A few minutes later, we were there, at the caves. The caves, however, were not on the river. We had to disembark at an incredibly steep landing and walk several hundred meters into a side gorge.

This was the location of the Pingling Caves, one of China's major centers of ancient Buddhist art. And its fame was well deserved. The caves were carved out of the cliffs some 1,600 years ago and contained hundreds of the finest Buddhist statues and wall paintings to be found anywhere in China. The protective galleries in front of the caves ran for about 200 meters, but the main section was accessible only by a series of staircases, and admission cost an additional 150RMB, or thirty bucks, per person. Most visitors settled for the lower galleries and the view of the huge twenty-seven-meter-high statue of Maitreya, the buddha of the future.

Although it was well worth whatever effort it took to get there, passengers were supposed to return to their boat after one hour. The only alternative would have been to return on a later boat, which meant one had to spend the night near the dam. And on the way there, I didn't notice anything that looked like a hotel. An hour didn't leave much time, and I probably shouldn't have paid the extra charge to see the upper galleries, as I didn't have time to see them all. But it

was so impressive, especially the murals. I kept thinking about them on the boat ride back to the dam and on the bus ride back to Lanchou. But it was really too bad there wasn't a hotel or hostel of some kind at the dam.

The next morning I boarded another early morning bus, but this time from the city's south station. This time I was headed south instead of west. Once again, the only thing worth noting about the landscape was the barrenness. However, there was one long section where the road followed a high ridge that looked down on narrow green valleys. And we had to stop a number of times to let herds of goats and sheep cross the road. We finally stopped ourselves three hours after leaving Lanchou in the town of Linhsia. Linhsia was known as Little Mecca. Ninety percent of the people in the Linhsia area belonged to various Muslim ethnic groups that included the Hui, the Paoan, the Salar and the Tunghsiang. They all had stories to tell about how they ended up there, but the Tunghsiang story was especially enlightening.

As near as an analysis of the Tunghsiang language and oral traditions could determine, the Tunghsiang were once a branch of the Sogdians, and they lived in the region of Samarkand in what was now Uzbekistan, which was more than 3,000 kilometers west of Linhsia. At the beginning of the thirteenth century, the ancestors of the Tunghsiang became mercenaries in the army of Genghis Khan. They followed the Great Khan to Kansu, and it just so happened that Kansu was the scene of Genghis' final campaign.

Genghis died in 1227, just east of Lanchou, and it wasn't until three years later that the Mongols consolidated their forces again and resumed large-scale campaigns against the Chinese. In the meantime, the Tunghsiang members of his army took a liking to the Linhsia area. Linhsia, after all, had been visited by Muslim missionaries soon after the death of Mohammed, and the Islamic Tunghsiang felt at home there.

They have been there ever since. At last count there were 38,000 Tunghsiang living in the area, and over the centuries they had been joined by other Muslim groups, like the Salar, the Paoan and the Hui, all with their own stories and all of them tied to the Silk Road.

Linhsia was once a major entrepot on the Silk Road and much more important than Lanchou. In fact, it was a population center as early as 5,000 years ago. Linhsia was the area where much of the painted pottery in the Kansu Provincial Museum was unearthed. And until about a thousand years ago, Linhsia, and not Lanchou, was the major focus of Silk Road trade in that part of China. The old road, though, was now somewhere beneath the Liuchiahsia Reservoir. Now the main road went through Lanchou. In addition to the Muslim groups in the area, there were also Tibetans. And after taking an hour-long break for lunch at Linhsia, the bus I was on headed for the Tibetan center known as Labrang, another four hours to the south. The bus, in fact, was full of Tibetans on pilgrimage. They chanted and joked and maintained a general atmosphere of playfulness the whole way.

Just past Linhsia, the landscape of barren hills gave way to wheat fields and distant snowy peaks. But judging from the number of lumber yards along the way, those peaks were being heavily logged. If there was any reforestation going on, it wasn't evident on any of the hills we passed.

Two hours south of Linhsia, we turned off the main road and entered a long, winding valley. A family of Tibetans was sitting along a stream eating lunch. They were all wearing heavy woolen skirts, and the men were naked from the waist up, their long black hair hanging down to their shoulders. One glance and it was clear that Tibet might be part of China, but Tibetans were a different race of people from the Han Chinese.

Finally, after a long, long bus ride, we arrived in the town

of Hsiaho. This was where the Buddhist temple complex of Labrang was located. Labrang was one of the most important Tibetan Buddhist training centers outside Tibet, and the complex of buildings was huge, more like a town. But it was a one-street town. After checking into one of a half-dozen hostels that lined the street and dropping my bag in my room, I went back outside and walked along the road. There were dozens of shops selling anything a Tibetan pilgrim might want: a new saddle or boots, all sorts of knives, ritual ornaments and paraphernalia, jewelry and clothing. A number of antiques also changed hands, and one especially old and lovely Buddhist *tanka*, or religious painting, fell into mine.

After passing through the gauntlet of shops, I reached the temple complex to find a month-long prayer session in progress. The central courtyard was filled with thousands of Tibetans unable to get inside the shrine hall where several prominent lamas were chanting sutras. The lamas, though, were using microphones, and everyone was able to follow the chanting over loudspeakers. About half those listening were young novice monks, many of them still children, dressed in maroon robes. The Tibetan men were wearing sheepskin coats and hats, and the women were covered with turquoise, coral and silver jewelry. And everyone was fingering beads or prostrating themselves on the ground. As I walked through the crowd, I couldn't help but wonder about the hardships these people had faced to reach this spot and to maintain their faith in the face of four decades of religious oppression.

Labrang was seven hours by bus south of Lanchou, and most of the people who visited Labrang were Tibetan pilgrims. But Chinese and the occasional Western tourist also made the trek. To accommodate the different interests of visitors, the temple organized a public tour of six of Labrang's fifteen shrine halls. But when I went over to the building where the tour began, a monk inside said there was only

Pilgrims in Labrang

one tour a day, and it began at nine o'clock in the morning. I walked back to my hostel and had an early dinner and was there the next morning, with my flashlight.

During the Cultural Revolution, two-thirds of the buildings were destroyed, but those that managed to survive were treasure troves of Tibetan religious art. Again, I was glad to have my flashlight and binoculars, or I would have missed much of the intricate beauty of the incredible wall paintings. After the tour ended, I walked back through the shrine halls and looked once more at the murals. I didn't know anything about Tibetan Buddhism, but it certainly possessed a rich artistic heritage. There were so many deities and so many stories portrayed on the walls.

Afterwards, I walked back past the gauntlet of shops to my hotel and had lunch and considered my options. If I had felt more adventurous, I could have hired a horse, or even a bicycle, and gone riding into the nearby grasslands. But I contented myself with hiking to the top of a hill that overlooked Labrang. This was the hill where the lamas unrolled a painting of Shakyamuni Buddha as big as a basketball court. But they did that in summer, and it was only May.

Since it was still early afternoon, I lay down on the dry grass that was just beginning to turn green again and actually fell asleep. Another day with a nap in it. This was becoming more and more like a vacation. But the vacation came to an end the next day, as I endured another seven-hour bus ride back to Lanchou. Again, I was amazed at the barrenness of the landscape.

The next day, I decided to find out more about the environment I had been traveling through and visited China's Institute for Desert Research. It was located among the rambling buildings of the Academica Sinica, a few blocks east of the Lanchou Hotel. Normally, such organizations weren't open to the public, and visits by foreigners had to be cleared

with the local foreign-affairs authorities. But I had found that it didn't hurt to try the direct approach. I called the institute and was able to arrange a briefing by several of its researchers, of which there were amazingly 220. The desolation that I had seen the past few days, they said, was not a recent phenomenon. Changes in the climate since the last ice age coupled with the constant warfare waged over the past 5,000 years between the Chinese and the various nomadic groups in the region had resulted in extensive deforestation and loss of ground cover. Areas that were green as recently as several hundred years ago were now desert. And new deserts were growing not only in the northwest, but in every province in China. Sixteen percent of all the land in China was classified as desert. Imagine 1.5 million square kilometers of sand, and imagine it spreading at the rate of 1% per year and in some areas at the rate of 10% per year. Desertification, as it was called, was clearly one of China's biggest problems.

The researchers at the institute told me they not only studied the formation and control of deserts, they oversaw the administration of all desert areas, and they advised local governments on means of combating the formation of deserts. I could see that the authorities realized the seriousness of the problem, but considering the enormity of China's deserts, I had to wonder if they were not 5,000 years too late.

I thanked the researchers for taking the time to talk to me about their work and walked back outside. Although Lanchou had never been renowned for its beauty, and it was sliding fast toward the ugly end of the scale, there were two places I wanted to visit before I left, if only for some relief from all the talk about desertification. After returning to the train station to buy a ticket for the following day to my next destination, I decided to visit the city's two parks.

I began at the south edge of town at Five Springs Mountain Park, where General Huo Ch'u-ping led an army

of 200,000 soldiers in 121 BC on his way to rid China's western borders of Huns. But when he reached Lanchou, Huo discovered there wasn't any water for his troops. In anger, he drew his sword and struck the boulder next to where he was standing and said, "I refuse to believe there's no water here!" And as the gods would have it, water gushed forth from the crack his sword made in the boulder. Impressed with his good fortune, Huo struck four more boulders, and four more springs appeared. And his soldiers quenched their thirst and marched on and chased the Huns back to wherever they came from. Meanwhile, the five springs have continued to flow and currently supplied the water for Lanchou's Five Springs Beer.

After strolling around Five Springs Mountain Park and tapping the rocks in vain, I crossed the bridge that spanned the Yellow River and visited the city's other famous park. It was called White Pagóda Park and with good reason. It was laid out around a white pagoda that housed the remains of a Tibetan lama who died there in the thirteenth century. What made a visit to White Pagoda Park special wasn't the pagoda but the view from the hill on which it stood. The sun was going down, and I looked down across the tiled roofs of an ancient shrine and across the steel spans of the first bridge on the Yellow River and across the swirling brown ribbon of the river itself. All of Lanchou was spread out, as T.S. Eliot once put it, "like a patient etherized upon a table" and just waiting for the surgeon.

Lanchou was situated midway between where the upper reaches of the Yellow River began in Inner Mongolia and the river's source on the Tibetan Plateau. Even though the river's silt content wasn't that high as it passed through Lanchou, it certainly looked muddy, as it flowed through a city whose factories were strung out along both banks for twenty kilometers. In the heart of the old part of town, between Five

Springs Park and White Pagoda Park, was the bridge that connected the two halves. The present bridge stood where the city's old floating bridge once spanned the river. The floating bridge was the first bridge ever built across any part of the Yellow River. It was first constructed in 1385 and had been replaced many times. But for 500 years, it remained the Yellow River's only bridge, which was an amazing thought. Imagine a river 5,000 kilometers long with only one bridge. Until modern times, all other sections of the river had to be crossed by ferry or on a goatskin raft.

Nowadays, there were more than a dozen bridges across the Yellow River, and more were being planned. But Lanchou's was the first. Although, the floating bridge of 1385 was long gone, as were its successors, the present steel span was almost as ancient. It dated back to 1907, when it was built by a foreign consortium. But it was so poorly built, it had to be rebuilt before the thirty-year warranty period expired. I took a taxi back across to the south side and spent one last night at the Friendship Hotel. My clothes were washed and dry, and I was ready for the final stage of my journey to the river's source.

CHINGHAI

The next morning I boarded a train head-
ed west for Hsining, the capital of Chinghai
Province. Until as recently as several decades
ago, the only way to reach Hsining was by
foot or on horseback. By foot, the 220-kilo-
meter journey took eight days; by horseback
four days. Now it only took five hours by
train, and Chinghai's relative isolation would definitely end
once its new airport opened and daily flights from Lanchou
and Sian began. The train, though, was the way to go. It was
so relaxing watching the countryside roll by without hearing
the constant honking of horns or the near-death experiences
of bus travel.

It was still early afternoon when I arrived in Hsining.
After checking into the Hsining Guesthouse, I went for a
stroll and somehow managed to find the Chinghai Provin-
cial Museum. There wasn't any sign, and the street vendors
selling noodles on the same block had never heard of it. A
small plaque announced its presence: "The Chinghai Center
for Historical Research." The most interesting part of the
museum was the building. It was the former residence of
Ma Pu-fang, governor of the province fifty years ago when
the KMT still controlled most of China. The museum wasn't
open to the public, which was probably why no one knew

where it was. But when I walked through the front door, I was mistaken for an American historian whom they were expecting, and I was given the grand tour.

The collection was terribly displayed, with little thought given to the selection and layout of items, but several pieces caught my attention. The most noteworthy was a 5,000-year-old painted pot showing a group of sexually aroused males dancing around its rim. It was the only pot of its kind ever found in China, and it was considered a national treasure. The thought occurred to me that the pot was meant to be spun, to make its figures appear to dance. If so, it would have been the world's earliest erotic movie. When I suggested that to the museum staff, I think they began to suspect I was not the American historian they had been expecting. And so I moved on to the city's other sights.

In addition to its nonexistent museum, Hsining also boasted a nonexistent temple. It was called Pei-shan-ssu, or North Mountain Temple. I could see its remains from the window of my hotel room, and I scanned its empty caves with my binoculars. It was one of the earliest known Buddhist centers in China, dating back 2,000 years to the first arrival of Buddhism in China. But it had been so completely destroyed during the Cultural Revolution, I stayed in my room and emptied a couple of beers and gazed at the mountain where its nonexistent shrine halls were once located instead.

Until the middle of the last century, Chinghai was part of Tibet, and signs of Tibetan culture were everywhere. In fact, one of the six most important monasteries of Tibetan Buddhism was less than thirty kilometers south of the city. It was called Ta-er-ssu. And that was where I headed the next morning. The reason for its prominence was because it was the birthplace of the founder of the Yellow Sect of Tibetan Buddhism, of which the Dalai Lama and the Panchen Lama were its current religious leaders. The founder's name was

Tsungkapa, and he lived there 600 years ago. From Hsining, I took a local bus to the town of Huangchung. And a horse cart took me the last kilometer or so for five mao, or ten cents.

Like Labrang, the temple was a complex of shrine halls. Altogether there were ten of them, and each had its own distinctive features. The price of admission allowed visitors into seven of the ten halls. Once again, I was glad I didn't forget my binoculars or my flashlight. The shrine halls of Taerssu contained what were easily the finest Tantric Buddhist murals outside Tibet, even better than the paintings of Labrang or Wutangchao.

Starting from the entrance, the first hall was built around a pagoda covered with 140 million RMB, or $30 million, worth of gold leaf. It was impressive, but the fourth hall contained the temple's greatest artistic treasures. The murals were breathtaking. Like most of the murals at Taerssu, they were first painted on cloth and then glued to the walls and finally covered with a protective lacquer. And the only light, other than that of my flashlight, was the light from butter lamps, which were used in place of candles or kerosene lamps because they didn't give off smoke. The smell, though, took some getting used to, and I watched one woman run out of the main shrine hall looking for a place to vomit.

Among the ten shrine halls at Taerssu, the one that always amazed visitors was hall number six. Inside was a huge relief carved out of colored butter portraying the founding and development of the Yellow Sect of Tibetan Buddhism. When I visited, it was housed inside a glass case and refrigerated. According to the temple guide, it was cooled with blocks of ice in the past. Every January, the monks melted it all down for use in butter lamps and spent a month carving a new relief.

Taerssu attracted tourists, but the tourists were easily outnumbered by the pilgrims, who came by the hundreds.

One Tibetan woman who spoke some Chinese told me she had walked to Taerssu from Labrang, a distance of more than 200 kilometers. Along the way, she did 40,000 prostrations, and at Taerszu she planned to do another 50,000. In addition to doing prostrations, pilgrims walked in a clockwise direction around the various shrine halls and stupas. And everyone turned prayer wheels and fingered prayer beads.

After paying my respects to Tsungkapa, I walked back outside the main gate. The street in front of the temple sold pretty much the same line of Tibetan religious paraphernalia as the gauntlet of shops at Labrang, with antique jewelry and the flashy knives made by the Paoan minority among the biggest sellers. Since I didn't think I would need a knife, I took a pony cart back to Huangchung and the next bus back to Hsining. It was still early afternoon, and I had already checked out and left my bag in the hotel storage room, and I was just in time for the last bus to the Lungyanghsia Dam.

In tracing the Yellow River, I had already visited two major dams, including the first dam ever built on the river at Sanmenhsia and another one just south of Yinchuan. But their importance paled compared to the dam that was still under construction at Lungyanghsia. It was southwest of Hsining and didn't look that far on the map, but it took the bus nearly two hours to get there. By the time I arrived, it was late afternoon and too late to visit the dam. But I managed to find a room for the night at the Water & Power Reception Center. It wasn't like spending the night next to the river at the Tayu Ferry or at Shapotou, but it was quiet. I was the only guest.

The next morning I walked across the street to the agency that issued visitor passes. The first tour began around 9:30 with a walk-through of the dam's interior. Although the project to build Lungyanghsia Dam was planned as early as 1955, the final phase of construction didn't get under way

until 1983, and it wasn't completed until 1987. Following completion, the downstream flow of the Yellow River was brought to a complete standstill for two months in order to fill the reservoir to a level sufficient to begin power generation. I wondered what the ecological repercussions were for stopping the flow of water, but my guide suggested there were more important problems.

The dam, it turned out, was an engineering disaster. Apparently, the geological data upon which the dam's initial construction was based was in error regarding the complexity and stability of the lower strata of rock. The dam was now being reconstructed: a new dam was being built on top of the old dam. Still, its potential for disaster was causing considerable concern in Beijing. My guide said that during a recent series of earthquakes, Premier Li P'eng called authorities at the dam on a daily basis for several months to keep abreast of the situation. Government officials, according to my guide, estimated that the collapse of Lungyanghsia Dam would lead to the collapse of all other dams on the Yellow River and the destruction of one-fourth of all industry in China. That sounded like an extreme assessment, but at least it was one that remained an assessment.

After touring the dam's interior, I joined several other visitors in a shuttle van that took us to where we could catch a bus back to Hsining. It was still early afternoon by the time we arrived back in the capital, but it gave me time to arrange the next and most difficult part of my journey. Travel beyond Hsining was limited to once-a-day highway buses on the province's two paved roads. Anything else required travellers to arrange their own transportation or to hitchhike. Considering the desolation of the landscape and thinking I had probably exhausted my store of good fortune, I decided I would hire a jeep and a Tibetan interpreter. There were several travel agencies in Hsining that provided such services.

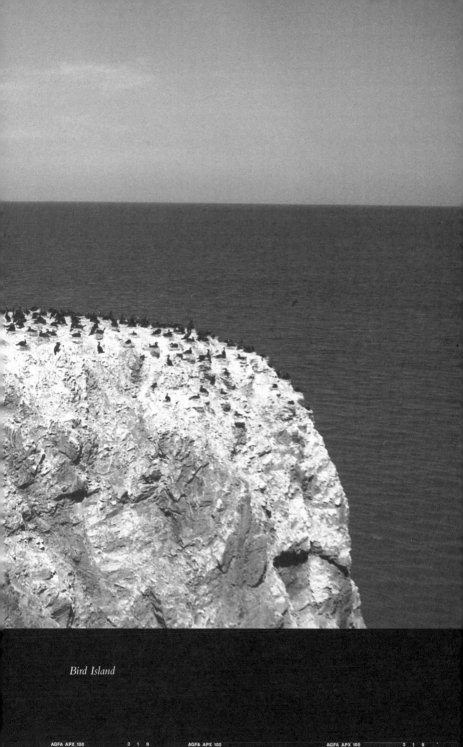

Bird Island

But I found the prices of China Youth Travel rock bottom. I was able to hire a Beijing Jeep and a driver for 1RMB per kilometer. The charge for the Tibetan interpreter was 50RMB per day. In addition, the cost for all food and lodging for the three of us was my responsibility – not that there were going to be much in the way of hotels along the way.

The next morning, my driver and interpreter picked me up at my hotel. But before we left Hsining, we stopped at a dry goods store and among other things bought ten day's worth of canned meat and hard bread and candles. Then off we went to find the source of the Yellow River. Neither my driver nor my interpreter had been within 200 kilometers of the source, and none of us bothered to bring a map. I figured we would just pick up the river outside the town of Mato and follow it west, and apparently that was what my driver planned to do as well.

But Mato was still a long way off, and there were a few sights I wanted to see first. From Hsining, we followed the Huangshui River west until it disappeared and we began climbing Sun-Moon Mountain. Two hours after leaving Hsining, we reached the crest and stopped at Sun-Moon Pavilion. The pavilion was actually two pavilions: one for the sun and one for the moon, and they were both on separate hills on different sides of the road. In ancient times, the Chinese thought that when the sun and moon set behind this ridge, this was where they rested. In ancient times, this also marked the western edge of the Chinese Empire, and to go beyond this point was to leave the land of people and to enter the realm of spirits. For only spirits could live, the Chinese thought, in the seemingly barren wasteland that stretched westward as far as the eye could see.

One person who decided to see if this really was where the land of people ended was King Mu. In 998 BC, the ruler of China's Chou dynasty ended that misconception when he

passed there on his way to the highest peak of the Kunlun Mountains on the modern border of Pakistan. The record of his trip was uncovered in a Han dynasty grave and still gives historians pause upon considering how he managed to make such a trip – with an army of 50,000 soldiers. In the T'ang dynasty, Princess Wen-cheng also paused here. She was the daughter of Emperor T'ai-tsung, and she was on her way to Lhasa to wed the King of Tibet. Before she left the capital of Ch'ang-an, her father gave her a magic mirror. He told her that whenever she wanted to see her home and loved ones, she need only uncover the mirror. But when she stopped on the crest of Sun-Moon Mountain and realized she had reached the limit of the Chinese Empire, she threw away the mirror to steel her resolve.

When I visited the place where King Mu and Princess Wen-cheng paused before continuing their journeys, it was mid-May, and there was still no sign of grass. A cold wind whipped down the snow-covered peaks of Sun-Moon Mountain, and I zipped up my jacket until the zippers reached the tangle of my beard and would go no further. A sign at Sun-Moon Pavilion noted the elevation was 3,520 meters, or just under 11,000 feet. I took a swig of what had to be the last bottle of scotch west of Sun-Moon Mountain and headed down into the vast brown grasslands below.

A few kilometers later, we passed through the truck-stop village of Taotangho. "*Taotangho*" means "backwards-flowing river." In China, nearly all rivers flowed eastward. To explain this, the ancient Chinese claimed that during a battle between mythical heroes, some of the pillars that held up the world were knocked down, and this resulted in rivers flowing eastward. The Taotangho, small though it may have been, was a rare exception. It flowed westward into Chinghai Lake.

The road also forked at Taotangho: south to Mato and the source of the Yellow River or west to Chinghai Lake,

Golmud and eventually Lhasa. I wanted to see the lake before heading south, so we continued along the Backwards-Flowing-River until it veered north and disappeared into the distance. The road was paved and straight as an arrow. It was like driving in the Australian Outback or the American Southwest. But there were fewer vehicles. In fact there were more herders than vehicles, and several times we had to stop to let their sheep or yaks cross the road. The grasslands were still a month away from turning green, and they were looking for whatever they had missed the previous summer.

Three hours after leaving Hsining, we finally saw the endless mirage of Chinghai Lake. My interpreter pointed to a side road that led to a place called Hsiaopeihu thirty kilometers to the north. Foreigners, he said, liked to go to Hsiaopeihu to roll nude down the sand dunes into the lake. Even girls from Hong Kong and Taiwan, he said, had been known to fall under the spell of the dunes. But it was only mid-May, and I wasn't about to take off my jacket, much less my pants, even if I did have half a bottle of whiskey left.

The road continued west, along the south shore of Chinghai Lake, and we continued with it. Two million years ago, most of Chinghai Province was submerged beneath a huge sea. As the Asian landmass rose out of the sea, mountains were formed, and their waters drained east into the Yellow River. Then, about 130,000 years ago, Sun-Moon Mountain rose to block the drainage in that area, and a huge lake was formed. Since it was formed on the bed of an ancient sea, it became a salt lake, and it still had a salinity ratio of six percent.

After following the lake's southern shoreline for two hours, at the village of Heimaho near its western end, we turned north on a dirt road. An hour later, we reached a hostel that had been built there four years earlier for tourists. Except for the handful of people who worked there, it was deserted. The man at the front desk said we were the

only visitors in over a week. It wasn't expensive: rooms were 50RMB, or ten dollars, a night. Naturally, a hot bath was out of the question. They weren't about to turn on the hot water for three people. But at least it was clean.

After checking in and dropping our bags in our rooms, we continued on to Bird Island another thirty minutes of bad road to the north. We parked our jeep at the fence that was erected to protect the nesting birds from foxes and other unwanted intruders. From the parking lot, we walked along a sandbar to Bird Island. Ten years earlier, the island could only be reached by boat. But due to increasing aridity and decreasing snowmelt, Chinghai Lake was shrinking. Still, it had an average depth of twenty meters.

At the end of the sandbar was a headland, and beyond that was a huge limestone rock covered by hundreds of nesting cormorants. It was mid-May, and the nesting season wasn't quite over. Looking down the coastline to the west, I could see horses running wild along the shore. We walked back to the fence, then headed out to an enclosure, where we met a wildlife official who was in charge of the place. He led us inside. Just beyond the enclosure's windows, thousands of gulls and bar-headed geese were nesting along a shoreline covered by several acres of down. Down was everywhere, including in our noses.

According to the wildlife official, as a result of the increasing numbers of intruders – both foxes and tourists – the nesting population of cormorants, gulls and bar-headed geese had dropped from 100,000 to less than 20,000. Many of the birds that used to come there now nested on small, more remote islands in the middle of the lake. Even though the nesting population on Bird Island had dwindled, it was still an impressive sight, with hundreds of birds constantly flying off and coming back again with food for their nesting mates and young chicks.

Although the nesting area was used by several species of birds, including gulls, terns and snipes, bar-headed geese took it upon themselves to form a circle around the entire area and to act as the guardians of the whole community. By stretching their long periscope-like necks, they had a full view of the surrounding shoreline, and woe be the fox or human who ventured too close. According to the wildlife official, the sentries were males who had lost their mates.

The official said the most dangerous predator for the nesting community were the black eagles, and he said he had seen mid-air dogfights in the area lasting several hours in which gulls and geese joined forces to drive the bigger birds away. The official also explained why migratory birds chose that area to nest in the first place. First, underground hotsprings kept the ground on the island warm even during winter. Second, the surrounding lake and a nearby freshwater stream were rich in plankton and fish, including the lake's most unusual fish: *huang-yu*, or scaleless carp.

After visiting the community of nesting birds that formed there every spring, we returned to our hostel for a dinner of the very fish the wildlife official had mentioned: *huangyu*. The chef deep fried the fish and then served it in a sweet-sour sauce. A more delicious fish I could not remember eating. In late March, hundreds of thousands of these fish swam up the rivers that drained into Chinghai Lake to spawn and die. The spawning climax occurred in May and June near Bird Island in the estuary of the Puha River, which was one of the reasons birds nested there in the first place.

According to scientists, the ancestral home of the scaleless carp was the Yellow River. The ever increasing elevation of the Chinghai-Tibet Plateau forced these fish to make gradual adaptations to higher altitudes, stronger radiation and lower water temperature, and eventually they lost their scales. The Tibetans who lived in that area regarded the fish as the

spirits of the lake and refused to catch or eat them. But since Liberation, the Chinese had begun harvesting 50,000 tons of the fish per year. Outside our hostel, the hotel manager showed us a huge truck onto which was loaded a special container supplied by the United Nations for holding the lake's scaleless carp, which were then shipped to scientists around the world.

After dinner, I walked past a small Tibetan village and climbed a small hill behind the hostel. From the top of a hill, I watched the sunset turn the lake red and gold and finally purple. Walking back downhill, I had to be careful not to stumble in the gopher holes that covered the slope. Fortunately, the stars were as bright as street lights.

The next morning, we left Bird Island and headed back to the main highway. Along the way, we stopped to talk with a truckload of Tibetans who had come to the lake on pilgrimage. They planned to throw Buddhist scriptures tied to stones into the lake. They said the scriptures were for the dragons that lived there. Suddenly I didn't feel so good about my dinner the night before. We said goodbye and continued on and rejoined the highway at Heimahe. Instead of heading east, back toward Taotangho and the road that led to Mato and the source of the Yellow River, I told the driver I wanted to head west to the town of Chaka. Less than two hours later, we were there. "Cha-ka" was Mongolian for "salt source." The Tibetan-Chinghai Plateau was dotted with hundreds of salt lakes, and Chaka was one of the largest.

Just south of town, we entered the main gate of the state-run salt processing center. After making arrangements with officials, I boarded a miniature train for a tour of the lake, while my driver and guide stayed with the jeep. The charge was only 25RMB, or $5, and I offered to pay their fare as well. But they weren't interested. From the main gate, the train chugged along for about thirty minutes and then

Chaka Lake and salt processing equipment

turned off toward a section of the lake that was being excavated by machinery.

The salt that covered the lake's surface was four meters thick. Beneath the salt, there was another fifteen meters of water. According to my guide, once the salt was removed, it took about two years for new salt to form from the water below. The raw salt, meanwhile, was transported to the nearby processing center, where it was washed, ionized and dried. Once it was dry, the salt was then sent to cities throughout China for use in food preparation. Other lakes in the province produced salt for industrial use, but Chaka produced salt exclusively for humans. My guide said the emperors of the Ch'ing dynasty insisted on it. I tasted some: it tasted like...salt.

Chaka is one of the province's biggest salt lakes. It is twenty kilometers long and ten kilometers wide, and it had been a source of edible salt in China for at least three hundred years. At the time of my visit, more than a hundred workers recovered up to 200 tons of salt per day from the lake between April and September. Between October and March, the weather was too windy and too cold for outside work, and production came to a standstill.

When I visited in May, the lake was a beautiful white, and the sky was perfectly blue, and filling the holes where salt had been removed, the lake water was emerald green. After a two-hour tour of the lake and its production facilities, I returned to the jeep and told my driver and interpreter that I had seen enough. It was time to head for the source of the Yellow River.

THE SOURCE

From Chaka we headed east, back the way we had come. But instead of returning all the way to Taotangho and the highway that led to Mato, my driver decided to try a shortcut he had heard about from the manager of the hostel where we had stayed the night before.

Neither my driver nor my interpreter had been on the shortcut before, but they liked the idea of a shortcut. So did I. But it was not a good idea. We bumped along on a dirt road that at times simply disappeared, and every half-hour or so we had to stop to ask directions from the occasional herder. For five hours we headed east. Then we turned south only to find ourselves hopelessly lost in a rocky valley that seemed to go on forever.

Then, in the middle of nowhere, we spotted a temple. There was no road to the temple, so my interpreter and I got out and walked there. It looked closer than it was and took us about thirty minutes. I suppose that was because there was nothing else to compare it to, other than the deforested hillside on which it was built. But finally we reached the temple, and at least the lamas inside were friendly. And they understood where we wanted to go. They pointed us toward a side valley. There was no road, just a grassy slope, but they

insisted that was the way. So we walked back to our jeep, and into the side valley we drove. And up we went, and down we went, and across we went, over endless meadows, following a trail meant for horses. Eventually it turned dark. And still we continued on. The jeep's headlights only illuminated what was directly in front of the jeep, and if there had been a turnoff somewhere, we wouldn't have known it. But finally, at eight o'clock, we saw lights in the distance and drove toward them. An hour later we reached the highway and the truckstop village of Hoka. Altogether, we spent nine hours on that shortcut. And the thought of being lost in a desolate landscape of *gobi* desert and dry grasslands had exhausted us. We were hungry too. But mainly we were thankful. And dining by candlelight on hot noodles and mutton and sleeping in a mud hut on boards in the truckstop village of Hoka seemed simply wonderful.

The next morning was the twenty-third of May, the anniversary of the liberation of the Tibetan masses from feudalism and religious oppression. Happy Liberation! It had snowed during the night, and the landscape was blanketed in white. But at least we were on a highway, and there wasn't more than an inch or two of snow on the road. As we continued south, we crossed several passes and paused for lunch at the village of Wenchuan, which was named after the local hot spring. After more bowls of hot noodles and another plate of mutton, we walked down to the stream, and I washed my hair and soaked my feet in the hot water. It would be my last bath, hot or otherwise, for the next five days.

As we continued heading south, the landscape became even more dramatic. Finally, at the village of Huashihhsia, it became magnificent. The road followed a river through a gap in the Ahnimaching Mountains. The beauty of their snow-covered, serrated ridges surrounded by vast meadows and no sign of humans was too much to comprehend. How

could there be a place like that in China, the land of a billion black-haired people?

At Huashihhsia the road divided. The road to the left led to Ahnimaching. Among the twenty-one mountains sacred to the Tibetan people, Ahnimaching's 6,000-meter peak was ranked number four. As such, it was the frequent scene of sky burials, and it had only recently been opened to outsiders. But my time was limited, and I had to pass it by. We continued south and shortly before sunset arrived at Mato.

Truckstop villages notwithstanding, Mato was the only town in that part of China. And we arrived there just ahead of a snowstorm. Before finding a place to spend the night, we parked our jeep in front of the local police station and went inside to register. It didn't take long to learn that the travel service through which I had hired the jeep and interpreter had neglected to arrange a permit for us to enter the wilderness between Mato and the source of the Yellow River. Incredible, but true.

While I sat there in the police station wondering what to do, I recalled stories I had heard from other foreigners who had arranged to visit restricted areas in China that required a permit through travel agencies only to discover that the agencies had forgotten about the permit or, in some cases, the permit turned out to be forged. My heart sank, while snowflakes swirled outside, and the conversation between the police and my interpreter switched from Chinese to Tibetan. It was just as well. I didn't want to hear it. Then my interpreter left and came back with another official. Suddenly the snow stopped, the sky cleared just as the sun was setting, and my interpreter said it was all arranged. One of his uncles, it turned out, was the county magistrate. The gods had smiled. And I smiled back. We all gathered around the police station's faded map to plot our route. Mato would be the last sign of civilization we would be seeing until we returned.

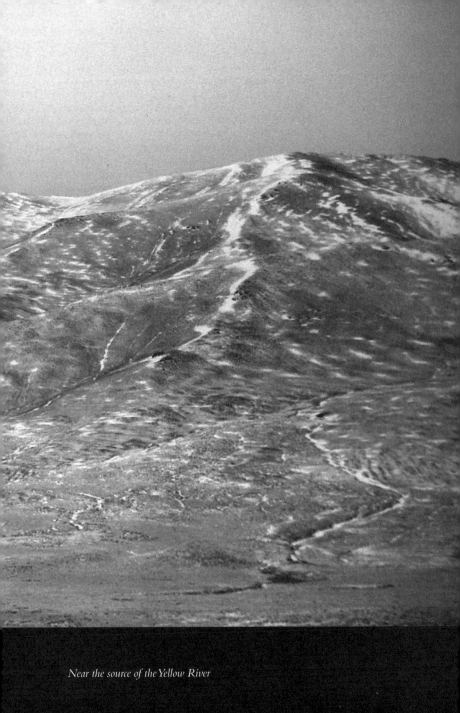

Near the source of the Yellow River

Afterwards, we dropped our bags across the street at the Cadre Reception Center, and while the staff stoked the pot-bellied stoves in our rooms, we walked over to the county magistrate's house for dinner, where we drank medicinal wine. The next morning I discovered what it meant to have a hangover at 4,000 meters. A girl came in to start a fire in the coal stove that sat in the middle of my room. Mercifully, she brought me some hot water, and I made three cups of instant coffee and swallowed four aspirins. They didn't help. I would just have to try to make it to the end of the day.

Outside, it was snowing again, and I thought we would have to wait until the weather lifted before heading off, which was a happy thought. I just wanted to stay in bed. But I was wrong. My Tibetan interpreter bounded in and said it was time to go. I tried to speak, but my voice was gone. I pointed at the snow falling outside, thinking he either hadn't noticed or hadn't been outside. But he had been outside, and both he and the driver were ready to go. I had no choice. After all, it was my trip.

We all gathered our gear and threw it in the jeep, along with ourselves, and headed out of town. After less than a hundred meters, the paved road ended, and we were on our own. There weren't any tracks in the snow, and the dirt road came and went. We had to stop every few minutes to scout ahead to see if we were, in fact, still on the road. We still didn't have a map, but I don't think it would have mattered. It was all snow. After bumping along for more than an hour, we finally joined the Yellow River and began following it upstream. Shortly afterwards, we passed a set of tire tracks on the left. They led across the river to a small fish-processing center. I was just beginning to wonder what a fish-processing center was doing out there in the middle of nowhere, when suddenly the expanse of Njarling Lake came into view and filled the whole horizon. What the Tibetans called Njarling Lake, the

Chinese called Ehling Lake. Along with its sister lake, Cha-ling ten kilometers to the west, Ehling was the highest lake in China. The elevation was 4,300 meters, or 14,000 feet.

Ehling was the larger of the two, covering an area of 600 square kilometers, fifty square kilometers more than Chaling. Both lakes were fed by the source of the Yellow River and had an average depth of fifteen meters. They were also home to a number of alpine fishes peculiar to that region. Due to the elevation, the fish grew at a very slow rate, taking ten years before they weighed half a kilo. As a result, the fish-processing center we passed near the eastern edge of Ehling Lake was not kept very busy.

After reaching Ehling, we followed the road along the lake's northern shore and then left the lake and headed into the rolling hills again. Somewhere to the south, on the west-ern shore of Ehling Lake was a hill. In the seventh century, the King of Tibet met his Chinese princess there, then es-corted her to Tibet. I met Princess Wen-cheng earlier, where she broke her magic mirror and never looked back, and wished I knew more about her. She was credited with intro-ducing Buddhism to the Tibetans. At least that was the story everyone tells. In any case, she must have been an incredibly determined person to have traveled across such a landscape by horseback, rather than by jeep.

At least she would have had a guide. We were traveling blind and had to stop whenever we saw herders to ask if we were still on the right road. There were no signs, only a trail of tire ruts with other ruts branching off here and there in other directions. Following the wrong set of ruts could have meant the end of my attempt to find the source of the Yel-low River. One herder we stopped to ask had a young lamb under his sheepskin coat. He said the lamb fell into a stream and would have died if he hadn't kept it warm. We waved and continued on, hopefully embraced by the gods.

An hour after passing Ehling Lake, the dirt road took us along Chaling Lake, the second of the two lakes fed by the source of the Yellow River. We stopped for lunch along the lakeshore: canned meat on fried bread. A lone eagle settled close by to watch us. Along the lakeshore rust-colored fire ducks foraged for food, and a nearby island was covered with thousands of nesting gulls and bar-headed geese. Apparently foxes couldn't swim that far. We continued on, following a set of tire tracks that finally veered away from the lake. About an hour later, we came to a fork in the road. Ever since we left the provincial capital of Hsining, we had passed hundreds of tractors pulling wagons piled with all sorts of gear heading in the same direction. According to one of the herders we stopped to ask directions from, they were all headed for that fork in the road in the middle of the Chinghai Plateau. The road to the right led to the biggest gold strike in China. Gold had been discovered several years earlier about ten kilometers to the north. Since then, a town of 20,000 miners had grown up in the middle of one of China's greatest wilderness areas. The only thing preventing the town from growing even larger was the effort by police to stop tractors from outside the province. According to our guide, the whole project was being financed by a single wealthy individual in Hsining, who obviously was going to be a whole lot wealthier.

We took the fork on the left, and after another twenty minutes, we passed a group of tents. Unlike the felt tents of Tibetan herders, these were made of canvas. Later, we learned they belonged to a team of geologists who were prospecting for minerals and oil in the wilderness area. We learned that the geologists were not only prospecting in a protected area, they were also killing endangered species for food and skins.

Just past their camp, the road led down across a vast plain dotted with hundreds, if not thousands, of ponds. This was the Sea of Stars. In the Yuan dynasty, the Mongol court

sent an official to find the source of the Yellow River. The year was 1280, and this was as far as he got. I wasn't surprised. We crossed the pond-dotted sea in late May, when the ground was still frozen. By late-June, the plain was said to turn into a veritable bog, and neither jeeps nor horses could make it across until the ground froze again in October.

As we headed across the Sea of Stars, we entered one of the wildest places left in China. First a marten, then a red fox darted ahead of us and disappeared into their burrows. Less than a hundred meters from our jeep, four wolves stared at us as we passed by. Pairs of Tibetan gazelles stopped grazing to make sure we weren't headed their way. But the most amazing sight of all was a herd of wild asses. For some reason, as soon as they saw us coming, they tried to cross the road in front of us, and for several minutes they ran alongside our jeep, not more than thirty meters away, but unable to run faster than the jeep. It was a beautiful sight: their tan and white flanks heaving for air, and their hundreds of hooves flashing across the dry grass and sending plumes of powdery snow into the air. Finally, they realized their folly and veered away from the jeep and disappeared into the distance. I thought we must be in Africa, not China.

The wild asses had apparently evolved from asses brought there by Middle Eastern merchants who traveled the southern branch of the Silk Road a thousand or more years ago. About halfway across the Sea of Stars, we forded a stream about five or six meters across. It was the Machu River, which was the main tributary from the source of the Yellow River. The Machu emptied into Chaling Lake, which emptied into Erling Lake, which was where the Yellow River officially began. My driver stopped to check the river's depth. It was only knee deep, and we drove across. Thirty minutes later, we arrived at the village of Mato.

The village of Mato was not the same as the town of

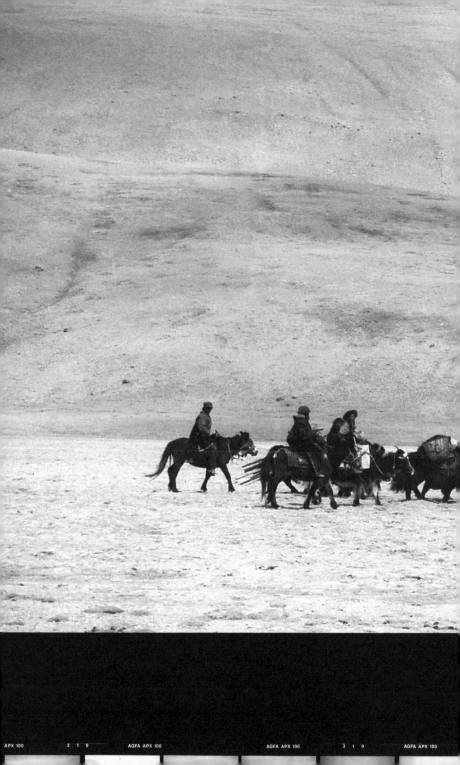

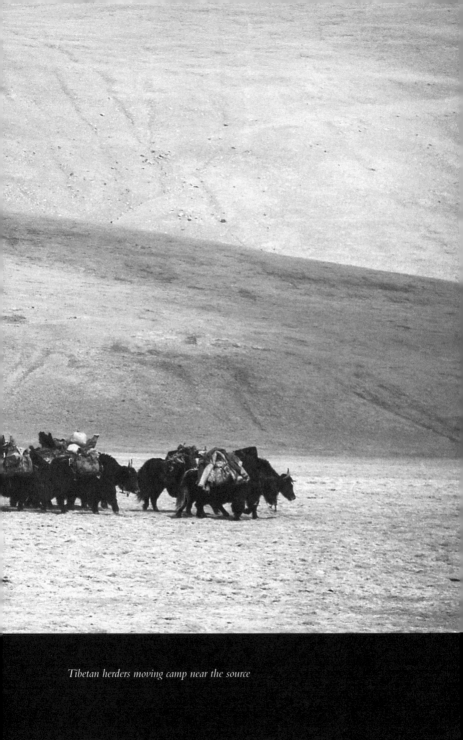

Tibetan herders moving camp near the source

Mato. The town, which was where we left the highway, was the county seat of Mato County. The village was in neighboring Chumalai County. In any case, the Chinese characters for both Matos were different. It was only me who was confused at first by the names. And certainly, the places were a world apart. The town had dozens of stores and even a movie theater. The village had a generator that was cranked up every Sunday to power a TV and a VCR, gifts of the provincial government. The village was actually a trading post, and Sunday was the day most herders brought in a few sheepskins to trade for a bolt of dyed cloth or a new cooking pot or a pair of sunglasses. The trading post was 225 kilometers from the nearest paved road, which was the one we left earlier that day, and about 500 kilometers from the nearest hot shower, which was hopefully waiting for me in Hsining. As far as supplies went, a truck from the county seat of Chumalai visited Mato once a week and sometimes twice a week in summer.

We stopped just past Mato's three stores at a small brick building. Inside, we met the one and only official in charge of overseeing the entire area around the source of the Yellow River, an area of about 5,000 square kilometers. The official's name was Ni-ma Tsai-jen. He was Tibetan. When I told him I was hoping to reach the source of the Yellow River, he smiled. Then he laughed. He couldn't contain his mirth. He said only a handful of Chinese and a camera crew from Japan's NHK had succeeded in reaching it. Of more than a dozen Westerners who had visited the area, none had made it to the source. I was surprised, but I told him I still planned to try. When he realized he couldn't dissuade me, he asked two of his assistants to accompany us as guides. Neither of them had been to the source either, but he thought they might be of some help, or at least make sure we came back alive.

When I asked him how the Chinese had determined the source, he said it was based on the length and water flow

of the various tributaries and the size of their watersheds. For the past few decades, three places had been competing for the title. But recently, a team sent to film a TV documentary for the provincial TV station had settled on the Yuekutsunglie Tributary.

While I talked with Ni-ma Tsai-jen, his assistants cleaned out a room that consisted of a six-meter-long sleeping platform. As soon as the coal dust settled, we unloaded our gear, and while my driver and Tibetan interpreter worked on the jeep, I went for a stroll. Just outside the village wall was a trash heap, and right on top was a book. I was surprised that it hadn't been used to light fires. But perhaps the person who threw it there was making a statement. The book was *The Selected Speeches of Chairman Mao.*

We were less than fifty kilometers from the source of the Yellow River, but the sun was fading on our efforts that day. After another dinner of hot noodles and mutton, courtesy of Ni-ma Tsai-jen, we settled in for the night. It was a long night. The village's elevation was slightly over 4,400 meters, and the air was so thin, several times during the night I woke up suffocating from lack of air. It was like sleeping under water. My sides ached for weeks afterwards. I wasn't alone. My driver and interpreter were having the same difficulties. Shortly before dawn, we finally gave up, loaded our gear into the jeep and took off. We all squeezed into the front seat, while our two Tibetan guides supplied by Ni-ma Tsai-jen sat in back. Neither of them had been to the source of the Yellow River either, but they had a rough idea of the general direction, which was more than us.

From Mato, we headed southwest on the road that led toward the county seat of Chumalai, which was about 100 kilometers away. After about ten kilometers, we turned off onto another dirt track. It had been snowing off and on for several days, and we could barely make out the ruts that led

over a crest and down into the Yuekutsunglie Basin. Suddenly there was a break in the storm clouds to the east, and the first rays of dawn washed the snow in a salmon-colored glow. The Yukutsungli Basin was vast, empty and ringed on all sides by snow-covered hills.

We snaked our way to the bottom of the basin and began heading across it. The snow was beginning to melt, and there were small ponds everywhere. The driver gunned the engine and drove through a small stream. We came to a second stream, and he tried the same thing. This time, the far bank, it turned out, wasn't frozen, and the wheels sank about a foot into the mud and gravel. We spent an hour trying to get it out, but nothing worked. Not only were the tires stuck in the mud, the engine wouldn't start either. We were stuck, indeed.

After repeated failures to get the engine going and the wheels unstuck, my interpreter suggested I try to go the rest of the way on foot. If I left right then, he said, I just might make it. After talking to the two guides, he said the source was around ten kilometers away. I thought about it. There were ten hours of daylight left. And if I walked at a pace of two kilometers an hour, I just might make it there and back. At normal elevations of 1,000 or 2,000 meters, I was able to average between three and four kilometers an hour. But the Yuekutsunglie Basin was well over 4,000 meters. While I looked across the basin and at the snow-covered ridge where the source was supposedly located, I hesitated. Finally, one of the two guides said he would go with me. How could I refuse? And so we began walking across the tundra. There were still a few snowflakes in the air, but the morning sun was shining just above the eastern horizon. Despite the inauspicious beginning, it looked like it was going to be a great day. We trudged on, hopscotching our way on the tufts of dry, bunched grass and making frequent detours around small ponds. After two hours, my guide spotted a herd of yaks on

the horizon, and we veered towards it. Half an hour later, we reached the herd and asked the herders if they knew where the source of the Yellow River was.

It seemed like such a stupid question. Why would they know where the source of the river was? They were herders. But they surprised me. They pointed toward one of the snow-covered hills that ringed the Yuekutsunglie Basin. It looked too far to walk. When I asked if we could hire their horses, they said they were too thin. In that part of China, a horse was a person's most valuable possession, and they didn't like to ride theirs until the beginning of summer, after their horses had fattened up on new grass. Since it was too far to walk, and we couldn't hire horses, my guide suggested heading back. I looked again at the hill the herders had pointed to. It was on the west side of the Yuekutsunglie Basin, and it did look far away. But I decided to try. I told my guide that we could turn back later, if it looked like we couldn't make it there and back before dark. I thanked the herders and started walking.

The basin had an elevation of 4,500 meters, or nearly 15,000 feet, and distances were deceptive at that altitude. Also, the thinner air forced us to walk at a slower pace. We spent the next several hours panting our way across the tundra, not talking, just walking and gasping for air. After about three hours, we saw another family of herders and stopped again to ask directions. Again, they knew where it was. The source of the Yellow River, they said, was on the other side of the ridge. It was right in front of us, only about an hour away. It was hard to believe. We were almost there. But my guide said we had already gone too far. If we didn't start walking back to our jeep now, we would never make it before dark. I shrugged and told him to go back without me; I would spend the night with the herders if I couldn't make it back, and they could pick me up the next day, assuming they got

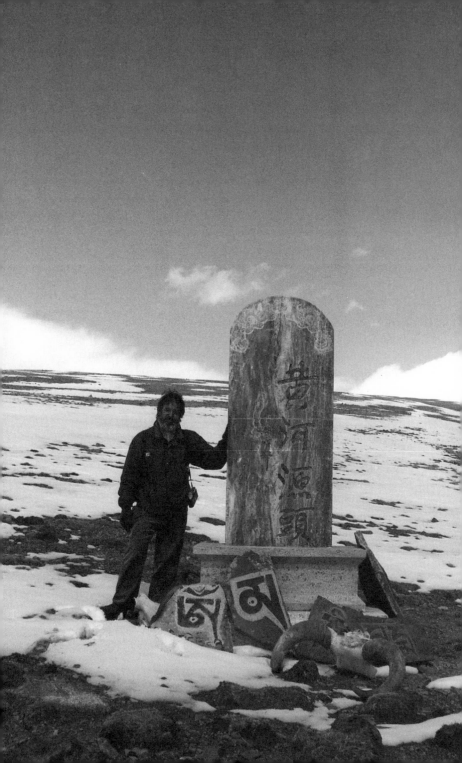

the jeep unstuck and the engine working again. Obviously, the thin air had impaired my judgment. I thanked the herders and headed off alone. Realizing I was not to be reasoned with, my guide caught up with me.

It wasn't long before I was regretting my impulsiveness. Every step was agony. My lungs said stop. My eyes had trouble focusing. I finally turned to my guide and said I had had enough. But now it was his turn to push me on. Twice we both dropped to our knees to catch our breaths, but that didn't seem to help. We stood back up and staggered on. Somehow, we managed to cross the ridge, and there they were, the stone slab and the yak horns that marked the source of the Yellow River. We were finally there. The stone slab said: "Source of the Yellow River." I was too tired to laugh and too tired to cry. My guide and I took each other's pictures. Next to the marker was another stone put there in 1987 by a team of Chinese adventurers prior to rafting down the river to the sea. I learned later that they didn't make it. They drowned south of Hsining near the section of the river where the Lungyanghsia Dam was built.

The day was getting late, and the snow had started falling again. But before leaving, I bowed three times in front of the small stone carved with the Tibetan mantra: "*Om mani padme hum.*" The thought finally dawned on me that maybe this time I had asked too much of the gods that had protected me. We started back but at a slower pace, we were both exhausted – the elevation had taken its toll.

As we staggered down from the heights, the cobalt morning sky had given way to a late afternoon snowstorm. We headed in the direction where we had left the jeep, which hopefully would be repaired and out of the mud and

The author at the source of the Yellow River

waiting for us. As we plodded across the tundra, we decided to veer away from our beeline to the jeep. We headed toward the yurts of some Tibetan herders we had seen in the distance on our way there. As we started in their direction, my guide told me to get behind him, and he reached into his shoulder bag and pulled out a pistol. What the hell was going on, I thought. With his other hand, he pointed at half a dozen small black dots near the yurts. The dots were headed our way, and they were getting bigger. The dots turned out to be very large dogs – very large snarling dogs. As soon as they got close enough, my guide fired his pistol into the air twice. The dogs stopped their headlong rush and started circling. With his free hand, he then reached into his bag and took out a long rope. On one end was a heavy pyramid-shaped metal weight. He started swinging it over both our heads, letting it out gradually until the weight was swirling about ten meters from us. As the dogs watched it whiz past their heads, they backed off, and we proceeded like that across the tundra toward the yurts. When we got to within hailing distance, the herders called off their dogs, and my guide put away his weapons.

One of the herders lifted the flap of one of the yurts and invited us inside. The yurt was made of yak hair and inside was an iron stove and just inside the tent flap was the fuel, a pile of dried yak dung. It gave the tent a distinctive smell. But the smell of the yak dung was nothing compared to the smell of yak butter, apparently rancid. Just inside the tent flap, across from the dung, there was also a waist-high pile of butter. I guess they were placed on different sides of the flap so no one would confuse the piles in the dark.

Once we were inside, I was surprised how much room there was. The yurt was about ten meters across, and it was held up by two ridgepoles. The stove was between the poles, and the family's possessions were in wooden chests that lined

the inside wall. And next to the chests were bedding and carpets, all of it rolled up. As we entered, our hosts unrolled several of the carpets, and we sat with our backs against the bedding. Opposite the door was a family shrine, with a picture of Kuan-yin, the Buddhist bodhisattva of compassion. One of the women came in from outside with an armful of snow. She put the snow in a cooking pot, then threw a couple of dung chips into the stove. As soon as the snow melted and came to a boil, she walked over to the pile of yak butter and took a handful. Then she added it along with some yak milk and some tea leaves and some sugar to the boiling water. A minute later, it was ready, and we all sat around sipping big cups of hot yak milk and butter tea, or pocha, as Tibetans called it. My guide and I were so thirsty, we didn't say anything. We just drank. And when our cups were empty, the woman filled them again.

Finally, my guide explained what we were doing, and he asked them if we could hire their ponies to take us back to our jeep, which we were hoping would be repaired by the time we got there. The herders shook their heads. They said their ponies were still too weak from the winter. But we were feeling weak too, and we persisted – or at least my guide did, at my urging. It was only with great reluctance and thirty bucks for three ponies – two for us and one for an escort to bring the ponies back, that they finally agreed.

I was so relieved to be riding instead of walking, I could hardly contain myself. And on our way across the tundra, I taught my companions the words to the only riding song I knew, which I edited for the occasion:

> One morning when I was out walking for pleasure,
> I spied a young herdboy a-riding along.
> His hat was pushed back, and his prayer beads did
> jangle,

and as he approached, he was singing this song:
'Whoppie ti yi yo, get along little doggies,
it's your misfortune and none of my own.
Whoppie ti yi yo, get along little doggies,
you know that Tibet will be your new home.

I was pretty much on my own for the first part, but they rose to join me for the "whoppie ti yi yo" part. The herder also sang a couple Tibetan songs, and my guide joined in. I gave up after a few tries and just bobbed along, letting the pony do all the work.

Tibetan ponies have short legs, to avoid the potholes in the tundra, but they cruise right along. In less than two hours, we made it back to our jeep, just as it was getting dark. The vehicle was, as we had hoped, ready and waiting. After thanking our escort, we all climbed inside and headed back to the Mato trading post.

It was May 25th, and the year was 1991, and I had finally reached the source of the Yellow River. It had taken me more than two months to travel the river's 5,000 kilometers tracing the river along whose shores Chinese civilization began 5,000 years ago and where the Chinese people had first established the sensibility that had made them Chinese. Sitting in the jeep as we bumped our way back across the Yuekutsunglie Basin in the dark, it all came surging back: the China Coast Ball in Shanghai, the Islands of the Immortals off the Shantung coast, the barren mud flats at the river's mouth, the weeds on the tomb of Confucius, the cloudy peaks of the sacred mountains of Taishan and Sungshan, the narrowness of the Hanku Pass, endless erosion of the Loess Plateau, and the desert sands, the bumpy roads and the hard seats, and those damned airhorns truck drivers used to clear the road, and the cold beer and the warm beer, and the crowds that gathered

whenever I took out pictures of my family. But mostly, I re-membered the river, flowing, yellow and relentless.

Suddenly, the jeep's lights went out. We stopped, and the driver jury-rigged a wire to the generator and asked me to keep the wire taut. The lights came back on, and by the time we reached the trading post, it was midnight, and my arm was numb. I was too tired to care. I could have slept for days. But I didn't. We started back the next morning.

YELLOW RIVER ODYSSEY GLOSSARY

Modified Wade-Giles	Pinyin	Traditional Chinese Characters
Ahnimaching	Animaqing	阿尼瑪卿
Anyang	Anyang	安陽
Beijing	Beijing	北京
Chafang	Chafang	茶坊
Chaka	Chaka	茶卡
Chaling	Chaling	扎陵
Chang Kuo	Zhang Guo	張果
Changyu	Zhangyu	張裕
Chao duke	Zhao	昭
Ch'ang-an city	Chang'an	長安
Cheng Hsuan	Zheng Xuan	鄭玄
Chengchou city	Zhengzhou	鄭州
Chenpeitai fort	Zhenbeitai	鎮北台
Ch'eng brothers	Cheng	程
Chiahsien town	Jiaxian	佳縣
Chiang Kai-shek	Jiang Jieshi	蔣介石
Chiang Tze-min	Jiang Zemin	江澤民
Chiehchou	Jiezhou	解州
Chienfoshan	Qianfoshan	千佛山
Chihsien	Qixian	吉縣
Chinan city	Jinan	濟南
Chinghai lake	Qinghai	清海
Chingtao city	Qingdao	青島
Chingtung dam	Qingtong	青銅
Chinshui road	Jinshui	金水
Chiufeng mountains	Jiufeng	九峰

Chiyun pagoda	Qiyun	齊雲
Ch'i state	Qi	齊
Ch'in dynasty	Qin	秦
Ch'ing dynasty	Qing	清
Chou dynasty	Zhou	周
Chou En-lai	Zhou Enlai	周恩來
Chu Te	Zhu De	朱德
Chuang-tzu	Zhuangzi	莊子
Chufu city	Qufu	曲阜
Chuhsienchen town	Zhuxianzhen	朱仙鎮
Chumalai county	Qumalai	曲麻萊
Chungchou hotel	Zhongzhou	中州
Chungnan mountains	Zhongnan	終南
Chungshan road	Zhongshan	中山
Chungtiao mountains	Zhongtiao	中條
Chung Tzu-ch'i	Zhong Ziqi	鍾子期
Chungwei town	Zhongwei	中衛
Chungyueh temple	Zhongyue	中岳
Ehling lake	Eling	鄂陵
Erlangshan mountain	Erlangshan	二郎山
Fanlou restaurant	Fanlou	樊樓
Fanta pagoda	Fanta	繁塔
Fawang temple	Fawang	法王
Fen river	Fen	汾
Fenglingtu ferry	Fenglingdu	風陵渡
??Feng Sheng	Feng Sheng	
Fuku town	Fugu	府谷
Genghis Khan	Chengjisi	成吉思汗
Golmud town	Ge'ermu	格尔木

Han dynasty	Han	漢
Han Chung-li	Han Zhongli	漢鐘離
Han Hsiang-tzu	Han Xiangzi	韓湘子
Han Yu	Han Yu	韓愈
Hancheng city	Hancheng	韓城
Hangchou city	Hangzhou	杭州
Hankukuan pass	Hanguguan	含谷關
Heimaho river	Heimahe	黑馬河
Hengshan (north) mountain	Hengshan	恆山
Hengshan (south) mountain	Hengshan	衡山
Ho Hsien-ku	He Xiangu	何仙姑
Hochin town	Hejin	河津
Hoka village	Heka	河卡
Holan mountains	Helan	賀蘭
Honan province	Henan	河南
Hopei province	Hebei	河北
Hotse town	Heze	荷澤
Houma	Houma	侯馬
Hsi Ho	Xi He	羲和
Hsia dynasty	Xia	夏
Hsiaho town	Xiahe	夏河
Hsiangkuo temple	Xiangguo	相國寺
Hsiaokoutzu gorge	Xiaokouzi	小口子
Hsiaopeihu lake	Xiaobeihu	小北湖
Hsiehchih lake	Jiechi	解池
Hsilitu temple	Xilidu	席力圖
Hsinchiang province	Xinjiang	新疆
Hsingtan	Xingtan	杏壇
Hsining city	Xining	西寧

Hsiung-nu nomads	Xiongnu	匈奴
Hsu Hao	Xu Hao	徐浩
Hsu Hsia-k'o	Xu Xiake	徐霞客
Hsu You	Xu You	許由
Hsuan Sheng	Xuan Sheng	宣聖
Hsuan-tsung emperor	Xuanzong	玄宗
Hsun-tzu	Xunzi	荀子
Hua Mu-lan	Hua Mulan	花木蘭
Huan, duke	Huan	桓公
Huangchung town	Huangzhong	湟中
Huangkuoshu falls	Huangguoshu	黃果樹
Huangling tomb	Huangling	黃陵
Huangpu river	Huangpu	黃浦
Huangshui river	Huangshui	湟水
Huangti emperor	Huangdi	黃帝
Huashihhsia village	Huashixia	花石峽
Huayuankou dike	Huayuankou	花園口
Huhohaote city	Huhehaote	呼和浩特
Hui minority	Hui	回
Hui-k'o	Huike	慧可
Hukou falls	Hukou	壺口
Hungkou park	Hongkou	虹口
Juicheng town	Ruicheng	芮城
Kaifeng city	Kaifeng	開封
Kansu province	Gansu	甘肅
Kaocheng village	Gaocheng	告城
Kaomiao temple	Gaomiao	高廟
Kiangsu province	Jiangsu	江蘇
Kuan Chung	Guan Zhong	管仲
Kuan Kung	Guan Gong	關公

Kuan Yu	Guan Yu	關羽
Kuan-ti	Guandi	關帝
Kuan-yin	Guanyin	觀音
Kuang-wu emperor	Guangwu	光武
Kuangchou	Guangzhou	廣州
K'uang Ch'ang-hsiu	Kuang Changxiu	匡常修
Kublai Khan	Hubilie	忽必烈
Kueichou province	Guizhou	貴州
Kueiwenke	Kuiwenge	奎文閣
K'ung Chi	Kong Ji	孔伋
K'ung Fu-tzu	Kong Fuzi	孔夫子
K'ung Li	Kong Li	孔鯉
K'ung Shang-jen	Kong Shangren	孔尚任
K'ung Te-ch'eng	Kong Decheng	孔德成
Kunlun mountains	Kunlun	崑崙
Kuo Shou-ching	Guo Shoujing	郭守敬
Kuyeh river	Kuye	窟野
Labrang monastery	Labuleng	拉卜楞
Lanchou city	Lanzhou	蘭州
Lan Ts'ai-ho	Lan Caihe	藍采和
Lao-tzu	Laozi	老子
Laochun temple	Laojun	老君
Laomutung cave	Laomudong	老母洞
Laoshan mountain	Laoshan	嶗山
Lhasa city	Lasa	拉薩
Li Ch'ing-chao	Li Qingzhao	李清照
Li Fu	Li Fu	李福
Li Pai	Li Bai	李白
Li P'eng	Li Peng	李鵬
Li T'ieh-kuai	Li Tieguai	李鐵拐

Li Yung	Li Yong	李邕
Linfen city	Linfen	臨汾
Lingpao town	Lingbao	靈寶
Lingyen temple	Lingyan	靈巖
Linhsia town	Linxia	臨夏
Lintzu town	Linzi	臨淄
Liu An	Liu An	劉安
Liu Hsiu	Liu Xiu	劉秀
Liu Pei	Liu Bei	劉備
Liuchiahsia dam	Liujiaxia	劉家峽
Liupu	Liubu	柳埠
Liuyuankou dike	Liuyuankou	劉園口
loess	huangtu	黃土
Loyang city	Luoyang	洛陽
Lu state	Lu	呂
Lu Hsun	Lu Xun	魯迅
Lu Tungpin	Lu Dongbin	呂洞賓
Luliang mountains	Luliang	呂梁
Lungmen caves or gorge	Longmen	龍門
Lungshan culture	Longshan	龍山
Lungting pavilion	Longting	龍亭
Lungyanghsia dam	Longyangxia	龍羊峽
Ma Pu-fang	Ma Bufang	馬步芳
Machu river	Maqu	瑪曲
Maichishan caves	Maijishan	麥積山
Mangshan mountain	Mangshan	邙山
Mao Tse-tung	Mao Zedong	毛澤東
Maowusu desert	Maowusu	毛烏素
Mato town	Maduo	瑪多

Mato trading post	Maduo	麻多
Meitaichao temple	Meidaizhao	美岱召
Meng Fan-chi	Meng Fanji	孟繁驥
Meng T'ien	Meng Tian	孟恬
Meng-tzu	Mengzi	孟子
Miao minority	Miao	苗
Michih town	Mizhi	米脂
Mienchih town	Mianchi	澠池
Mihsien town	Mixian	密縣
Ming dynasty	Ming	明
Mu king	Mu	穆
Nanching city	Nanjing	南京
Ninghsia province	Ningxia	寧夏
Ordos desert	E'erduosi	鄂尔多斯
Pai Chu-yi	Bai Juyi	白居易
Paima temple	Baima	白馬
P'an-ku	Pangu	盤古
Pao Kung	Bao Gong	包公
Paoan minority	Bao'an	保安
Paoshan factory	Baoshan	寶山
Paotou city	Baotou	包頭
Paotu Chuan spring	Baotu Quan	趵突泉
Peimang hills	Beimang	北邙
Peishanssu	Beishansi	北山寺
Penglai town or island	Penglai	蓬萊
Pihsia Yuanchun	Bixia Yuanjun	碧霞元君
Pingling caves	Bingling	病靈
Po-yi	Boyi	伯夷
Pohai sea	Bohai	渤海
Puchao temple	Puzhao	普照寺

Puha river	Buha	布哈
P'u Sung-ling	Pu Songling	蒲松齡
Salar minority	Sala	撒拉
Sanmenhsia dam	Sanmenxia	三門峽
Shang dynasty	Shang	商
Shanghai	Shanghai	上海
Shansi province	Shanxi	山西
Shantung province or peninsula	Shandong	山東
Shao music	Shao	韶
Shao Hao emperor	Shao Hao	少昊
Shaolin temple	Shaolin	少林
Shapotou nature reserve	Shapotou	沙坡頭
Shengli oilfield	Shengli	勝力
Shenmu town	Shenmu	神木
Shensi province	Shaanxi	陝西
Shihmenshan mountain	Shimenshan	石門山
Shouyangshan mountain	Shouyanshan	首陽山
Shu-ch'i	Shuqi	叔齊
Shun emperor	Shun	舜
Shutienchieh street	Shudianjie	書店街
Sian city	Xi'an	西安
Ssu-ma Ch'ien	Sima Qian	司馬遷
Suchou	/ Suzhou	蘇州
Sui dynasty	Sui	隋
Sun Yat-sen	Sun Yixian	孫逸仙
Sung dynasty	Song	宋
Sungshan mountain	Songshan	嵩山

Sungyang academy	Songyang	嵩陽
Sun-tzu	Sunzi	孫子
Suite	Suide	綏德
Tachao temple	Tazhao	塔召
Taer monastery	Ta'er	塔尔
Tahsia state	Daxia	大夏
Taichingkung temple	Taiqinggong	太清宮
Taishan mountain	Taishan	泰山
T'ai-an city	Tai'an	泰安
T'ai-tsung emperor	Taizong	太宗
T'ang dynasty	Tang	唐
Tangchia village	Tangjia	唐家
Tao	Dao	道
Taohsiangchu restaurant	Daoxiangju	稻香居
Taotangho river	Daotanghe	倒淌河
Tatung city	Datong	大同
Tayu ferry	Dayu	大禹
Tengfeng city	Dengfeng	登封
Tenggeri desert	Tenggeli	騰格里
Tiehhsieh village	Tiexie	鐵謝
Tienshui city	Tianshui	天水
Toumu temple	Doumu	斗母
Ts'ao Kuo-chiu	Cao Guojiu	曹國舅
Ts'ao Ts'ao	Cao cao	曹操
Tseng-tzu	Zengzi	曾子
Tsouhsien town	Zouxian	鄒縣
Tsungkapa	Tsongkaba	宗喀巴
Tu Fu	Du Fu	杜甫
Tunghsiang minority	Dongxiang	東鄉

Tungkuan pass	Tungguan	潼關
Tungsheng town	Dongsheng	東胜
Tungwancheng	Tongwancheng	統萬城
Tungying town	Dongying	東營
Tunhuang caves or town	Dunhuang	敦煌
Tzupo city	Zibo	淄博
Uighur minority	Weiwuer	維吾爾
Wang Chao-chun princess	Wang Zhaojun	王昭君
Wang Che	Wang Zhe	王喆
Wang Ch'ung-yang	Wang Chongyang	王重陽
Wangchiaping village	Wangjiaping	王家坪
Wanhuashan mountain	Wanhuashan	萬花山
Wei dynasty	Wei	魏
Wei river	Wei	渭
Weinan city	Weinan	渭南
Wen-cheng princess	Wencheng	文成
Wenchuan village	Wenquan	溫泉
Wenhsiang	Wenxiang	閺鄉
Wu emperor	Wu	武
Wuchih town	Wuzhi	武陟
Wuchung town	Wuzhong	吳忠
Wuhan city	Wuhan	武漢
Wuta temple	Wuta	五塔
Wutangchao temple	Wudangzhao	五當召
Wutangshan mountain	Wudangshan	武當山
Wuting river	Wuding	無定
Wuyi road (Kaifeng)	Wuyi	五一
Yang Kui-fei	Yang Guifei	楊貴妃

Yangcheng ancient city	Yangcheng	陽城
Yangchialing village	Yangjialing	楊家齡
Yangchuang village	Yangzhuang	楊庄
Yangshao culture	Yangshao	仰韶
Yangtze river	Yangzi	揚子or長江
Yao emperor	Yao	堯
Yaotien book	Yaodian	堯典
Yen Hui	Yan Hui	顏回
Yen Tzu-ling	Yan Ziling	嚴子陵
Yenan city	Yan'an	延安
Yenchih town	Yanchi	鹽池
Yentai city	Yantai	煙台
Yi river	Yi	伊
Yichuan town	Yichuan	宜川
Yin Hsi	Yin Xi	尹喜
Yinchuan city	Yinchuan	銀川
Yinshan mountains	Yinshan	陰山
Yu emperor	Yu	禹
Yu Po-ya	Yu Boya	俞伯牙
Yuan dynasty	Yuan	元
Yueh Fei	Yue Fei	岳飛
Yuekutsunglie mountains	Yueguzonglie	約古宗列
Yulin city	Yulin	榆林
Yumen gorge	Yumen	禹門
Yunglokung temple	Yonglegong	永樂宮
Yungning pagoda	Yongning	永寧
Yunkang caves	Yungang	雲岡
Yuwang terrace	Yuwang	禹王

Bill Porter is an award-winning author and translator also known by his pen name, Red Pine. He is considered one of the foremost translators of Chinese texts, especially Buddhist and Taoist poetry and sutras. His translation work includes major Buddhist texts such as *The Platform Sutra*, *The Diamond Sutra* and *The Heart Sutra* as well as the best-selling poetry collections *Taoteching* and *Collected Songs of Cold Mountain*. He is also the author of *Zen Baggage* and *Road to Heaven: Encounters with Chinese Hermits*. Porter lives in Port Townsend, Washington.